Japan Modern

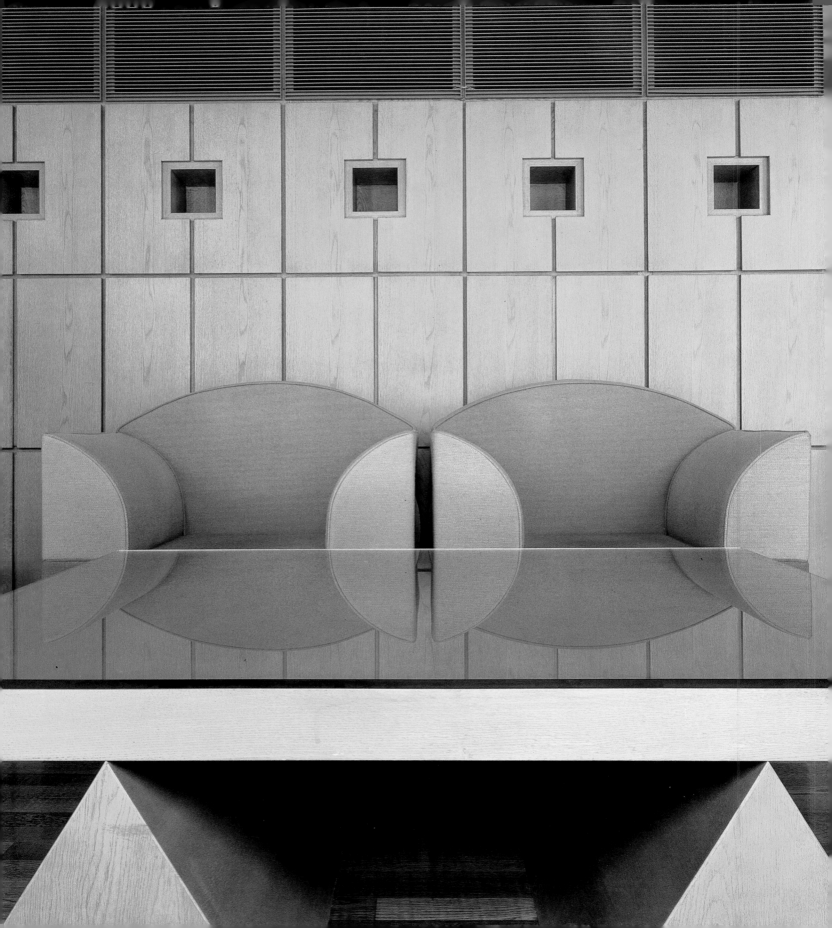

Japan Modern

New Ideas for Contemporary Living

Photographs by Michael Freeman
Text by Michiko Rico Nosé

PERIPLUS

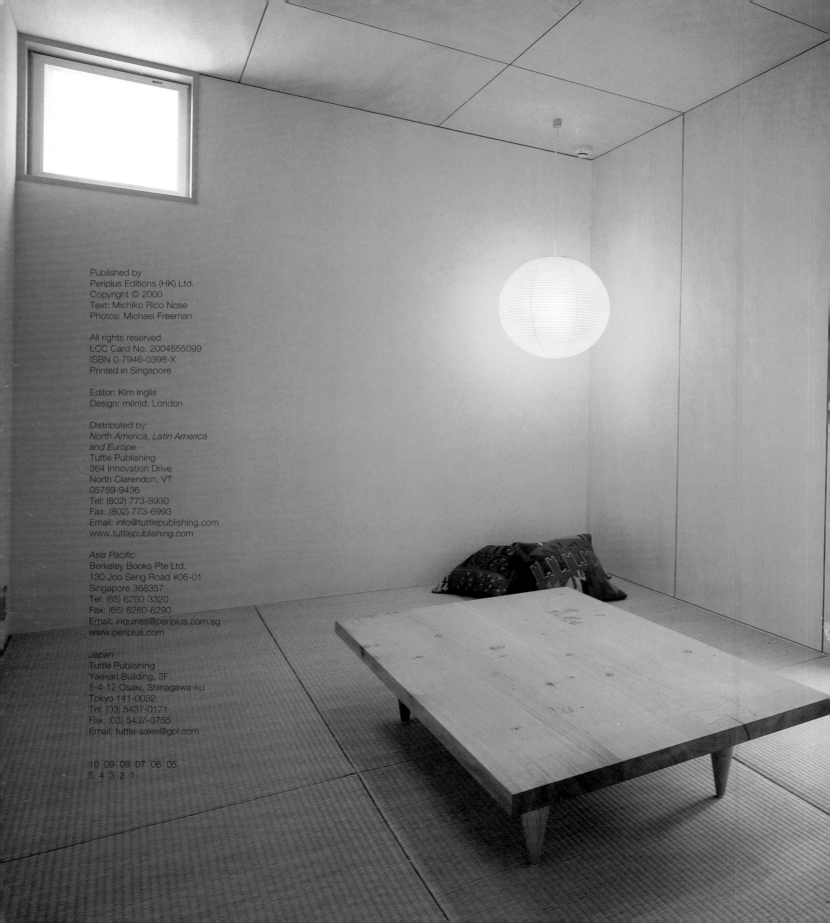

Published by
Periplus Editions (HK) Ltd.
Copyright © 2000
Text: Michiko Rico Nose
Photos: Michael Freeman

All rights reserved
LCC Card No. 2004555099
ISBN 0-7946-0398-X
Printed in Singapore

Editor: Kim Inglis
Design: m(in)d, London

Distributed by:
*North America, Latin America
and Europe*
Tuttle Publishing
364 Innovation Drive
North Clarendon, VT
05759-9436
Tel: (802) 773-8930
Fax: (802) 773-6993
Email: info@tuttlepublishing.com
www.tuttlepublishing.com

Asia Pacific
Berkeley Books Pte Ltd.
130 Joo Seng Road #06-01
Singapore 368357
Tel: (65) 6280-3320
Fax: (65) 6280-6290
Email: inquiries@periplus.com.sg
www.periplus.com

Japan
Tuttle Publishing
Yaekari Building, 3F
5-4-12 Osaki, Shinagawa-ku
Tokyo 141-0032
Tel: (03) 5437-0171
Fax: (03) 5437-0755
Email: tuttle-sales@gol.com

10 09 08 07 06 05
5 4 3 2 1

Contents

Introduction

For Japan, the last decade of the last century was dominated by the collapse of its super-heated but hitherto staggeringly successful economy. The trajectory that had taken the nation to the position of having the world's second strongest economy with, remarkably, an equitable distribution of wealth, had reached apogee by the end of the 1980s. In 1990 the recession began, and continued for more than ten years. Hardly the ideal circumstances, you might think, for the development of new and exciting ideas in architecture and design. Yet this is Japan, where things work in ways that are sometimes unexpected from a Western perspective.

As it is, the leading edge of Japanese domestic architecture and interior design (as we will see, the two are often inseparable) has never been so interesting, and the reasons lie in the upheaval wrought by the bubble economy and its deflation. What is happening now is both a reaction to former excesses and a re-evaluation of the Japanese way of life. The heady years of the '80s created a situation of insane land prices, shoddy housing developments, and a general desire to be as Western as possible. For those who could afford it, the high style of house design was borrowed from the West, albeit skilfully, and was characterized by concrete bunkers and castles more brutalist than the European models of Le Corbusier and others that inspired them. The Japanese were moving forward and becoming international, and by and large they wanted to look the part.

The legacy was a diminution of Japanese traditions and chaotic urban development of unsurpassed ugliness. Aesthetically, the residential districts of cities, where most of the population lives, are a catastrophe, made all the worse by the tiny plot sizes. For a people who pride themselves on their sensitivity to art, culture and the social graces of daily life, this is somewhat difficult to cope with.

Nevertheless, there is a side to Japanese character that flourishes in adversity, and the best of the new generation of architects and interior designers have found intriguing solutions to the problems of living in Japan. In this book we look at what we think are the 40 most interesting and imaginative, almost all of them previously unpublished in the West. Some are undoubtedly a little strange —

a few are quite eccentric — but every house that we visited and explored is enjoyed by its owners. Some may have had a few misgivings at first, and occasionally there have been certain trade-offs, such as between conventional comforts and aesthetic pleasures, but the results, covering a wide spectrum of ideas, have all been successful for the people who live in them.

One of our mentors in exploring the new architectural and design scene is Terunobu Fujimori, Professor of Architectural History at Tokyo University and himself a practising member of the avant-garde — we feature two of his houses in this book. Widely regarded as the leading commentator, he identifies two contrasting movements emerging in the last decade, what he calls the white school and the red school. The former is the heir to the fashion for bare concrete, and has developed a vocabulary of glass and metal, all the while becoming lighter, more transparent, more polished, with an airy palette of white, silver and grey. Ultimately, it derives from Mies van der Rohe, and similar movements are current in America and Europe, but here it is part of a longer process, what Atsushi Ueda, another architect-academic, describes as "the pursuit of lightness in Japanese architecture", part of "an ingrained tradition of the lightweight". In contrast to this cool abstraction, Professor Fujimori sees a red school — buildings that are dynamic, vital, sometimes even earthy, based as he puts it on "a sense of real existence". More varied than the school of glass and polished metal, it makes frequent references to regional and indigenous structures.

Within this context, we see three emerging trends, and they are due as much to changing attitudes among house owners as to ideas from the professionals. The first is a renewed interest in tradition, the second is an attraction towards natural materials and a personalized, craftsmanlike treatment of them, and the third is non-conformity and a search for individual expression.

Possibly the most traditional element in a Japanese house is the *washitsu*, or tatami room, with no equivalent in the West. It is a room defined by a flooring of fixed-size straw mats — defined not just in appearance but in use, which is to say barefoot, at floor level,

and in a uniquely Japanese way, with all kinds of historical and cultural connotations. For centuries, the tatami was universal, and as it was based on the dimensions of the human body ("half a mat to stand, one mat to sleep") it became a standard unit of measurement. Yet by 1965, as most Japanese raced to Westernize their lives and houses, only 55 percent of homes had such a room. Since the bubble years, however, there has been a reversal; according to a 1998 study, 91 percent of houses had a *washitsu*.

More interesting for us, however, are the methods chosen by new architects and designers for re-absorbing such traditions. They are being re-interpreted, sometimes in quite subtle and oblique ways. More than half of the houses in this book have in some way incorporated tradition, but always with a twist. The *washitsu* (and its more tightly focused version the *chashitsu*, or tea-ceremony room) is steeped in tradition and nuance, and has become something of a challenge for the modern designer. That challenge is to work within the canon, to capture the spirit, the Japanese-ness, while making imaginative leaps. Yasuo Kondo's version in OSB, Ken Yokogawa's lycra-roofed rooms perched under the rafters, and Kunihiko Hayakawa's cylindrical 'apparatus' are just some of the notable experiments in this genre. Other areas for exploring tradition are in space allocation (an old Japanese expertise based on light sliding partitions), in evoking the post-and-beam construction of *minka* farmhouses, and in the interior-exterior relationship with nature.

Indeed, nature is at the heart of the second emerging trend, and in one sense it reflects an old idea of lifestyle. The Japanese garden and the *sukiya* style of construction (which stressed under-statement, simplicity and rusticity) were both expressions of a love of nature and natural materials. Now, after the cold shower of the recession, a growing number of people are re-discovering these values. Some have rejected industrial chic in favour of wood, paper, rope and fabric, hand-crafted in a modern idiom. Others are intent on greening their immediate environment, whether by configuring limited space to accommodate trees, as in the Tiny House and Hanegi Forest, or by taking plant life up the walls and onto the roof,

as in Terunobu Fujimori's and Naoyuki Shirakawa's startling con-structions. Urban greening may be an international phenomenon, but the Japanese are doing it with reference to their own history.

The third trend is a major departure for the Japanese — a search for individual expression, in some instances to the point of eccentricity. Conformity was the hallmark of the regulated, corporate economy and a society that seemed to be working so well, but right now it is being questioned. This is by a minority, to be sure, but as has happened before, when the Japanese decide to embrace a new idea, they tend to do it with an unusual fervour. When it comes to radical homes, Japan is right up there at the front, and they are all the more prominent for being usually found in a sea of characterless housing. The ones we show here, gathered in the final chapter, have been selected for the variety of innovative ideas that propel them.

Kathryn Findlay, one of our featured award-winning architects and originally from Scotland, has worked for 20 years in Japan and was recently appointed associate professor at Tokyo University — only the second to a foreigner (the first was in 1877). She has a particular view on the reasons why the Japanese avant-garde can be so far forward — and yet acceptable to enough clients. She says: "The Japanese are so meticulously controlled. There's control in the way that people live and in the way that people relate to each other. There's a great deal of order, economic and social. And maybe, when you squeeze people so tight, and hard, which is what's happened in the last 50 years, some extreme things pop out at the edges." She likes the edges, and in partnership with Eisaku Ushida, has also been responsible for some radical homes, not the least eye-catching of which is the Soft and Hairy House shown here.

For all these reasons, at the turn of the century, the forefront in Japanese house design shows a greater maturity and confidence than at any other time. Lifestyles are changing, there is an increased awareness of the need for a Japanese identity in an international world, and the sharp shock administered by the economic collapse has encouraged the Japanese to take a more considered view of the framework that surrounds their daily lives — in particular their homes.

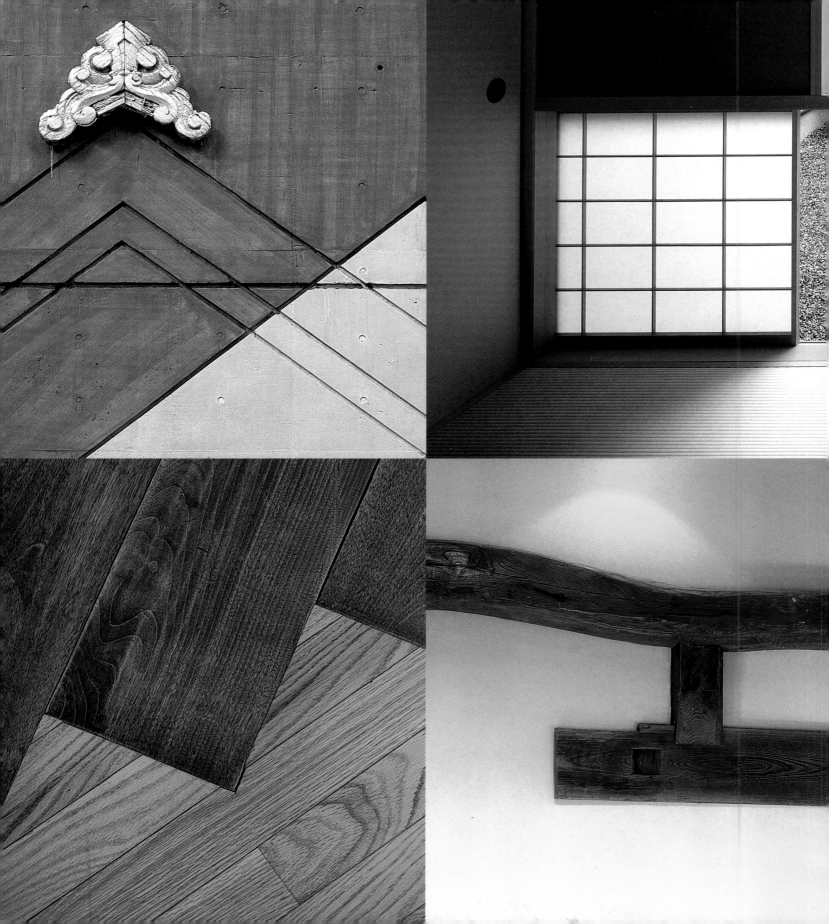

Reworking Tradition

The uncritical rush to Westernize is over. During the country's seemingly unstoppable economic rise, it seemed the obvious, international thing to do. But in the years since many Japanese have taken a more appreciative look at their long and complex artistic and cultural tradition. This is what now inspires many ideas, with interpretations varying from the subtle to the extreme.

Right: Evoking something of an old farmhouse, exposed natural timber beams allow a view from the living room the full height of the house. The balcony of the tatami rooms is at the upper right.

Below: The entrance to the house, with its juxtaposition of dark timbers and white walls, is preceded, just inside the door, by a concrete floor that swells up in the middle to make an almost sculptural flat-topped pedestal.

Lycra and Wood
New ideas for tatami rooms

For this house in Yokohama, Ken Yokogawa (who also designed the house featuring the oversized curved window on page 68 and the seaside villa on page 146) combined two traditional characteristics of Japanese living spaces that are in some ways contradictory. One is the high, open space with exposed timbers typical of *minka* country dwellings, of which the Hattori house on page 36 is a fine example. The other is the low-ceilinged proportion associated with small tatami rooms, which the Japanese have typically found comfortable and appropriate, particularly for sleeping.

He achieved this by locating the sleeping areas on a mezzanine close to the rafters, so that the full height of the building can be appreciated from the ground floor living areas, and by exposing the timber structure. Yokogawa then went an imaginative step further by building two adjoining tatami rooms with a twist — each has a tent-like roof of white lycra, held taut in the middle by a single cord attached to a rafter.

His reasoning was to create a "kind, soft ceiling" that would allude to a cloud, and break with the notion of tatami rooms as restrictive spaces overloaded with cultural tradition. In this way, individual living areas for guests keep an isolated privacy within a large, open interior and, in Western terms at least, evoke the sense of tree-house cabins.

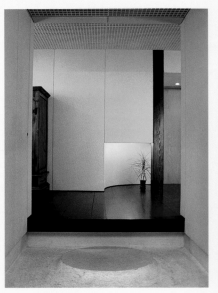

Right: Perched over the main living area, under the exposed rafters of the ceiling, are two adjoining mezzanine tatami rooms. Lycra was chosen as the soft ceiling material because of its two-way stretch properties. It adds a tent-like atmosphere, and for guests who stay here there is a hint of indoor camping.

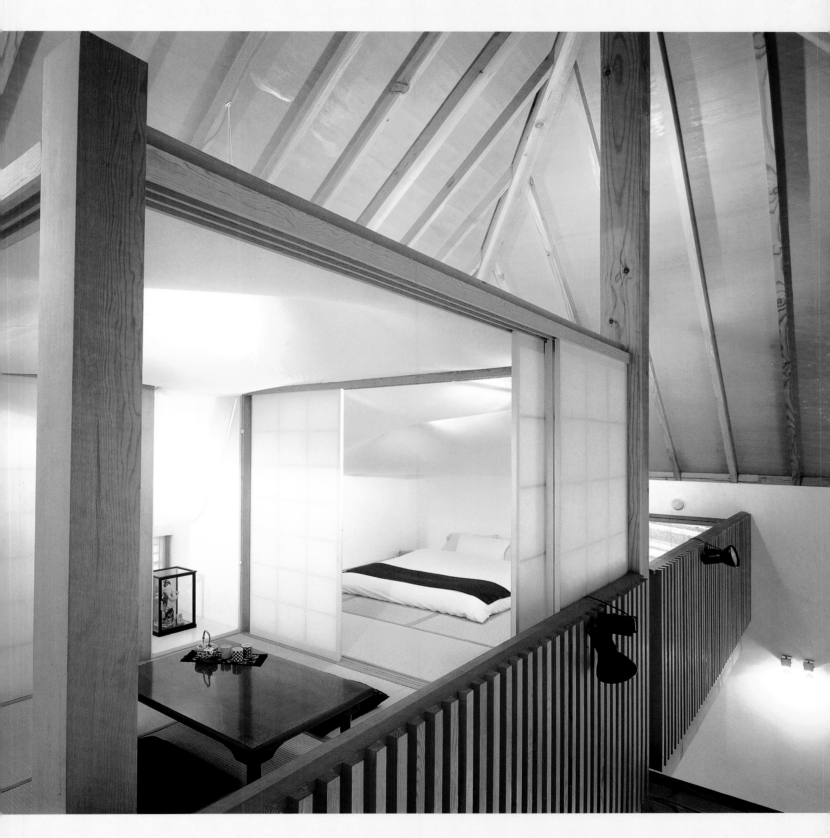

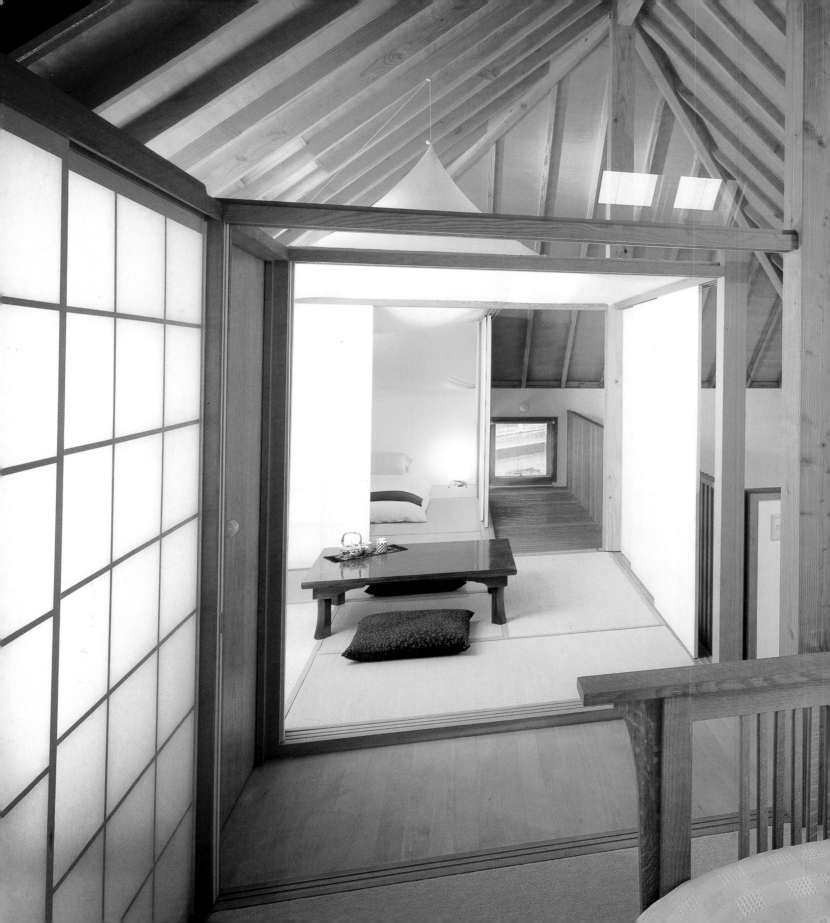

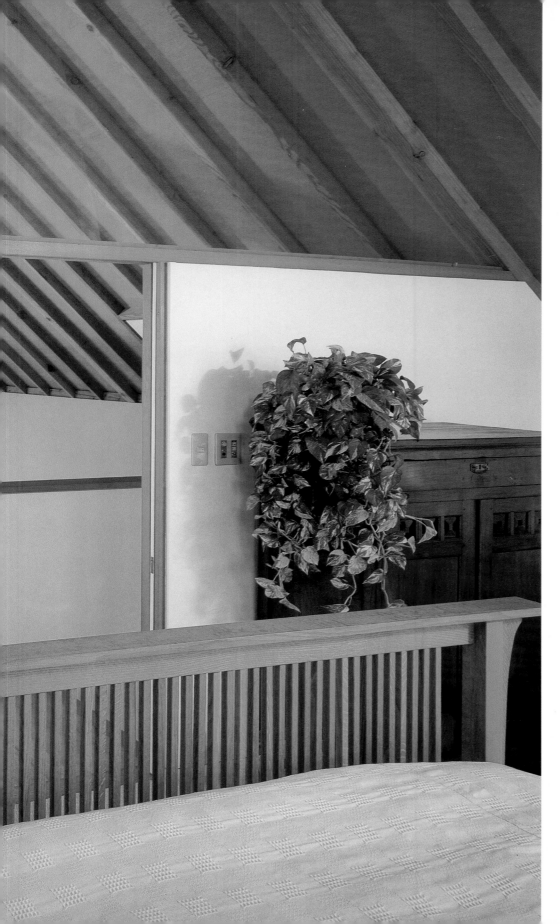

Left: The view from the bedroom through to the two tatami rooms. Sliding doors can enclose all three rooms.

Below: The architect's detailing includes the design of door handles in the form of two interpenetrating spheres, recalling molecular models.

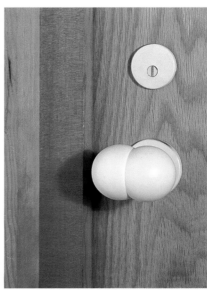

Barrier-free Minimalism
White simplicity in the Tofu House

In a quiet residential area of Kyoto, facing a small park, this single-storey white cube earns its name, the Tofu House, from its minimal façade. Inside, the clean simplicity, even severity, is continued in a bright barrier-free space. The virtually seamless living area was, in fact, part of the specifications for this, the retirement home for an elderly couple. Anticipating the owners' reduced mobility in future years, architect Jun Tamaki designed the entire house on one level, with no obstructions.

Although the volume of the house is reasonably modest — 8 x 14 x 4 metres — Tamaki gave it what he calls a deliberately 'monolithic' impression, with massive white walls. These are emphasized by the deep recesses of the windows, their frames concealed in the plasterwork. Despite the thickness of the walls, however, no space is actually wasted, as the subsidiary rooms and various storage spaces are embedded in them. The 3.6-metre ceiling rises the full height of the building and adds to the sensation of spaciousness.

To minimize the distances that the couple need to move, the core of the house is a large basic living space that can be partitioned into three when needed. Sliding doors, following the traditional *fusuma*, are used throughout, running smoothly on high-precision rails. The two main partitions that can divide the area into thirds slide fully back into recesses in the walls, while cross beams above them carry a separate upper set of partitions operated by handles.

Above: **Cantilevers above and below make both the roof and the house itself appear to float, giving it an impression of lightness — and also of being cubic, hence the name. The single deeply-recessed window on the façade maintains the minimal simplicity.**

Right: **A deeply sculpted recess in the centre of one wall is a modern version of the display alcove, or *tokonoma*, while on either side sliding doors access the colour-coded kitchen at left and utility room at right.**

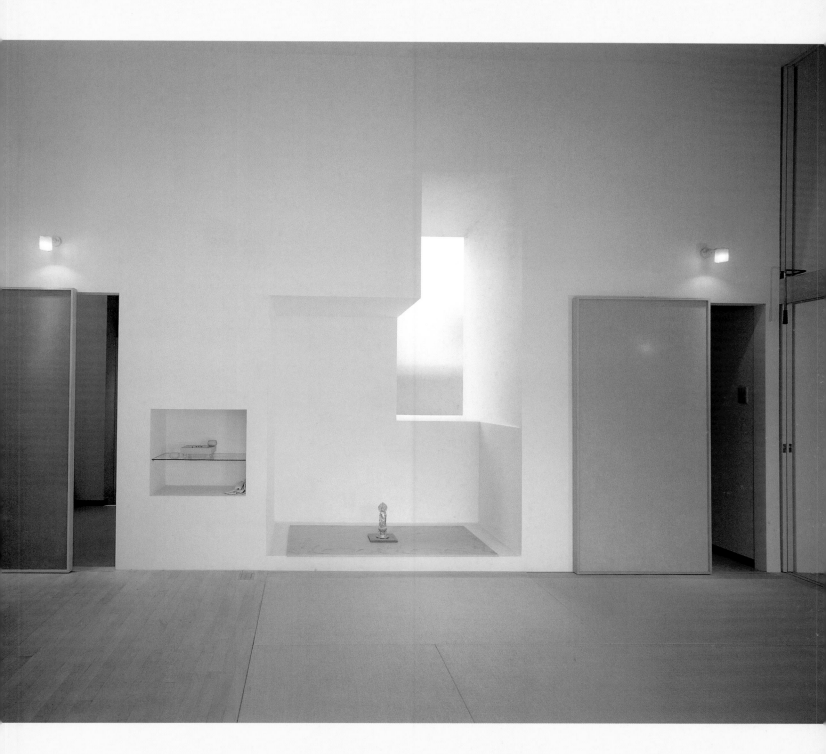

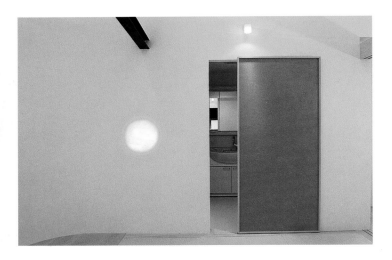

Left: A steel girder projects into the bathroom and is intended to carry a sliding invalid support in the event of either of the owners becoming infirm in the future. The doorway would then be widened.

Below: The rear of the house from the recessed alcove, with the sliding panels drawn back. The papered wall at the rear of the house conceals a porthole window to the bathroom.

Right: The view from the front window along the length of the house. The two cross beams, foreground and background, support sliding *fusuma* panels above and below, so that the space can be completely, or partially, divided into three rooms. The rear, seen here partially closed off, is used for sleeping.

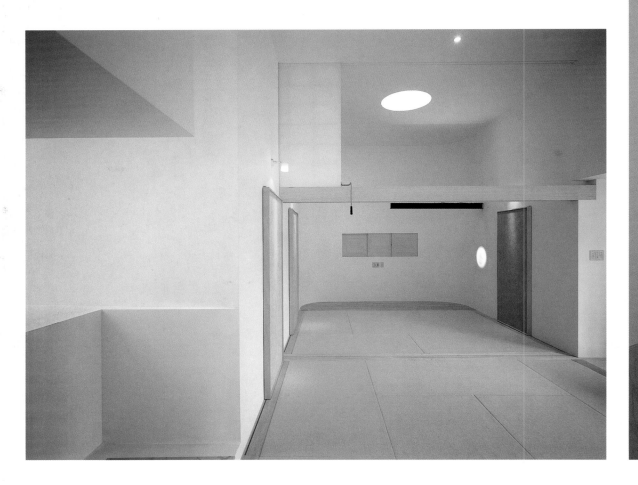

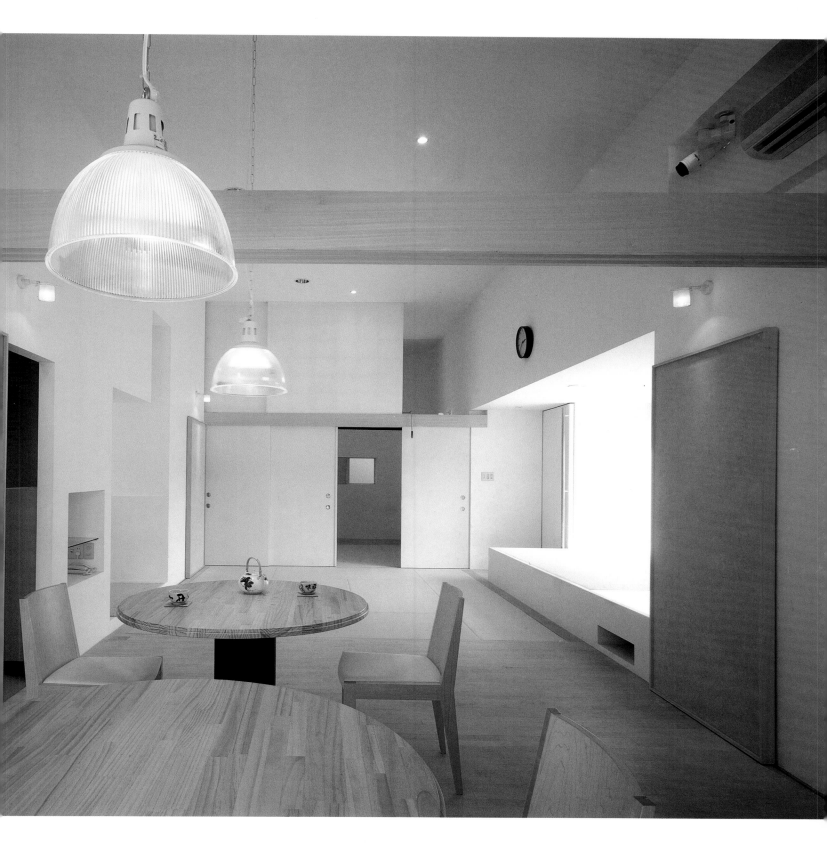

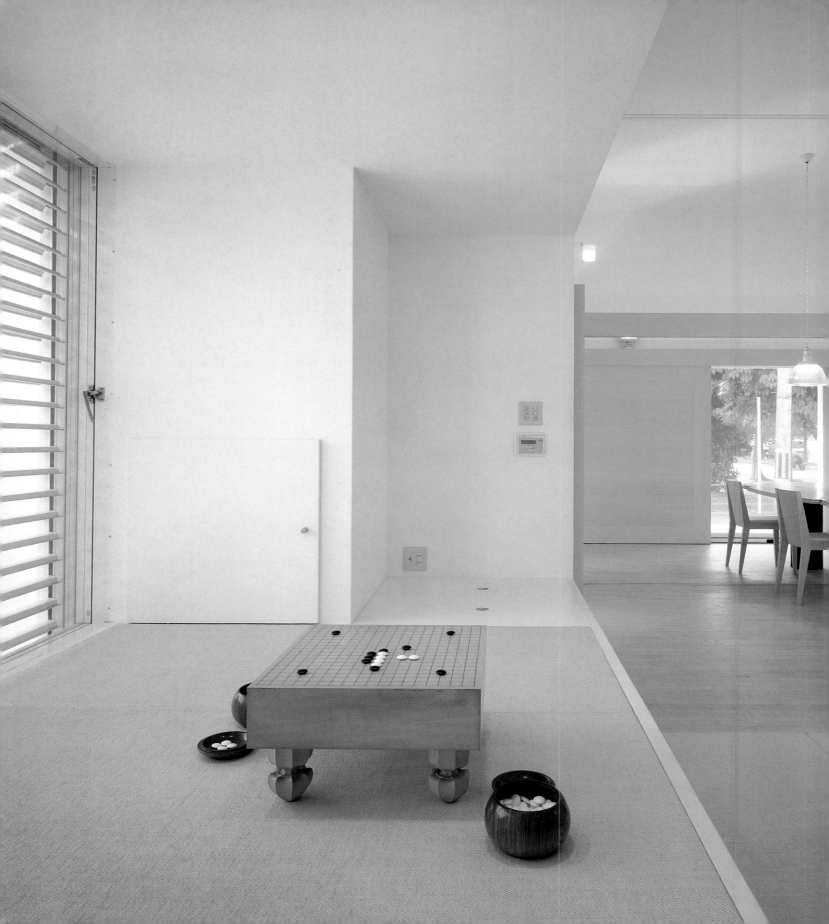

Left: On the side facing the alcove, a much deeper recess facing out over a small garden. This is a relaxation area for taking tea and for playing games such as the *go* board set up here. Beyond, the two circular tables seen on page 17 have been converted into one large oval table by the addition of a removable central section.

Below: The owner has a treasured collection of books, but decided to put most into storage when moving from the previous house. As a remembrance, the architect designed a single recess to take a favourite volume — a work on the painter Matisse.

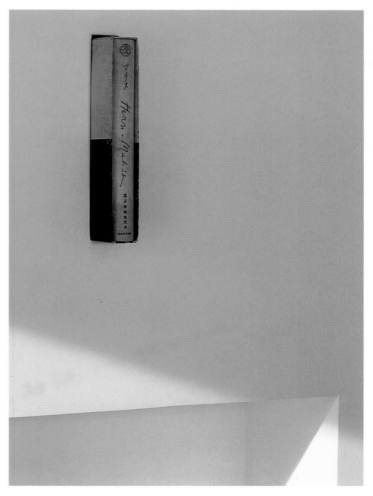

Right: The gently winding path leading up to the house is guided by three curved concrete walls including that of the garden at left, pierced by vertical slits.

Far right: The arrangement of sliding *shoji* screens on three levels in the tatami room was calculated to give an exact choice of framed views into the garden. Deliberately, it is not possible to see the entire tree; the only entire view is from the Western-style room (see overleaf).

East Meets West
Modern convenience and traditional views

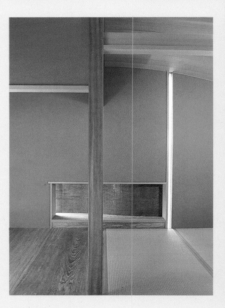

Above: The geometric division of the far end of the tatami room is softened by the curve of a section of the wooden ceiling and a low aperture lined with galvanized steel.

Overleaf: The garden and its adjoining tatami room seen from the Western-style area. A single tree provides the focus, its curved mound of peat a counterpoint to the curved concrete wall.

The owners of this large (by Japanese standards) house in Mihara, near Osaka, wanted a combination of Western-style amenities and the key elements of Japanese tradition in their house. This meant, on the one hand, space to entertain up to 30 guests, and on the other a garden with Zen meditative qualities and a *washitsu* or tatami room, including an area for tea ceremonies. More than this, they asked for new interpretations of the traditional components.

In the design of Chitoshi Kihara, the visual centre of the house is a curved-wall garden with the tatami room on one side and the sliding glass doors of the Western-style living area at right angles to this. Landscape gardener Yasujiro Aoki then chose as the focal point a single camelia tree — a 70-year-old white *wabisuke* — and set it on a crescent-shaped mound of peat surrounded with plain gravel.

His principle was that "the garden space has to become one with the rooms", and that its design "should be simple so as to create a feeling of quiet and stability". The crescent of peat invokes a sense of change, as in waxing and waning.

From the living room, guests can see the entire tree, and the owners hold a blossom-viewing party in the Spring. After admiring this view, they move to the tatami room, where the three-tiered arrangement of screens allows only partial views of the trunk and branches. As the designer intended, they then "enjoy an after-image of the whole tree" seen from the Western side.

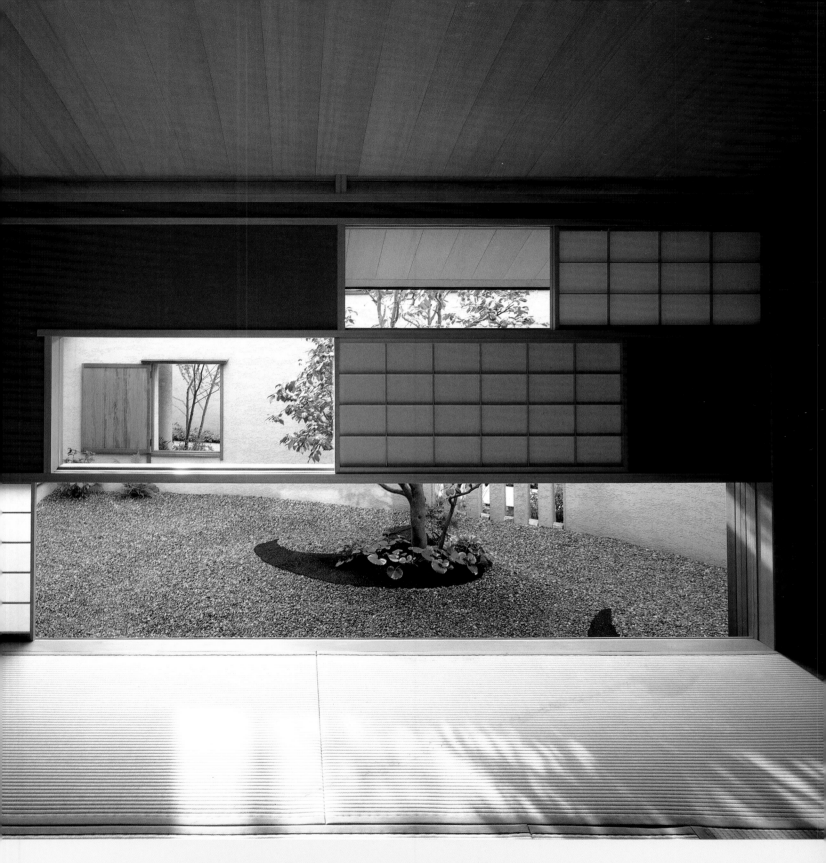

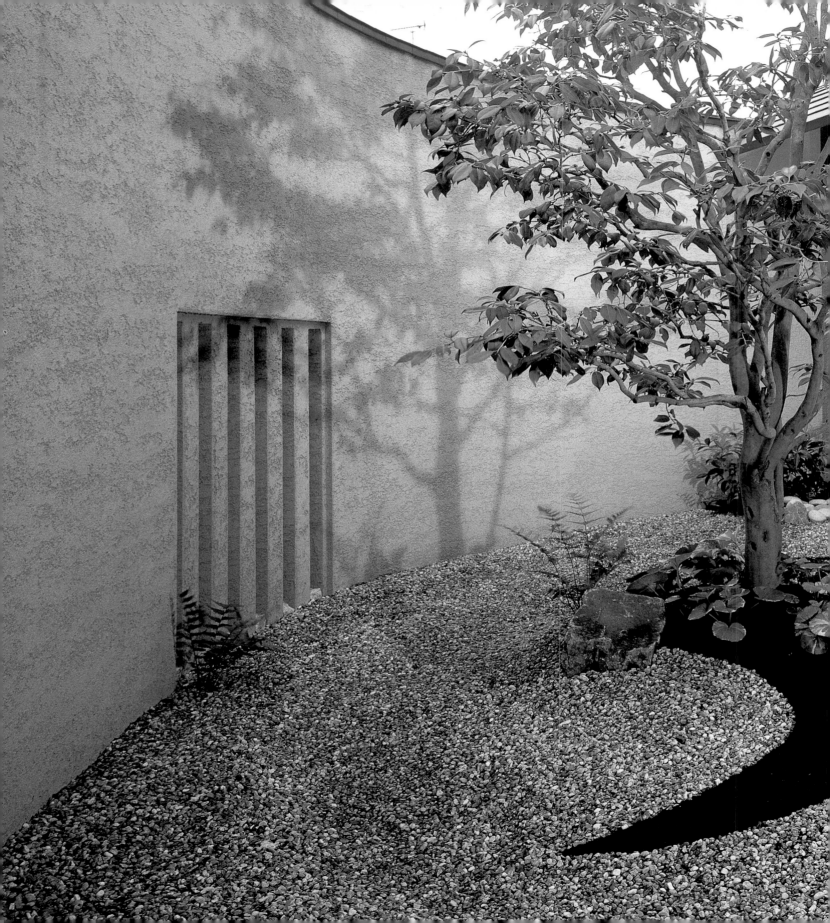

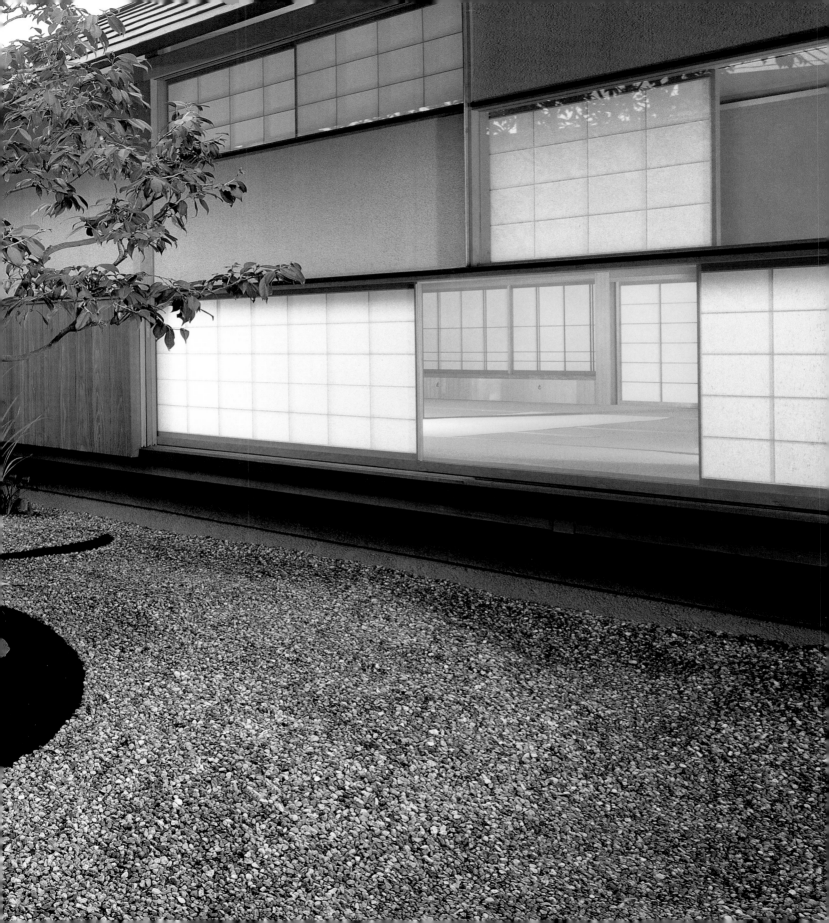

Old Within New
A calligraphy workshop enclosed by steel and glass

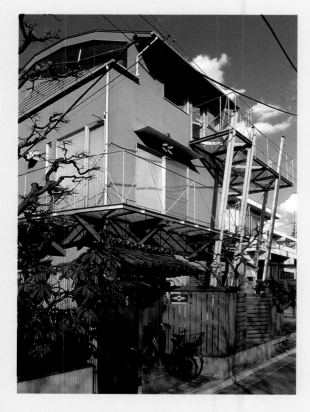

On the banks of a small stream running through the residential sub-urb of Setagaya in Tokyo, architect Shigeharu Isaka has created a house for two generations of the same family in which old traditions are incorporated in a strikingly modern structure. The owner is a calligrapher who runs a workshop, her daughter a fashion designer, and the decision was made to replace the old family house, which was inconvenient to divide into two, with an entirely new building.

Isaka retained and used certain parts of the old house, although not always in obvious ways. His basic idea was to have two very different entrances leading to a 'traditional' and to a 'modern' part. On the mother's side he placed the old gate, or *kido-mon*, but then took the roof tiles and laid them end-on inside. The calligraphy workshop has a mixture of old and new elements, while the larger part of the house occupied by the daughter and her husband is an open structure in steel and glass, with mezzanine floors connected by a spiral staircase.

The second tradition that the new house preserves is that of *hanami*, cherry-blossom viewing. The location is graced with one kilometre of choice *sakura* trees lining the stream that runs past the house. Most Japanese are content to do their annual viewing from ground level, but the architect gave the family a privileged position — on a level with the blossoms — by means of a bold terrace supported by diagonal girders.

Above: On the southwest 'traditional' side of the building, the entrance retains the 50-year-old wooden, tile-roofed gate. Its signboard, 'Kohyo-shoin', announces the calligraphy workshop.

Right: Diagonal steel girders on the 'modern' side of the house support terraces at two levels in expanded steel lathing. Although they give a striking contemporary appearance to the building, their function is completely traditional — for cherry-blossom viewing.

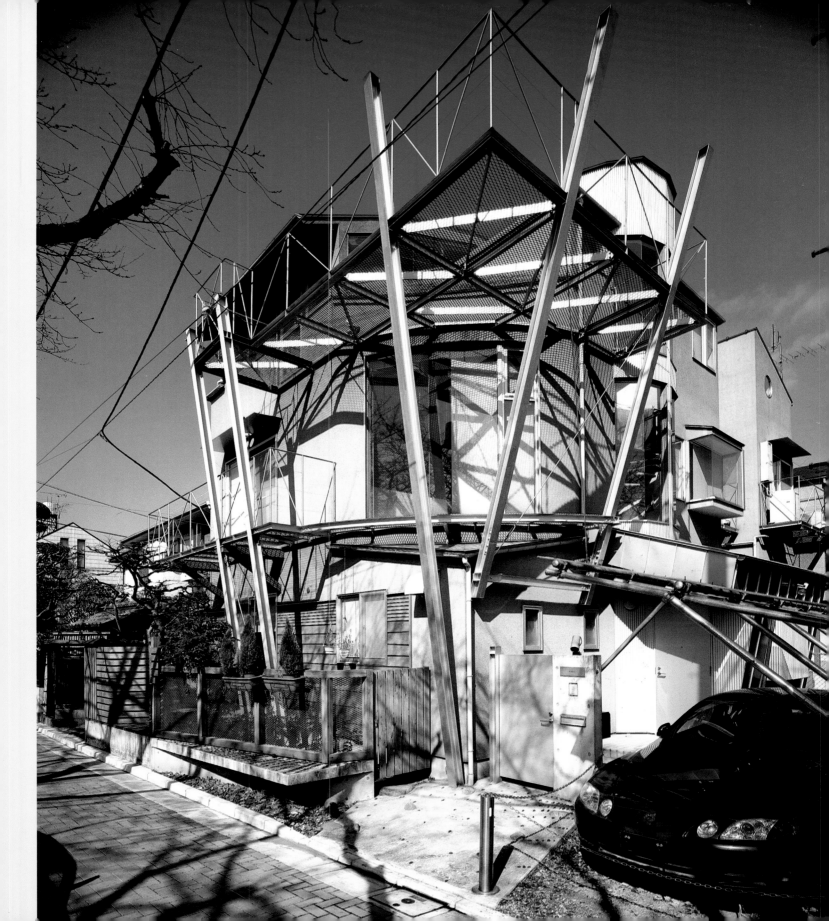

Right: The calligraphy room houses traditional elements, like the lintel-like *ranma* carved as an openwork landscape, but also incorporates idiosyncratic touches, such as the asymmetrical wooden inlays in the ceiling. On the sliding doors that lead to the 'modern' part of the house are the characters 'heart', 'flower', and 'heaven'.

Left: Calligraphy brushes hang on a rack in the bay window of the workshop.

Below: In contrast, the living area of the daughter's side of the house covers the second and third floors, with a steel bridge crossing the space to give access to the outside terrace.

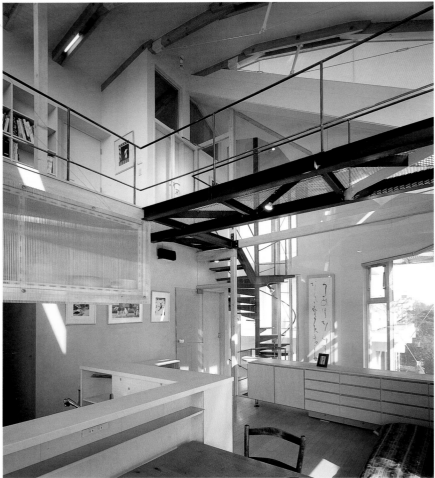

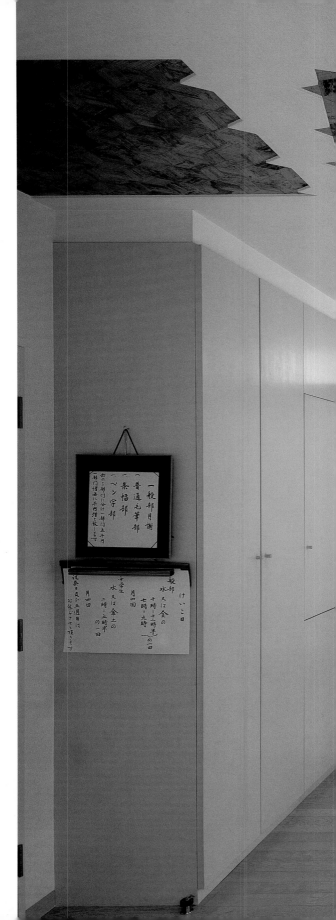

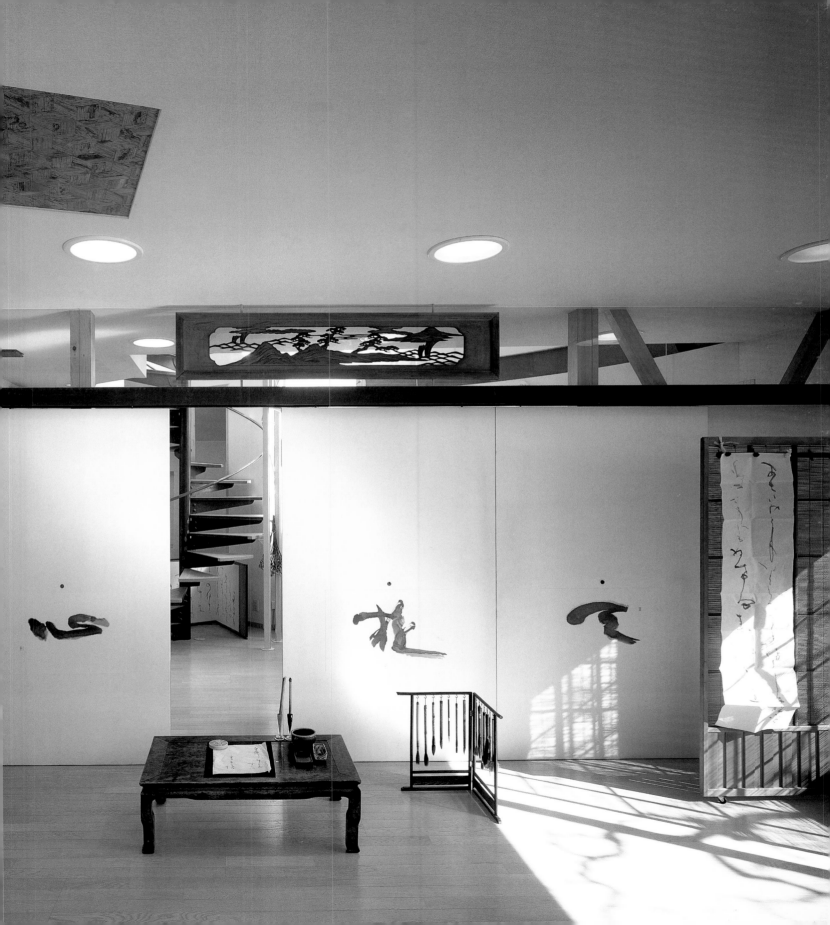

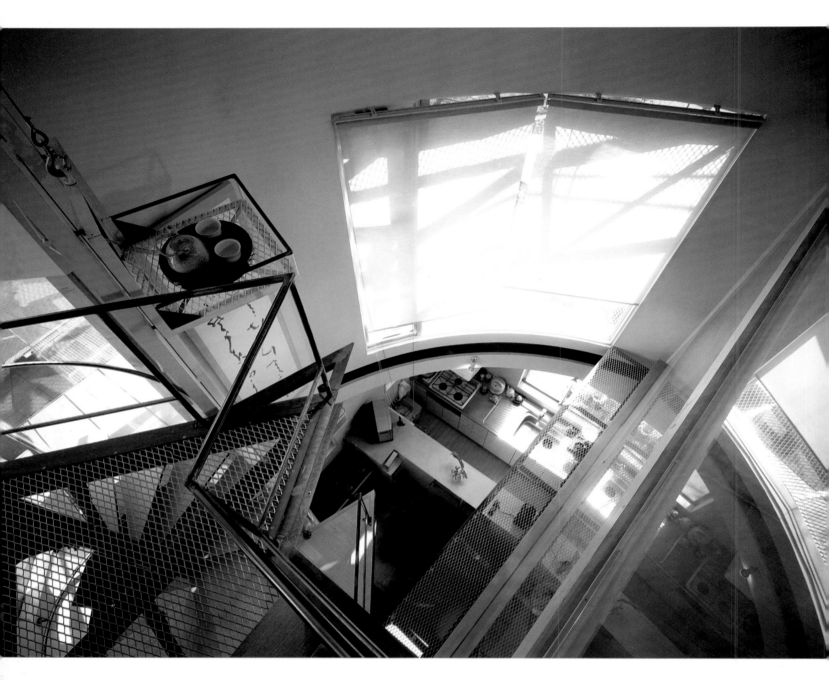

Above: A three-storey well on the southeast side of the house carries a spiral staircase and an effort-saving convenience — an electric-powered dumb waiter.

Right: The view up the stairwell from the ground floor kitchen to the top floor. Expanded steel lathing is used for the floor of the landings, as well as the terraces outside.

Below: The metal tray of the dumb waiter, used here to carry shopping upstairs. It is also put to work transporting meals prepared in the downstairs kitchen.

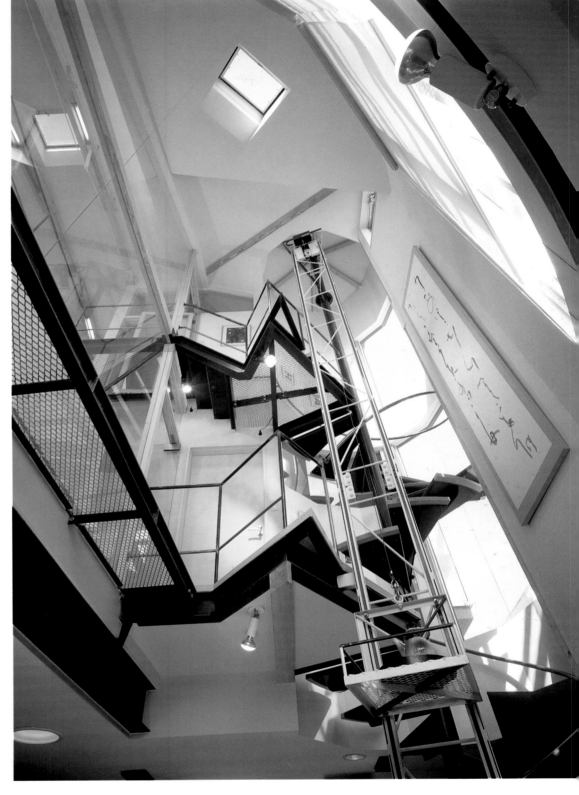

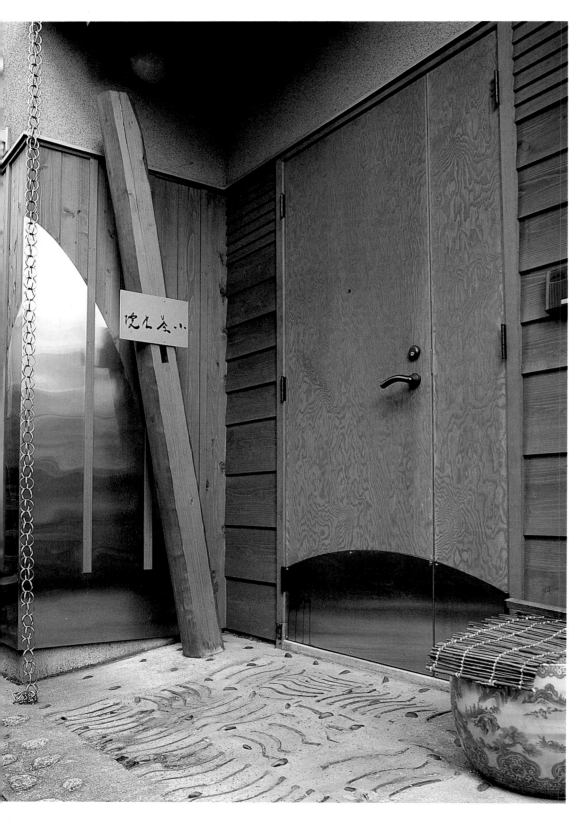

Left: The workshop entrance blends old and new in a mixture of timber and stainless steel plates. The steel chain carries rainwater from the roof spout to the drain.

Right: The plank fencing on the streetside is indented to form a bench for passersby, intended particularly for viewing the cherry blossoms opposite in Spring.

Below: Ceramic chips and tiles set into the concrete in front of the doorway.

Bottom: The roof tiles from the original family home have been put to a new practical use, buried end-on in the gravel inside the gate.

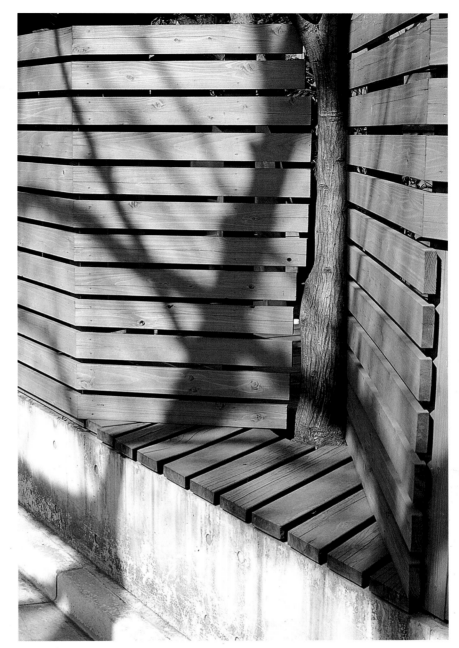

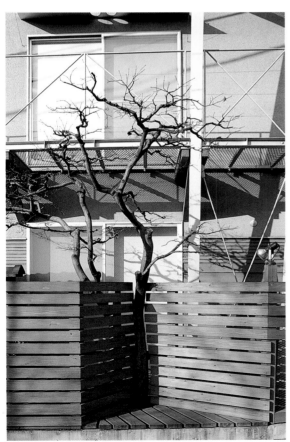

Modern Vernacular
Subtle updating of the sukiya style

The Kansai region, centred on the cities of Osaka, Kyoto and Kobe, maintains a distinct cultural identity. While Osaka has a reputation for brashness and energy, its inhabitants also value their traditions; like many of their neighbours in the Owase part of the city, the owners of this property wanted to maintain a tatami room and garden views as significant features of their otherwise modern house.

Kansai architect Chitoshi Kihara specializes in developing these traditional elements, often working with Yasujiro Aoki on the garden design. The references for *washitsu* or tatami rooms are both subtle and complex, and to design a new one of significance demands both a thorough knowledge of their history and the ability to extend and update the aesthetic.

Kihara chose to work in the *sukiya* style, the essence of which is the appreciation of unadorned natural simplicity. Normally the focus of the room is the *tokonoma*, or alcove, with its scroll display, but Kihara's idea was that modern lifestyles do not permit the time to attend to it properly, changing its display seasonally. Instead he re-oriented the room to use an external display — the minimalist garden pond — which would take care of its own seasonal changes. In front of a frameless glass window, an updated *shojii* screen has asymmetric over-sized paper panels to catch the reflections of ripples in the pond. The display shelf, known as a *chigaidana*, is normally two-stepped and by the *tokonoma*, but has been placed here instead and re-designed with three wave-like steps to refer to the water beyond.

Right: The chestnut furniture in the lower ground floor living room was designed by George Nakashima (1905-1990), the internationally acclaimed woodworking craftsman, whose pieces are in every major museum collection. His trademark combination of exquisite craftsmanship and rustic sensibility is yet another interpretation of the *sukiya* style that permeates the traditional parts of the house.

Above: A *chigiri*, or butterfly spline, elegantly secures the natural cracks in the table's surface. Nakashima did not see such features as faults, but part of the unique character of each piece of wood, to be respected and enjoyed.

Overleaf: Non-traditonal *shoji* screens in the *sukiya*-style tatami room open to reveal a tranquil pond with a bed of pebbles and a papyrus plant.

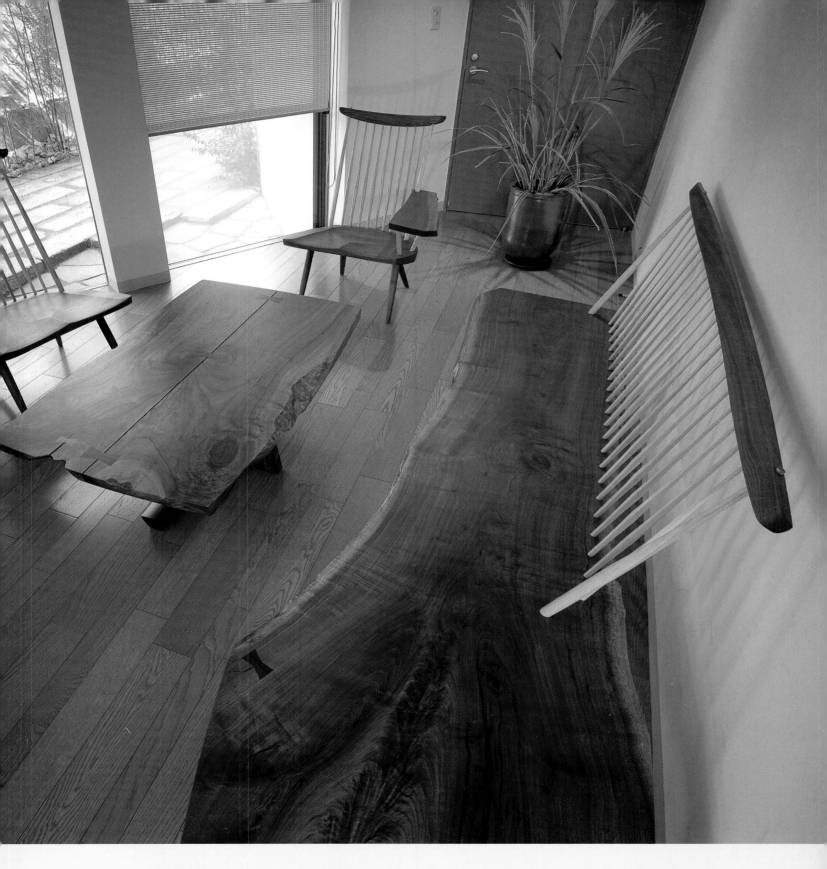

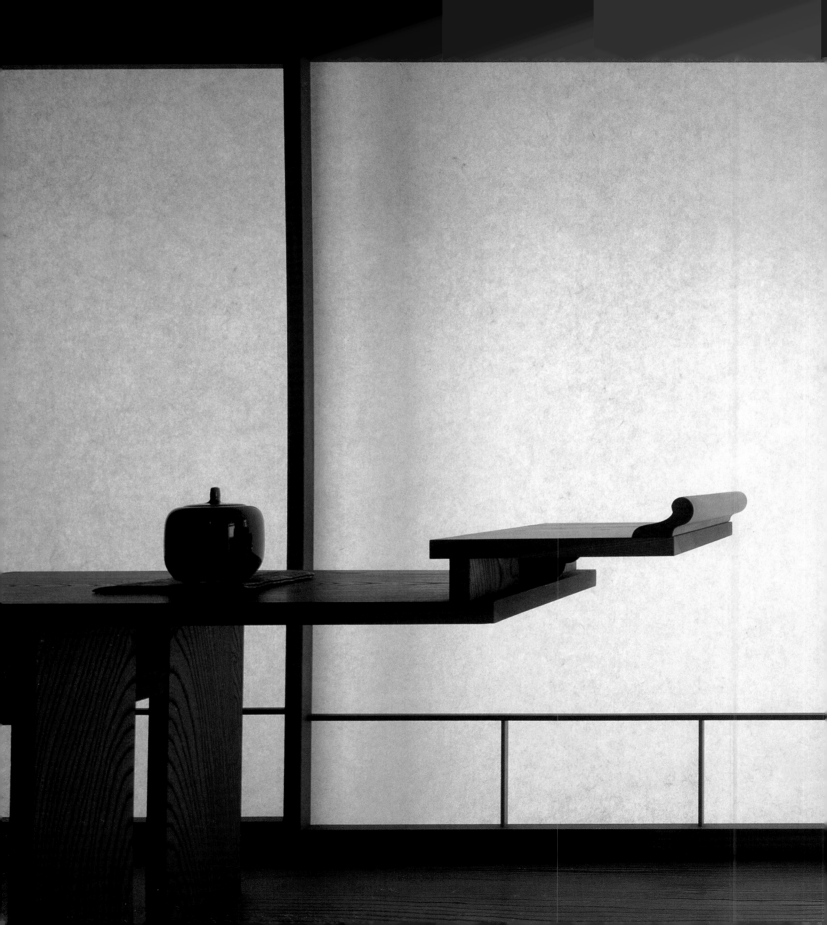

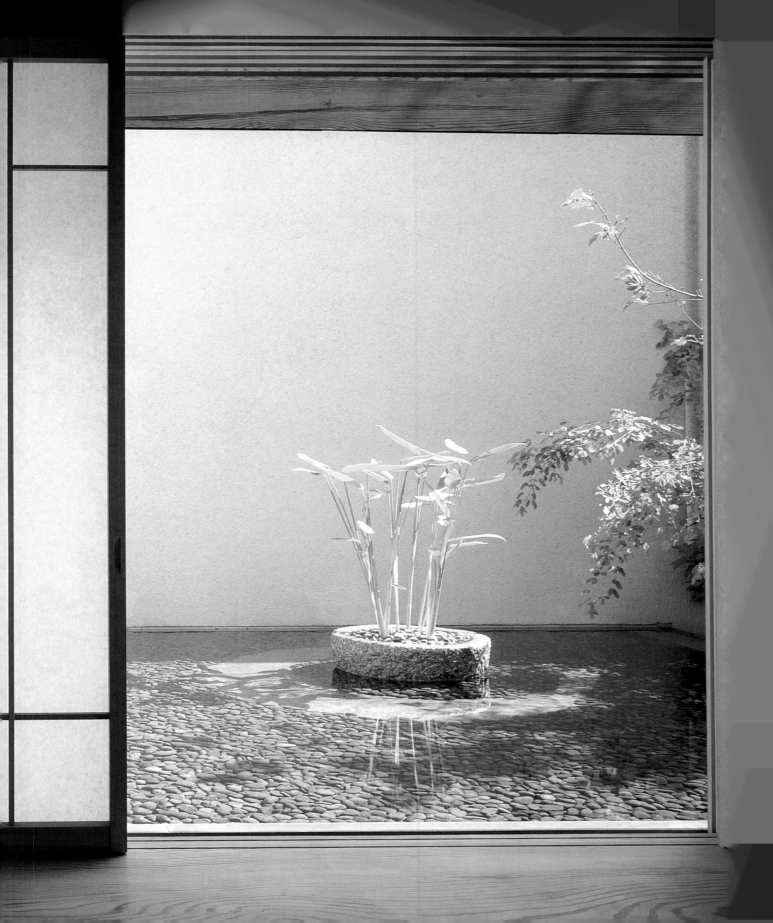

City Rural
Relocating an old farmhouse to the heart of Tokyo

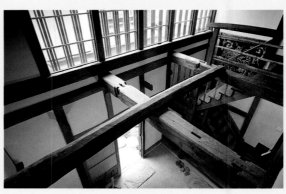

Novelist Masumi Hattori and her husband had an attachment to the rustic style of Japanese folkhouses, and for the family plot in central Tokyo, where she grew up as a child. It therefore seemed logical to try to recreate this in the city. More than this, in reaction to the wave of glass and concrete building that had characterized the bubble economy years, she felt that the most modern answer to living in the city was a revival of the more natural traditions of Japanese living styles. The location, Shinagawa, is now a very built-up area of central Tokyo, but during the Edo period (1600-1868) it was the start of one of the principal post roads leading out of Tokyo to the west.

The post-and-beam construction of traditional farmhouses, known as *minka*, makes them capable of being dismantled and re-assembled, despite their size. Indeed, some antique shops in Japan actually carry houses, advertizing them through photographs, and this was how Masumi Hattori acquired her old house, on one of her frequent antique-hunting expeditions. Once she had chosen it at the shop, she went to see it in its countryside setting in Fukushima prefecture in the north. "Even though this is a re-cycled house," she explains, "it cost the same as would a new one, because it was quite difficult to move. This area has such narrow streets; we had to bring it in piece by piece and very carefully."

Although intrinsically an old building, the Hattoris modernized it discreetly to suit a city lifestyle, replacing the traditional roof, installing a new granite bathroom, exercise room and study.

Top: With some adaptation, including truncating part of the rear of the structure, the farmhouse fits exactly into the lot. A modern roof complete with skylights replaces the original.

Above: The view down towards the entrance from the bedroom reveals massive, rough-hewn timbers, evidence of the abundance of forest at the time the farmhouse was built. The traditional earth floor just inside the door has been replaced by concrete, and the wooden floors of the house proper are raised.

Right: The entrance displays a complex structural pattern of pillars and cross beams, rising the full two-storey height. In order to withstand earthquakes, houses such as this had many mortised joints and wooden pegging that allowed for a certain amount of play in the structure. The author's study lies beyond.

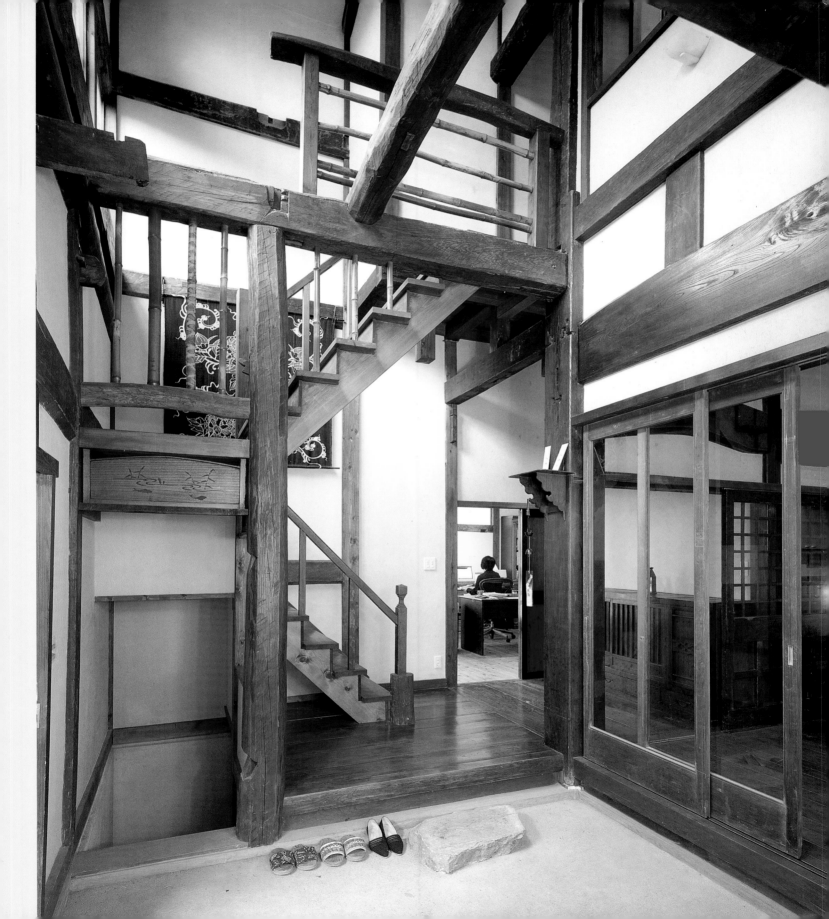

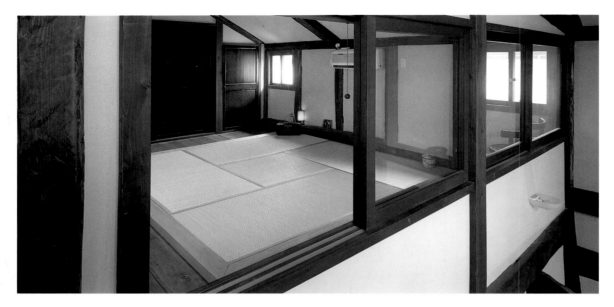

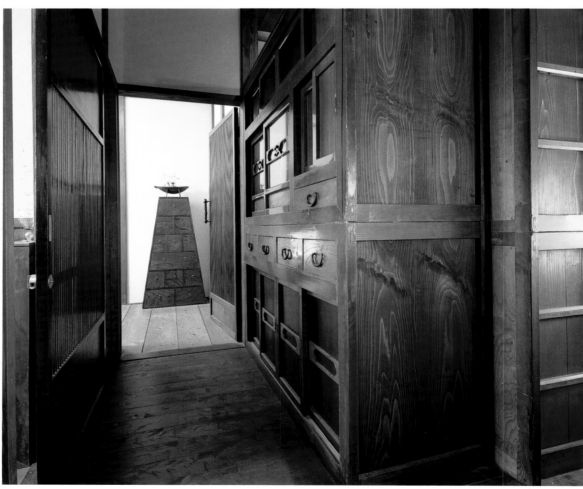

Left: A room of four and a half tatami mats, or *yojo-han*. The mats in a centrally placed wooden frame mark the sleeping area of the main bedroom, seen here from the top of the staircase. Sliding windows in the foreground give the effect of a balcony, looking out over the main entrance.

Left below: A mixture of old Japanese and Korean cupboards at the rear of the house. Slatted doors are fitted both in the original manner to slide on rails, and hinged in Western style.

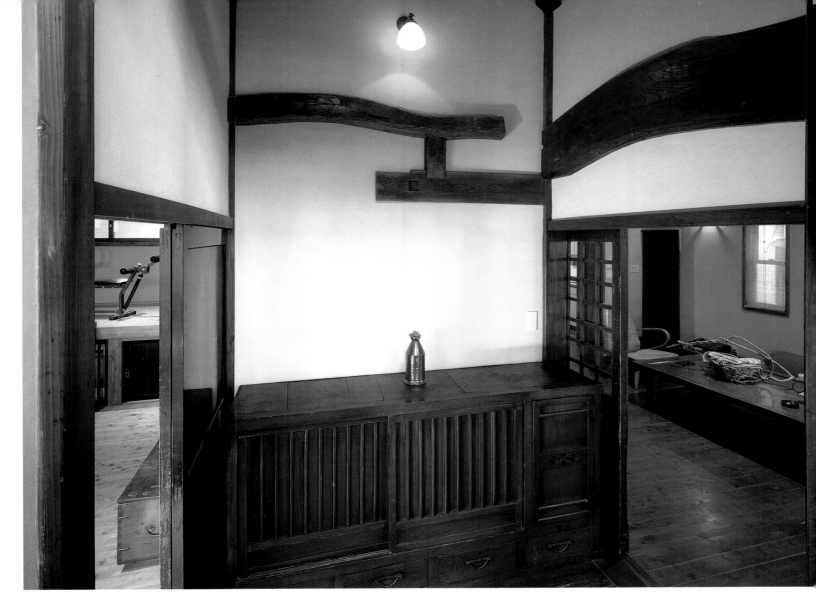

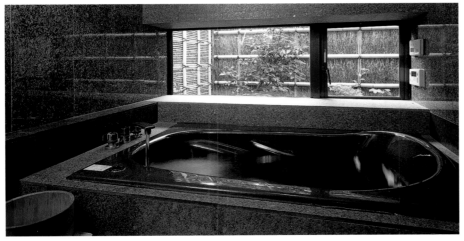

Above: The vestibule, set between a modern-equipped exercise room at left and the sitting room at right. Curved timbers such as the two exposed here were deliberately chosen for their natural form.

Left: The new stone bath adds a note of modern luxury, looking out onto a strategically placed small garden fenced with bamboo and brushwood.

Suburban Tradition
Old-style living in a low-cost modern frame

The owner of this small house to the west of Tokyo is, like the Hattori family (pages 36–39), in love with Japanese farmhouses (*minka*) but was unable to afford the high cost of moving and re-assembling one of these massive structures. The husband and wife team, Akira and Andrea Hikone came to the rescue with a small, low-cost frame that incorporates all the key *minka* elements and atmosphere.

The budget did not allow for any external *minka* features, and from the street the Casa Kimura is unremarkable. Inside, however, there is a surprising transformation. From the pebble-strewn floor of the narrow entrance hall, the visitor steps up into an open space that occupies almost the whole interior of the frame. The dark stained beams are exposed, as in a traditional farmhouse, and the centre is occupied, as it should be, by a sunken hearth, or *irori*. A long pole suspended from the rafters, with an adjustable hook on the end, can hold an iron kettle over the open fire, which the owner uses regularly.

True farmhouses in the old style (such as the Hattori house) are large, high buildings, and capturing their atmosphere on a miniature scale is a challenge for any architect. Andrea Hikone says she was "interested in the space sense of the *minka*", and the success of her and her husband's design lay in their concentrating on the principles rather than attempting a literal interpretation. Placing the roof ridge asymetrically maximized the exposure of roof beams while allowing a mezzanine floor for additional useful space.

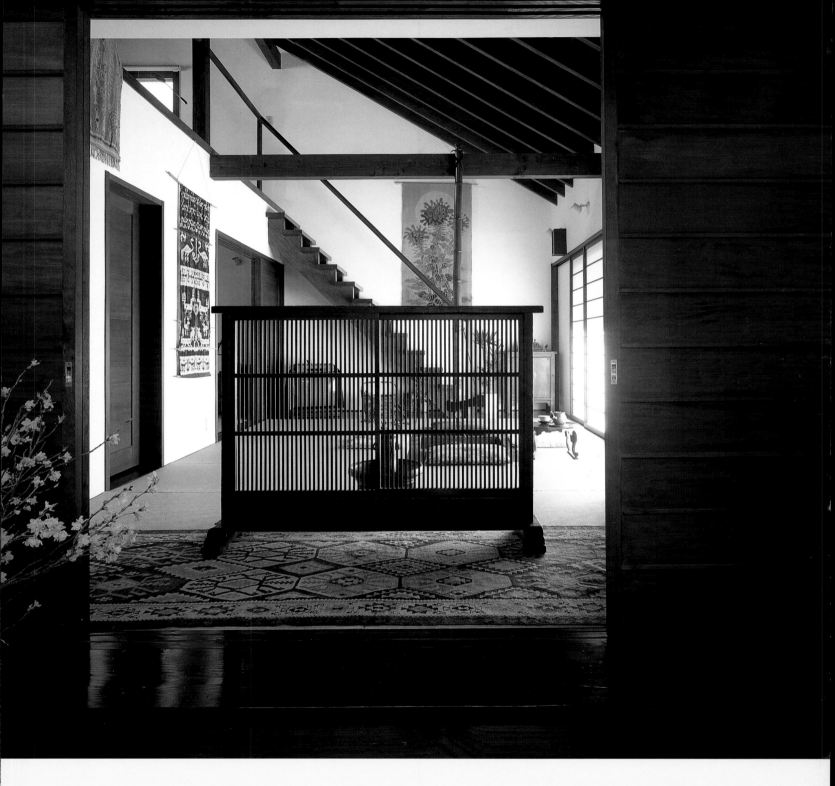

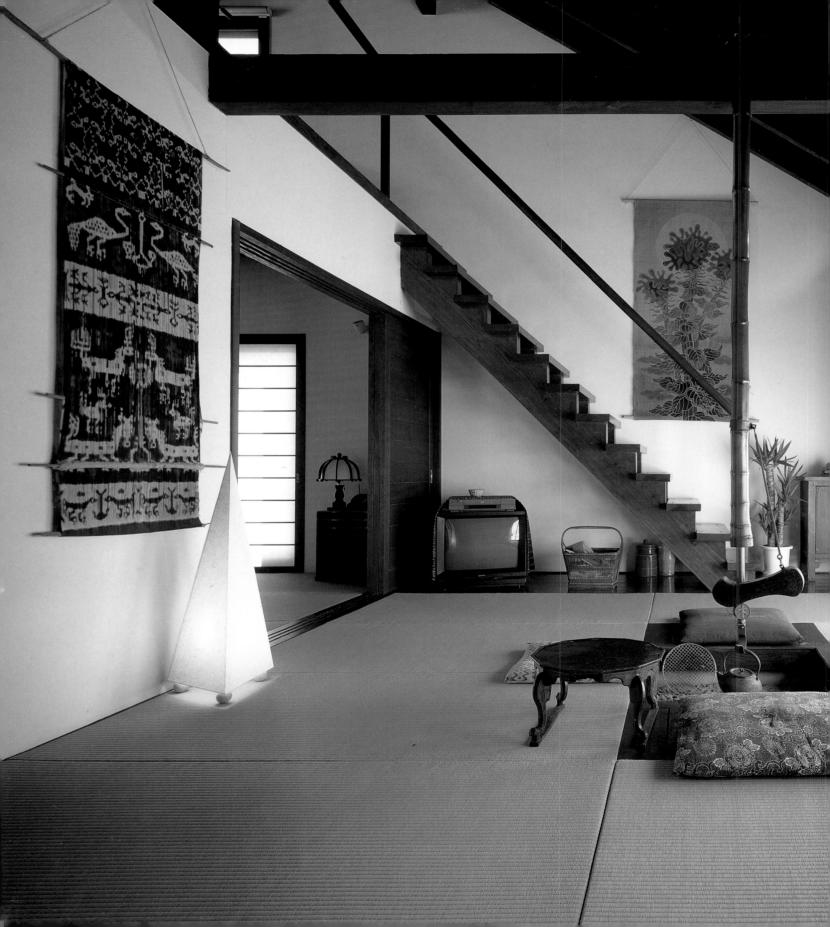

Far left: Recreating the effect of an old country house in what is essentially a bungalow, the architects exposed the timber work. By setting the roof ridge off-centre (to the left), they were able to devote most of the internal space to the main living room. Wall hangings reflect the professional interests of the owner, a textile artist.

Left and below: An *irori*, or sunken hearth, is the centrepiece of the room in traditional *minka* style. It serves a variety of purposes, from heating to the preparation of food and drink. The hook allows an iron kettle to hang over the fire, or rice-cakes can be cooked.

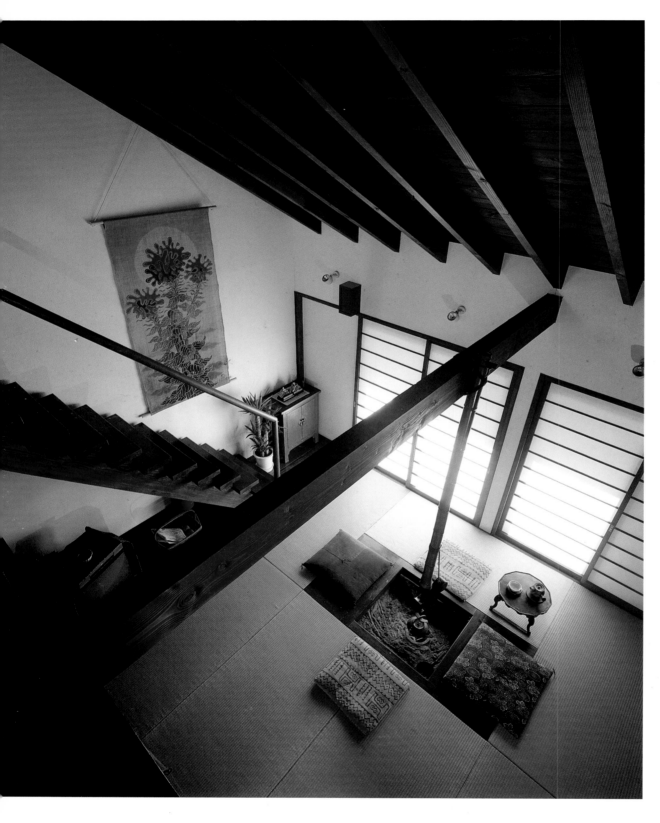

Left: The view down from the mezzanine to an area used as a study space. A bamboo pole tied to the cross-beam supports the hook for the kettle over the hearth. Sliding *shoji* screens take up the whole of the front wall, and allow a soft light to flood the interior.

Above: The bedroom, separated from the main room by sliding wooden doors. The futon, in a spring blossom motif, is one of the owner's designs.

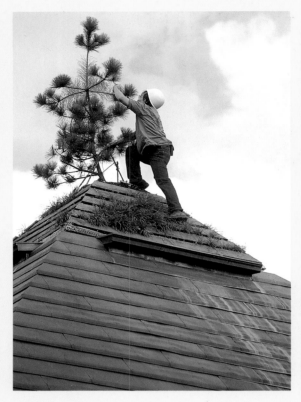

Right: The tree receives attention just once a year, when bonsai techniques are applied to ensure it remains the same size. The grasses growing through the wooden slats below will eventually cover the apex, while the copper cladding will turn green with verdigris over the years.

Natural Fusion
An unexpected planting on the Pine Tree House

As Professor of architectural history at Tokyo University, Terunobu Fujimori has an intimate knowledge of emerging trends, but as an architect himself he decided to strike out in his own direction. While glass and metal have dominated Japanese architecture for the last decade — what he calls the 'white school' — Fujimori has worked mainly in wood, aiming at an effect that is less precise, less clean, and more green. In fact, the greening of urban buildings has become something of a mission. As a result, he experiments with ways of incorporating the living earth, to create a structure in which, as he puts it, "the building and the flowers are unified, or rather combined, in such a way that they support each other's character".

When the owner of a grand traditional villa on the southern island of Kyushu decided to move to a smaller, more manageable house in the city, she asked Fujimori, already knowing his style, to work with her. His basic design began with a pyramid roof. He considered grass as a covering, but decided that it would not do justice to the "vigorousness" of a steep peaked roof, and that "a more symbolic form of green, such as a tree, would be absolutely necessary". Stainless steel forms a trough to contain the soil and also protects the roof from seeping moisture, but the main cladding for the roof is copper, cut and hammered by hand "to produce a loose impression". The owner, when she first saw the design, burst out laughing: "It looks just like a *samurai*'s top-knot!"

Above: A hollowed-out water-spout and its curved support retain the flavour of natural form through deliberately rough carpentry.

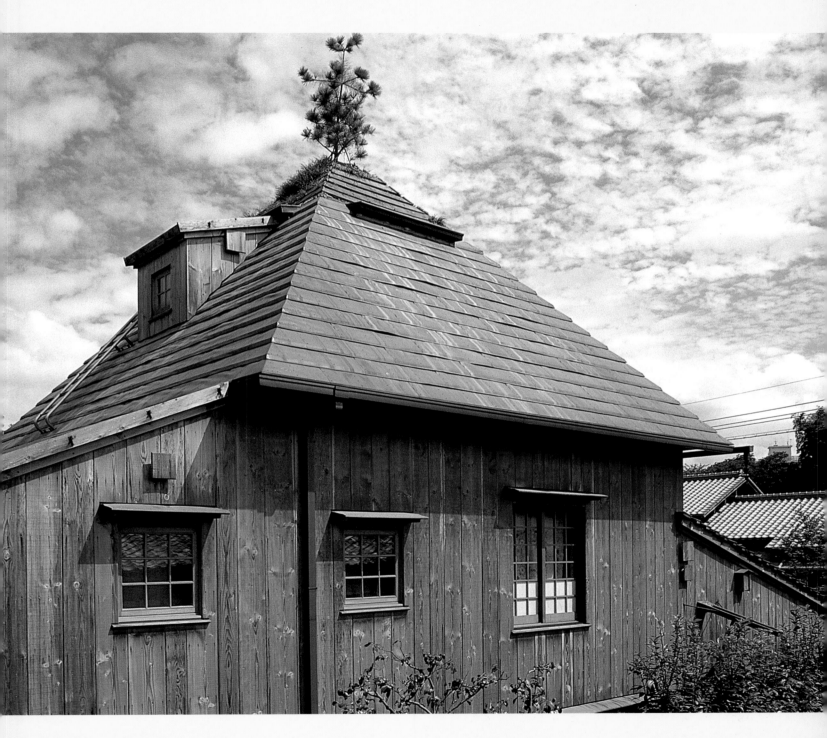

Above: Bringing rusticity to the city of Hakata, on the southern island of Kyushu, the house features unpainted wood and a handmade copper roof, with a single pine tree at its summit.

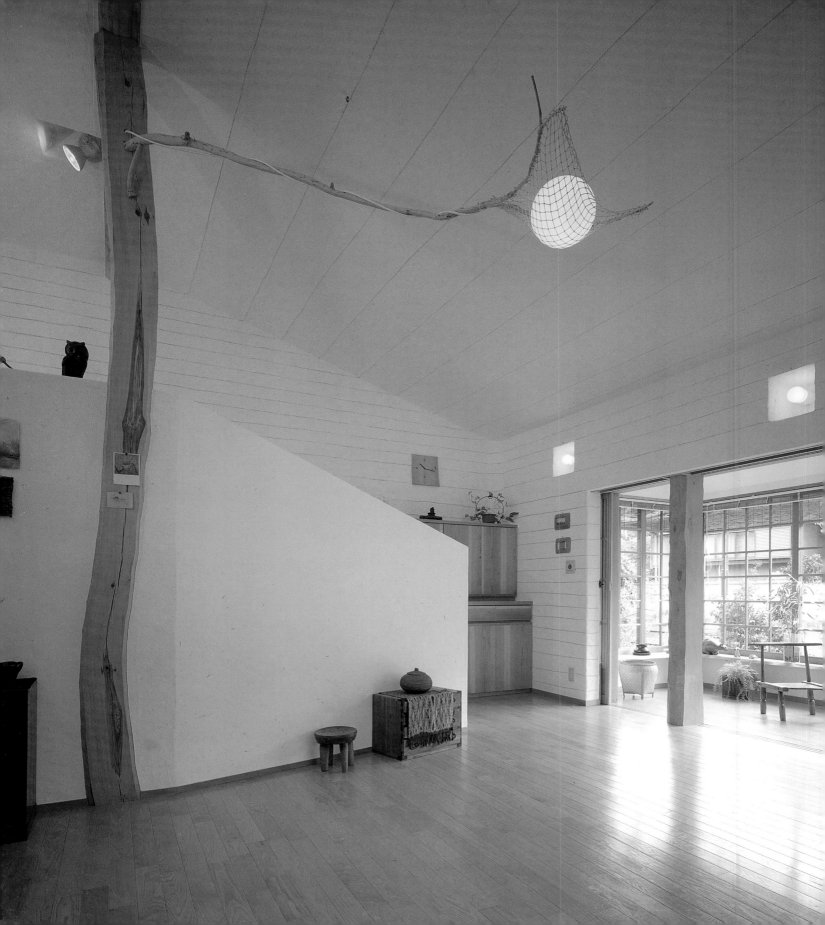

Left: In a playful reference to the main pillar of an old farmhouse, the architect selected a gently curving trunk for the main living room and gave it a rough-hewed finish. A lamp extends from it like a living branch (see below right).

Right: The height of the main bedroom on the second floor extends to the apex of the pyramid roof. A roughly finished post and lamp suspended from a branch echo that of the living room.

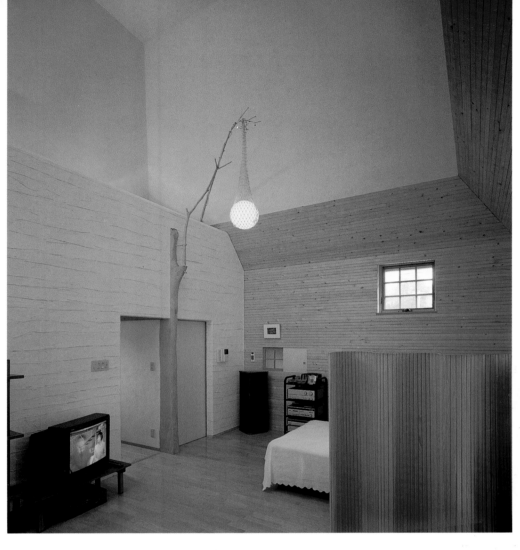

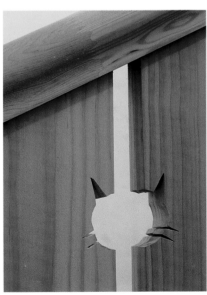

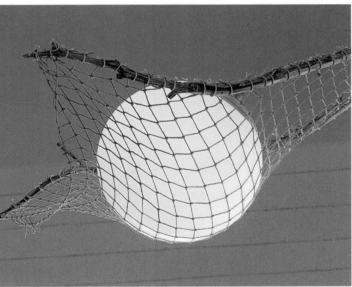

Above left: Fujimori devised a new method of plastering the interior, laying in thin strips of straw rope — non-traditional but still expressive of a rustic dwelling.

Far left: Detailing on the staircase balustrade includes the outline of a whiskered cat.

Left: Another invention of the architect is a globe lamp suspended in a net from the forks of a branch.

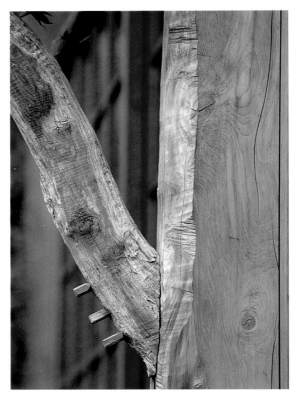

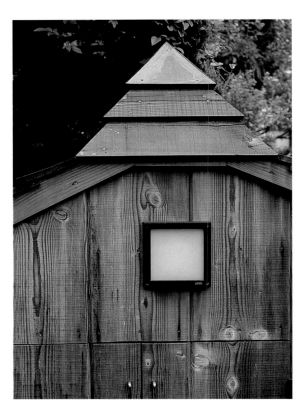

Far left: Hand-carved pegs secure the bracket for a wooden water-spout.

Left: In a reprise of the main roof, the entrance gate is topped with a small pyramid of untreated wood and an upper cladding of copper.

Below: The entrance blends natural wood, peeled reed, stone (including an old mill-stone) and gravel.

Opposite: A projecting eave creates the space for an enclosed verandah. This "edge-space" for relaxation, once common in Japanese homes, has been a victim of modernization.

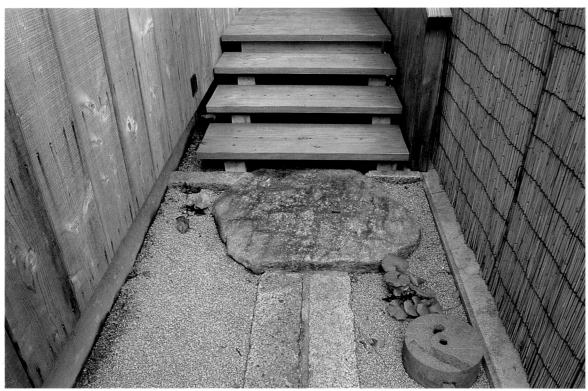

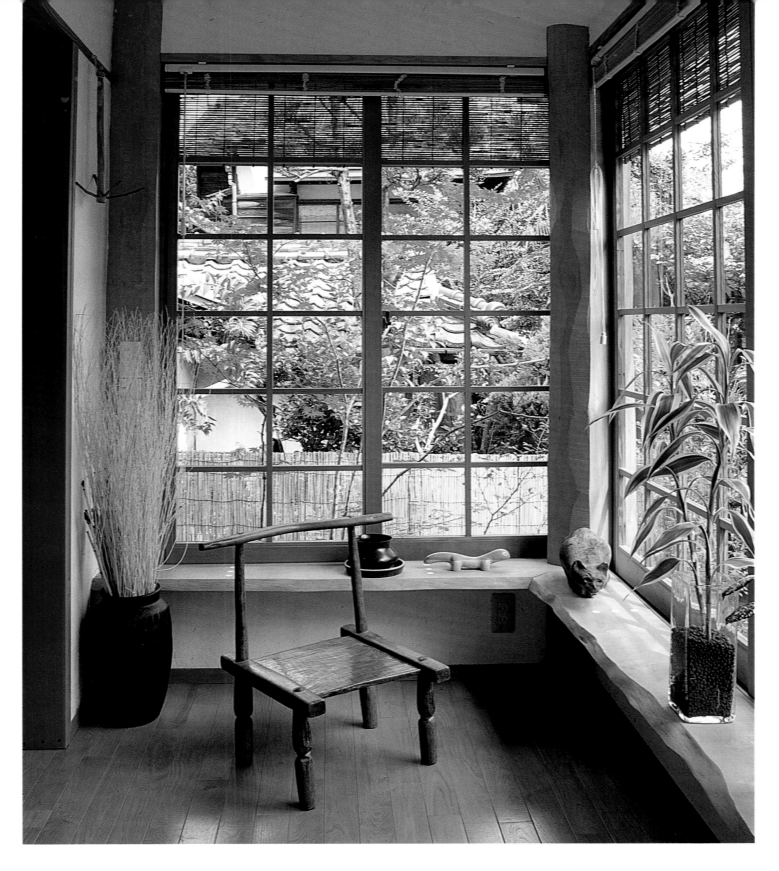

Right: The entire assembly, on the banks of the tiny Duck River, is a strange fusion of 19th-century brick warehouse, modern concrete and steel extensions, and kitsch decoration in the form of painted steel ducks. It lies in front of an adjoining multi-storey car park — the family business. This was designed as a monumental tower and decorated whimsically with steel-plate sculptures of ducks.

An Eclectic Mix
Spanning two centuries in the Duck Stream House

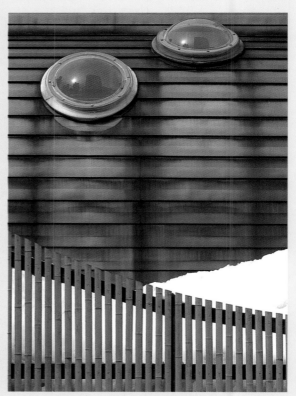

Above: Bamboo fencing and a snow drift by the side of the corrugated steel entrance hall, with its two domed portholes.

Right: The entrance hall, with a curved wall and roof of corrugated steel, opposite raw concrete. Ainu wooden carvings line the shelf at right, with a totem statue displayed on a stainless steel panel on the far wall.

The family property, belonging to the parents of architect Shigeharu Isaka, is set in a corner bend of the Kamokamo-gawa (literally Duck-Duck Stream), which runs through the heart of Sapporo, capital of Hokkaido. The area, close to the downtown district of Susukino, has almost completely changed in character since the beginning of the century, from upper class residential to commercial, yet the owners preferred to remain here, largely for nostalgic reasons. Ducks still paddle round the eponymous stream which acts as a kind of moat for the property, and while the living accommodation was no longer adequate and needed rebuilding, a separate original structure of some value remained — an 80-year-old brick library storehouse, or *bunko*, which the owners wanted to keep.

Isaka elected to build the new house in and around the *bunko* using contrasting modern materials, while re-using and re-distributing some of the older elements. So, for example, the *tokonoma* (alcove) and *tukeshoin* (shelf-desk) were restored and various external decorations were transplanted to the new façade. A new cupboard-like structure was designed to contain the large household altar, and an internal roof rising above it to a skylight (no-one should be able to stand over an altar). The intention of this fusion of old and new was to stimulate nostalgic associations; as Isaka comments: "The old materials are an entrance to memories and another entrance to the future." Hokkaido is so recently settled, beginning in 1869, that even the Taisho-period storehouse is a part of the island's heritage.

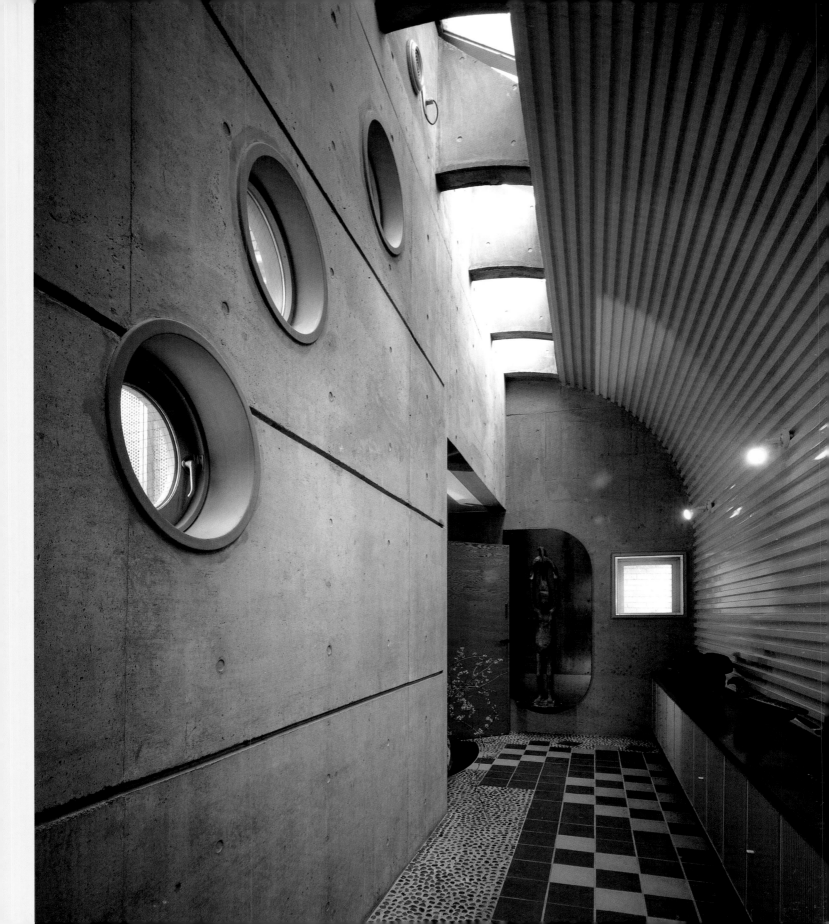

Left: The living room which is partitioned by *fusuma* from the tatami room. The transom over these — the *ranma* — incorporates a *gaku* tablet with calligraphy.

Below left: A light switch console in the living room in heat-treated steel.

Below right: The hall lights, designed by the architect in the form of a double-profile, have an Art Deco flavour.

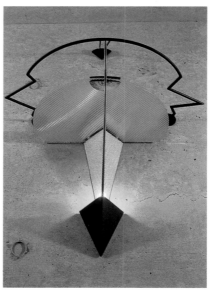

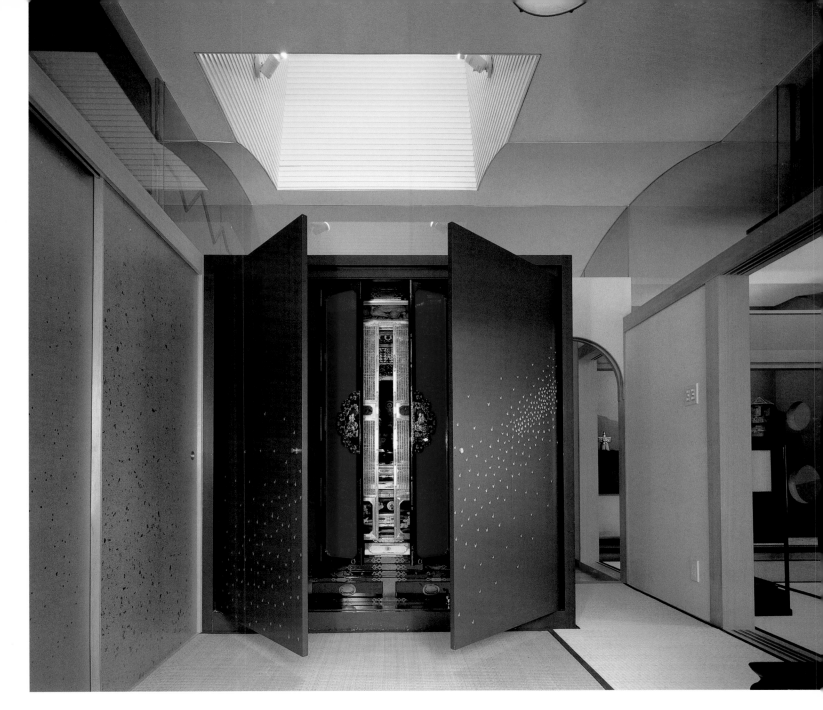

Above: The family shrine is located beneath a skylight specially designed for the purpose, set into a truncated steel pyramid set in the centre of the house. The gold-flecked pattern of its doors are carried over into similar decoration on the *fusuma*, or sliding doors.

House Surgery
Reviving the Completely Collapsed House

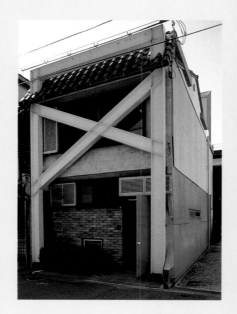

The same earthquake that prompted Shirakawa's grass-roofed house also brought Katsuhiro Miyamoto the inspiration, through necessity, to save a house in a highly original way. Japanese architects are fond of giving their creations unusual or oblique names, but in this case, the Completely Collapsed House, as it is called, justifies its extreme title. What began as a very unremarkable property — a modest terrace house in the town of Takarazuka dating back to the turn of the century — was transformed into something unique.

Miyamoto spent his childhood here and was happy to escape its ordinariness when the family finally moved elsewhere and leased it. Later, as an architect, he had second thoughts, and came to like its simple wooden, vernacular design. Just as he moved back in, however, the earthquake struck. As part of the reconstruction work, a team of architects assessed the damage by grading buildings according to the degree of damage, and this house was judged to be *zenkai*, or 'completely collapsed', fit only for demolition.

But Miyamoto had other ideas. He saw a way not only to keep it standing, but to invent a new architectural idiom. Using massive steel girders in an angular arrangement — what he calls a '*daikoku-truss*' — he effectively gave the old house a full-body implant of new steel. Bizarrely, the old and new structures interlock as if two buildings are trying to occupy the same space. For Miyamoto it is also a sentimental achievement. "My house had lived for 95 years already, so I thought I would give it another century," he said.

Top: Diagonal braces that stabilize the front of the steel 'box' overlay the north façade of the house.

Above: Where the new frame intersects with the old house, exact apertures are neatly cut — even through the glass panel of a once-sliding door.

Right: Girders pierce the old terrace building as part of a box-like steel framework. Unconcealed, they are treated as part of the combined new house.

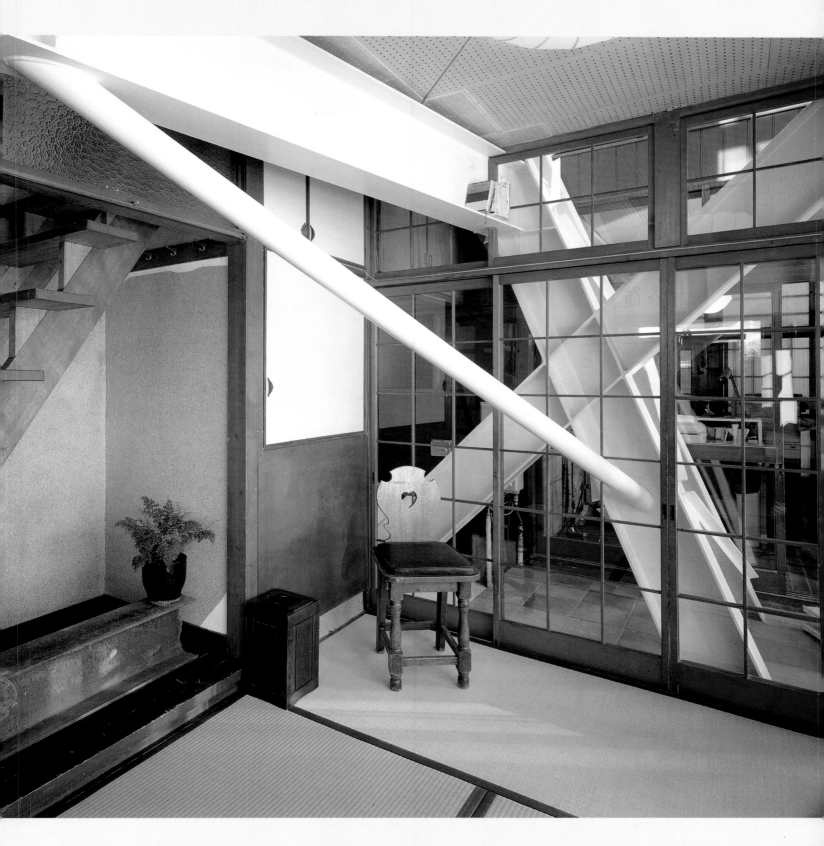

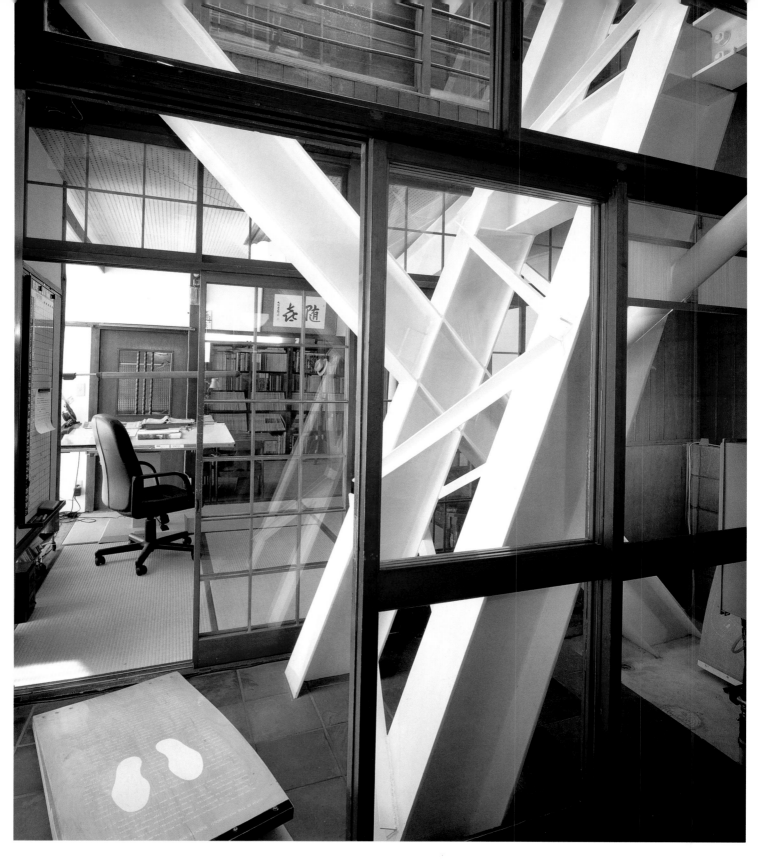

Left: In the centre of the narrow building, the angled *daikoku*-truss carries the main load of the house. In its own right it is also a powerful architectural feature, intentionally exploited by the architect who admits "my secret intention is that this complicated structure makes a new style".

Right: With the steel braces taking the strain, all of the original timber, including the rafters, could be left in place.

Right below: The wooden framework is secured to the steel frame so, as time passes, the loads will gradually be transferred. "We built a house within a house," the architect says.

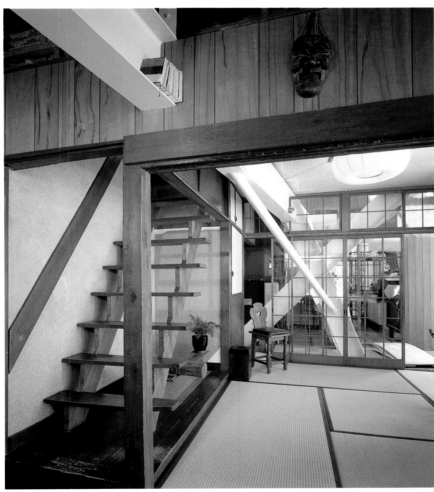

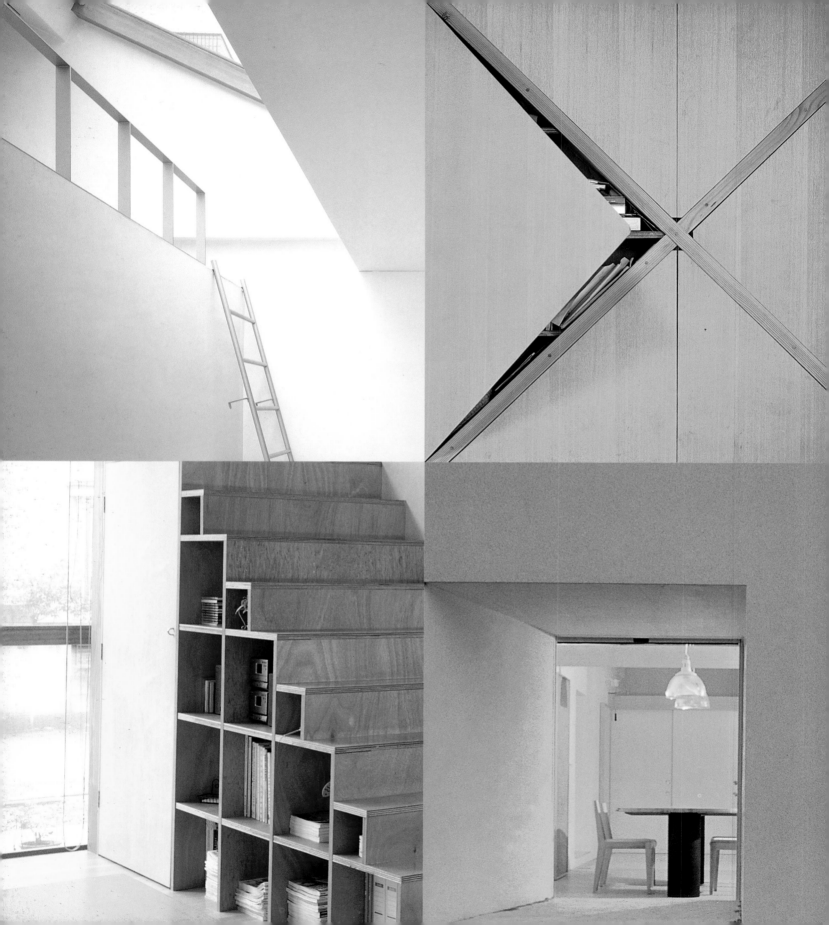

Managing Space

The Japanese have a legendary reputation for dealing with small spaces, but now they are adopting more innovative ways. The most interesting solutions go further than simply maximizing the physical area. They deal with perceptual and aesthetic space, using a variety of devices to give the sensation of spaciousness — a virtual rather than a literal approach, even if at times it means apparently squandering valuable cubic metres.

Left: Built for a cold climate, the concrete structure is clad in wood, and a covered walkway up from the street gives snow protection.

Right: The massive cylindrical base of the second floor appears to float over the living and dining area. The section in the centre houses a fitted television and hi-fi on its outer wall, and fitted kitchen units behind.

Stacked Cylinders
A floating concrete upper floor

The wooden façade of this house on the northern island of Hokkaido belies the massive concrete structure inside — a necessity in a region with snow cover from November through March. The owners, a middle-aged couple, wanted a house tailored exactly for their personal comfort, and approached architect Yoshio Maruyama, an old friend from university days.

Maruyama's concept was simple but radical. Apart from utility rooms in the basement, all the main functions of the house would be concentrated in a two-storey cubic space with windows running from floor to ceiling at the front and sides (the building is on a steep slope). The most important area was deemed to be the bedroom, bathroom and study, and the architect located these on a massive circular dais of concrete that rises above the ground floor. In essence, this upper floor 'floats' within the two-storey room, and shares the windows with the dining room, kitchen and entertainment space below.

A low circular wall and railing runs around the south side of the floating floor, looking down to the living area and out over the hills and valley. While the spectacular view is one of the most striking features of the upper floor, Maruyama did not want it to dominate the living experience, and so divided the window in the centre with concrete and an enigmatic, roughly truncated white pillar.

Above: The cylindrical concrete motif is continued in the corridor leading from the entrance with a large opening against the stairs up to the second floor.

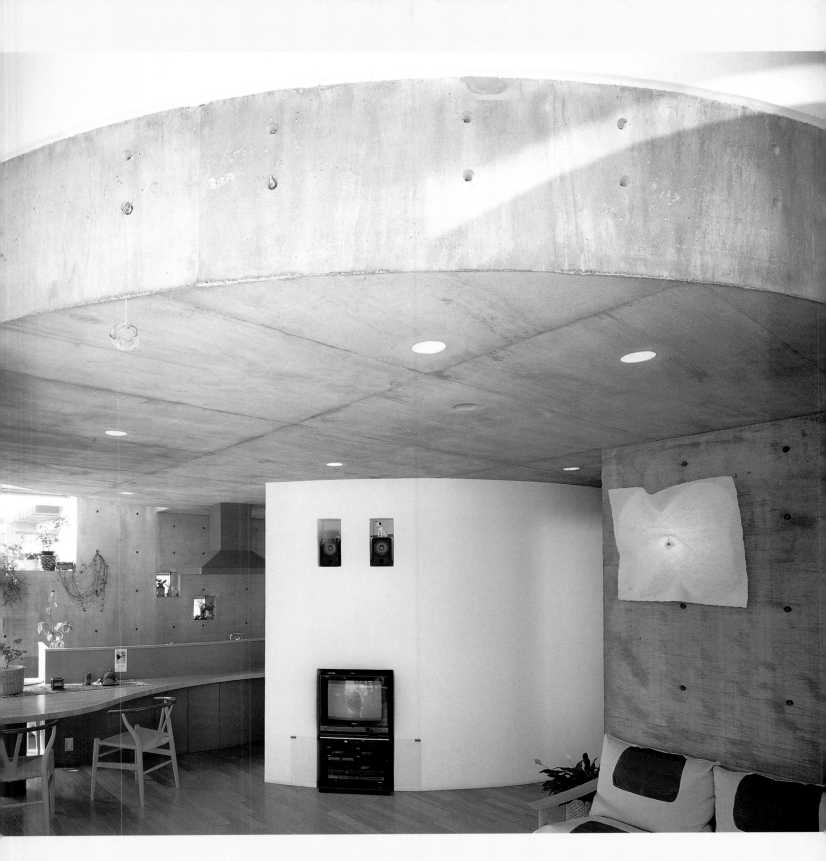

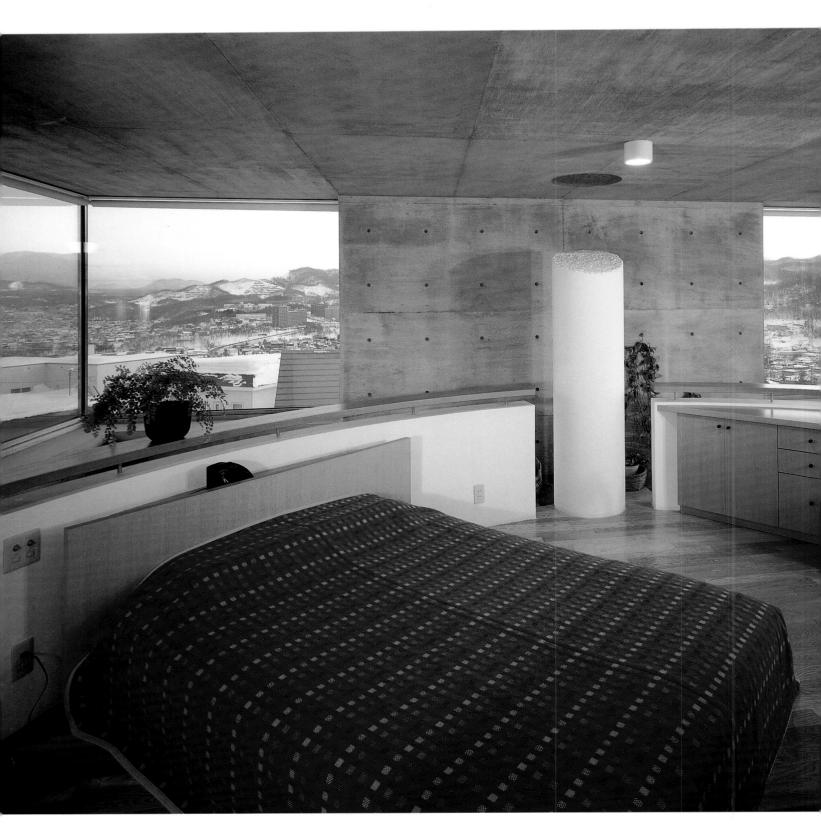

Far left: Perched high on the slopes of Mount Moiwa, the house has a spectacular view, and the design of the second-floor bedroom area with its curved balcony wall takes full advantage of it.

Left: The formwork fixings — typical of raw concrete surfaces — are here used to carry pegs and hooks that screw into the circular indentations.

Below: The study area in the centre of the second floor, enclosed by two low walls.

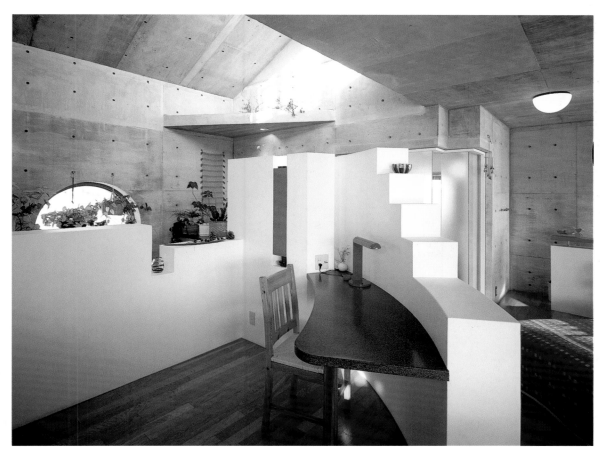

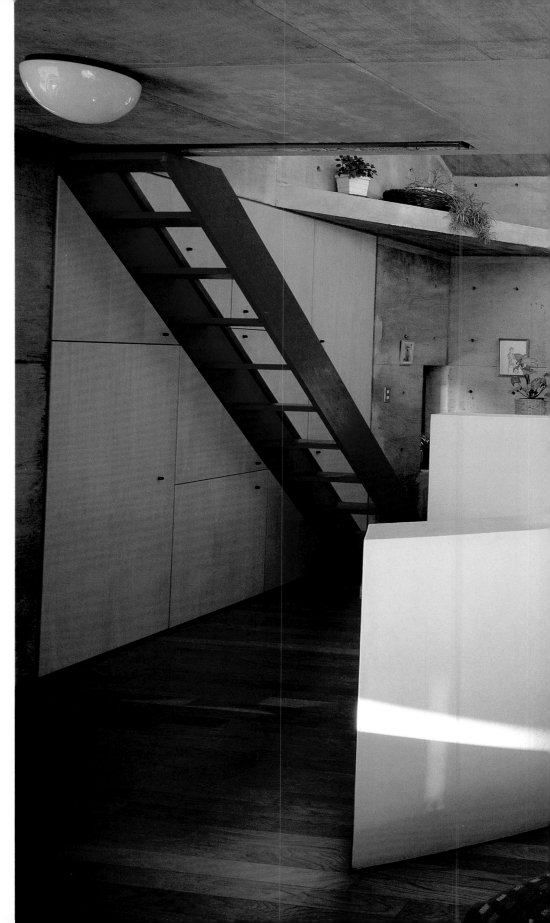

Above: An ingenious solution to storage and access is this cupboard space that opens in triangular sections around a sliding staircase. This either leads to the roof or fits away flush to the wall.

Right: The second floor is bedroom, study and bathroom in one — a private space where even the toilet is included. The cylindrical section from the first floor here emerges as a partitioning wall for the study.

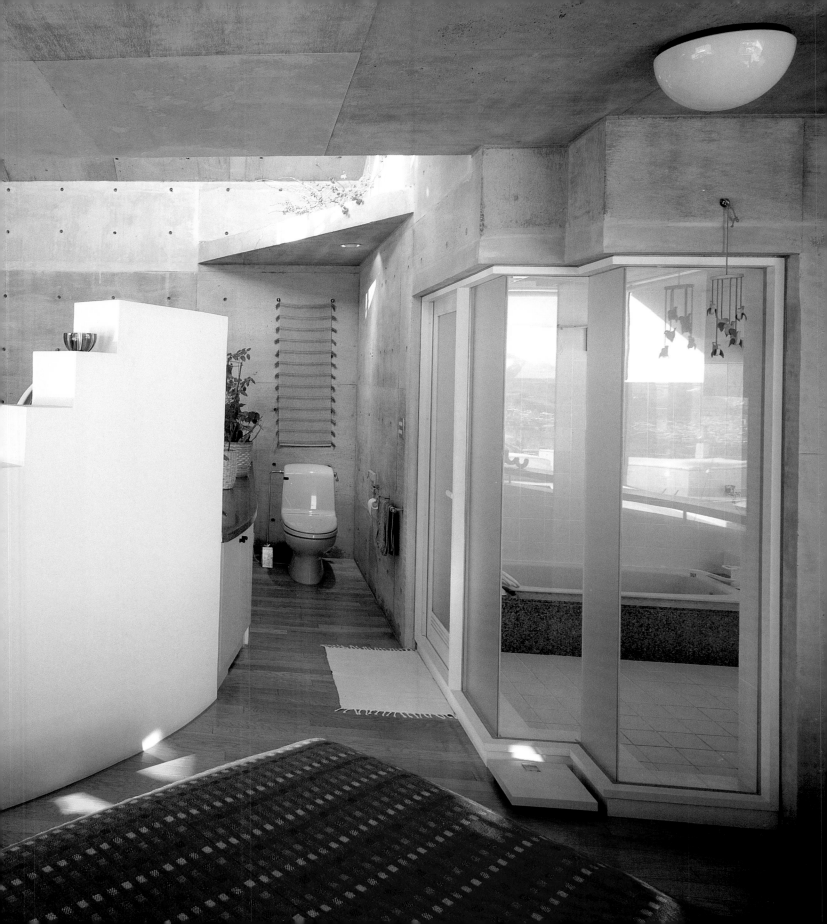

Left: The dining-room wing also carries a grass lawn on the roof.

Right: The huge curved window looks out onto the rocks and trees of the garden. Inside, a play of contrasting textures is set up between the wooden floor and furniture, and the wall of raw concrete, which carries the impression of its wooden formwork.

Picture Window
A house with a widescreen view

The Japanese have a continuing love affair, not to say obsession, with land, although this is often frustrated by the difficulty and expense of finding the right plot for a house. When the owners first came across this site in Tokyo's fashionable Yamanote district, they fell in love with the two old trees and boulders in the garden of the original property. They determined not only to keep the trees (the rocks were in any case too massive to move), but to enjoy them to the fullest capacity.

Architect Ken Yokogawa's solution was to build the new house in an L-shape with the maximum viewing area from large windows. The small plot allowed only a narrow extension at the side, and this became the dining room, fitted with a specially constructed 4-metre-long curved glass window which slides open until the end is almost over the street. The ground level of the house is nine feet above the street, which provides just enough privacy from passers-by.

Yokogawa designed the interior with a set of contrasting but modernist textures and surfaces. The glass and steel of the main window, like a huge widescreen monitor, abuts a wall of raw concrete, while natural wood screens and furniture and fabric-covered walls are used extensively throughout.

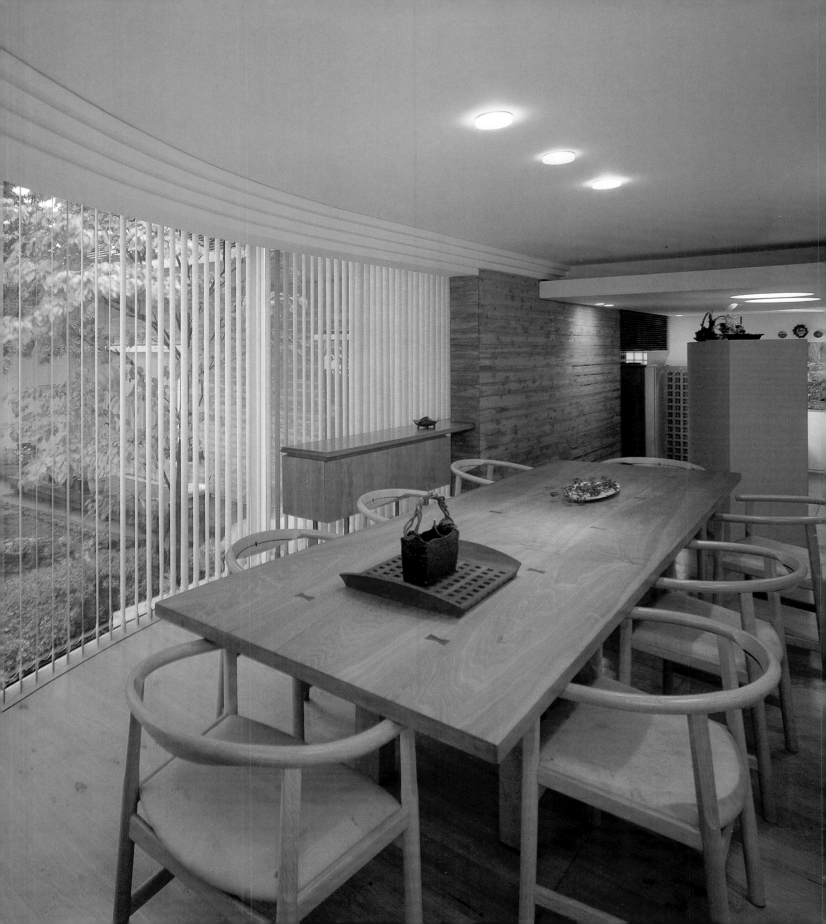

Left: Textural contrasts continue on the second floor, where the principal wall is covered in dark green cloth, giving it the impression of a free-standing partition.

Right: The bathroom combines etched glass, glass bricks and a wood ceiling.

Below left: Facing the entrance is a fitted unit that combines the function of partition and display case; it is a modern interpretation of the traditional *katsura-dana*, or ornamental shelves which were originally used by the *samurai* class.

Below right: The staircase wall and the partition for the kitchen are in the form of an open wooden grid.

Overleaf: One of the two specially constructed curved windows, each weighing 150 kilos, can slide out in an arc almost to the edge of the street.

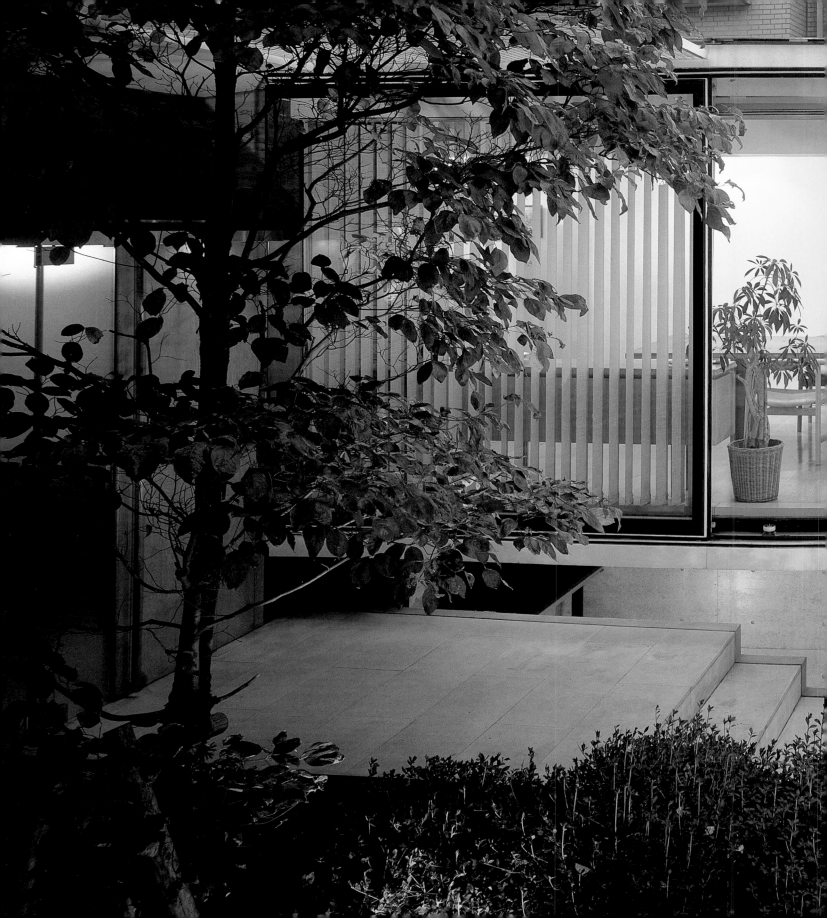

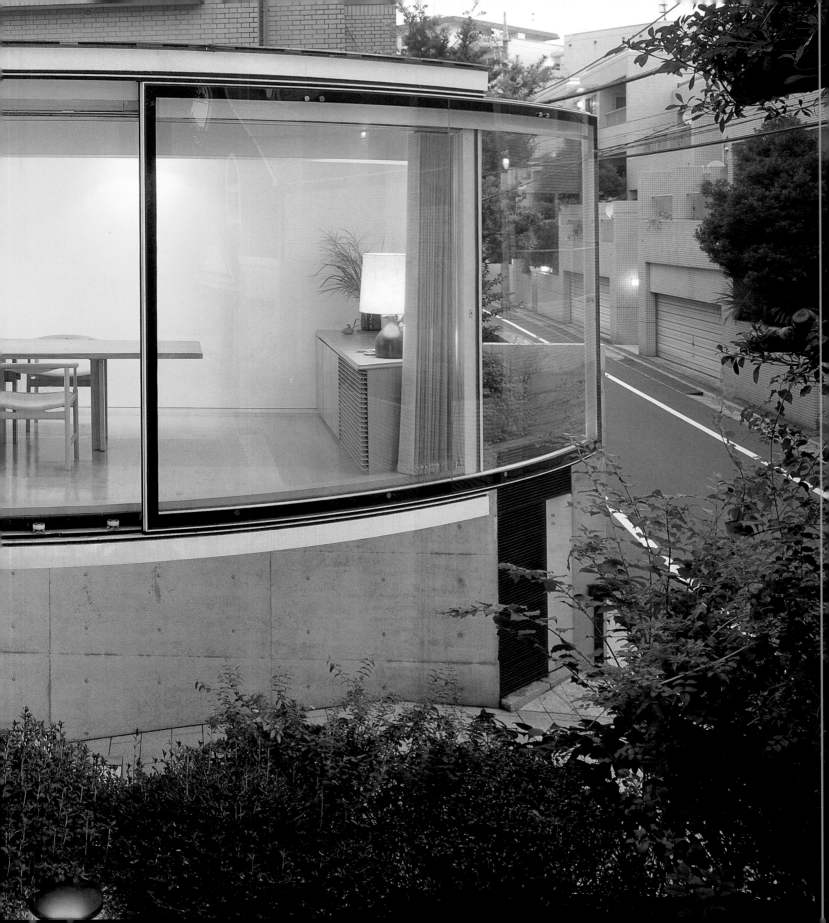

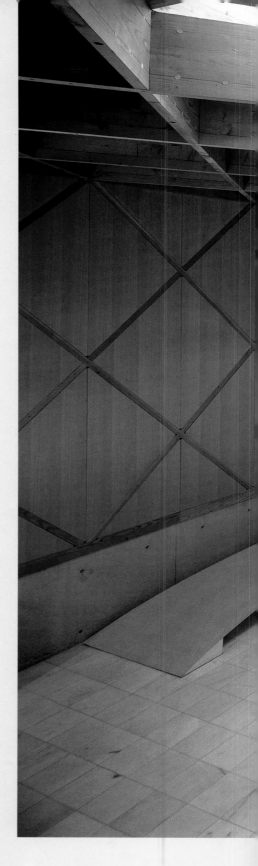

Corner Boxes
Wood-braced construction for open-space living

In this award-winning design, architect Kiyoshi Kasai's solution to the problem of utilizing space was to create a single, large area that could be shared by his family according to the time of day or the occasion. The bedrooms are located nearby in a small building accessed by a short covered bridge, but all the other functions of daily life take place inside this large box, 9 m by 9 m in plan, and 5 m high. For Kasai, it accommodates the new Japanese lifestyle.

The house departs radically from traditional Japanese building techniques in two ways: it dispenses with internal support, and severely challenges the inherited national preference for low ceilings. Using wooden components over a marble floor, Kasai's answer to the structural problem was a set of interlocking diagonal wooden braces, and in what is actually a return to tradition, these are all exposed — indeed exploited — for their design potential. As Kasai says: "The characteristic of Japanese wooden houses is that construction equals design; that is the big difference between the West and Japan. Our traditional building style is to show the materials."

The space has allowed Kasai to incorporate two striking free-standing features. A curved white wall partitions off the kitchen and also houses, above, a concealed study/play area, which his son and friends like to use as a kind of interior tree-house. Facing this is a metal ramp rising the whole length of one wall to the bridge. Kasai suspended this from the ceiling like a ship's gangplank, and echoed the theme by adding large porthole windows.

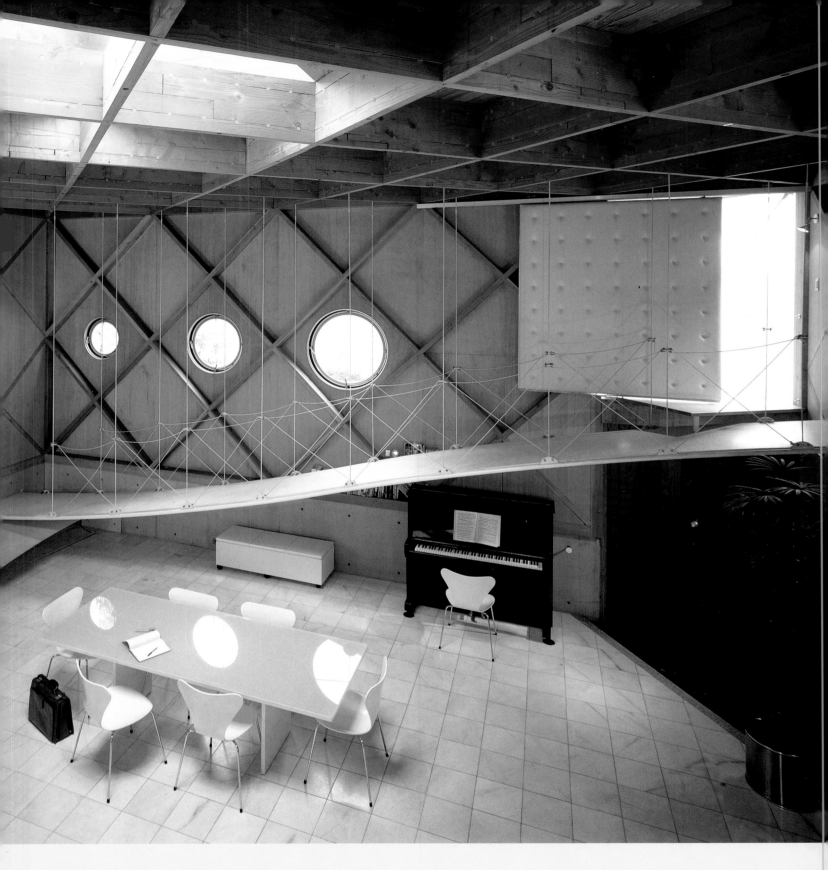

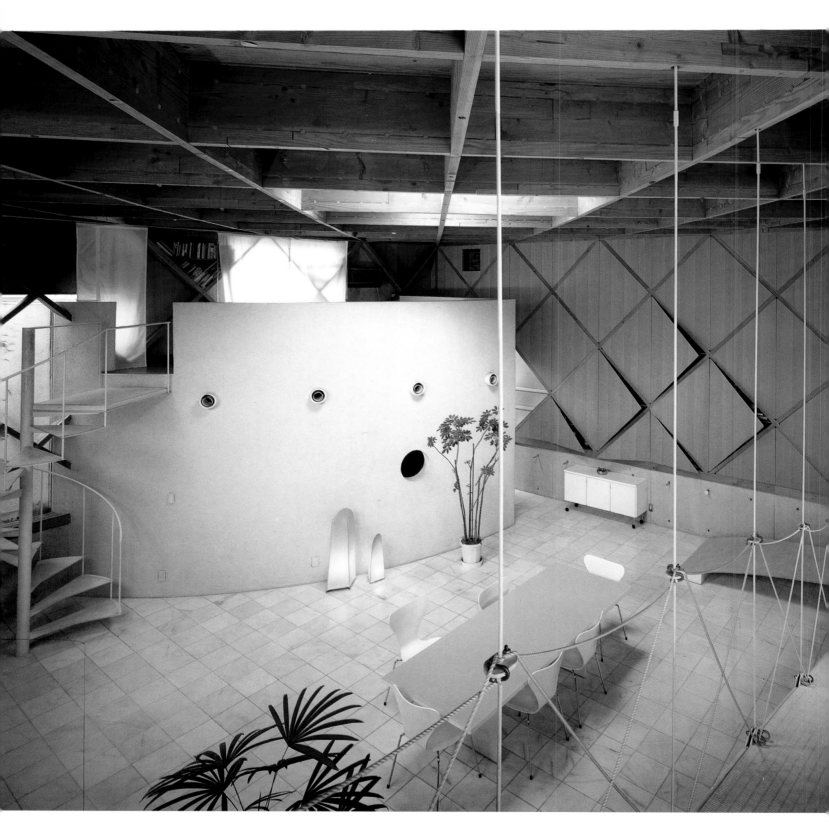

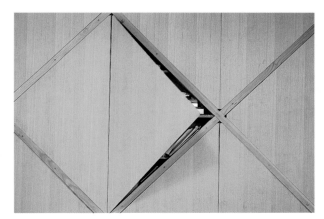

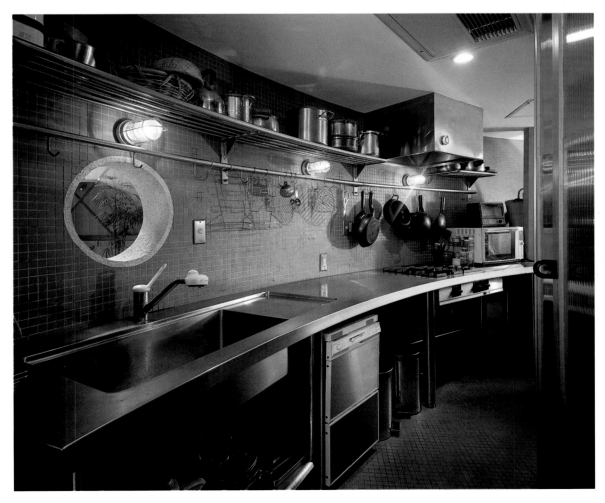

Far left: The view from the top of the ramp. The free-standing curved wall, pierced by circular vents and a porthole, encloses the kitchen and provides a partially concealed study and play area above, accessed by a spiral staircase.

Left: The diamond sections of the wall panels conceal a large amount of storage space, fitted with triangular doors.

Below: The curved kitchen, in stainless steel, fitted with bulkhead lights and a port-hole through to the main room, has the professional feel of a galley.

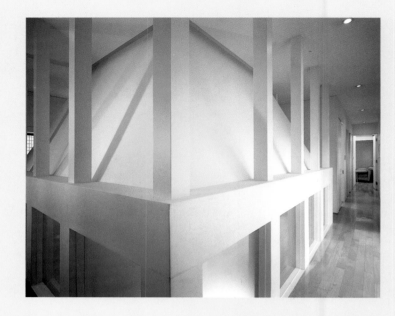

Meditation Space
An interior pyramid makes a house within a house

Built on family land in the residential Tokyo suburb of Setagaya, this house for Yoshiaki Kobayashi is unremarkable from the outside, blending in with that of his parents-in-law and the neighbours. As not infrequently happens in Japan, however, all the creative imagination for this unusual dwelling has been applied to the interior space.

Kobayashi is a highly successful advertising art director, and often has to work on campaign ideas at home. He commissioned interior designer Yasuo Kondo, who specializes in commercial and retail sites, to organize the building in such a way that it would be interesting, original and yet provide an atmosphere conducive to creative work. Kondo's solution was the rather startling one of giving the principal room the extra function of a meditation space — by borrowing from traditional temple design. "An *o-do*," explains Kondo, "is the dome of a temple, and I decided to create the equivalent space inside the house, with a second ceiling. It helps priests' concentration, so it should do the same for him!"

What Kobayashi calls his "house within a house" is in fact an internal pyramid, painted white inside and out. Its roof emerges through the second floor, to no practical effect. However, although it occupies precious space physically, the conceptual effect for the owner is immensely satisfying. "The living room door shuts perfectly; I close it and this room is completely sealed off from the world."

Above: A second-floor corridor runs right around the pyramid roof of the main room below. The glazed panels at the base are the windows seen on right.

Right: Looking up to the ceiling of the main living and dining room reveals that it is, in fact, a separate building in its own right. The skylight right at the top pierces the outer roof of the house, but the pyramidal ceiling is also an internal roof, and the row of upper windows are at the level of the second floor.

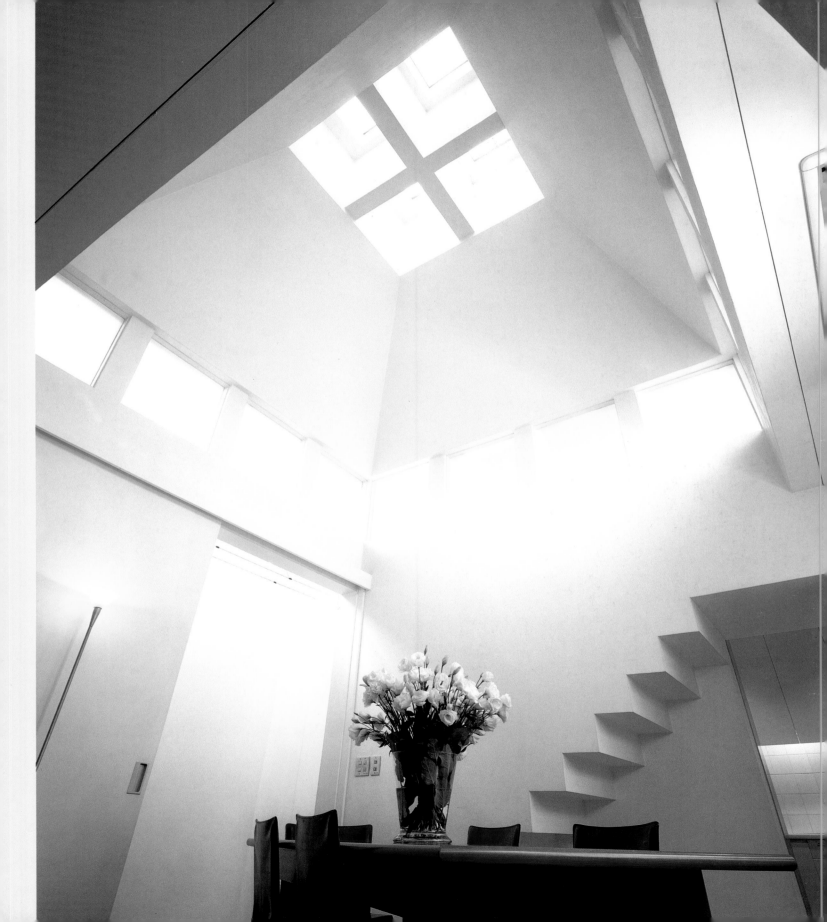

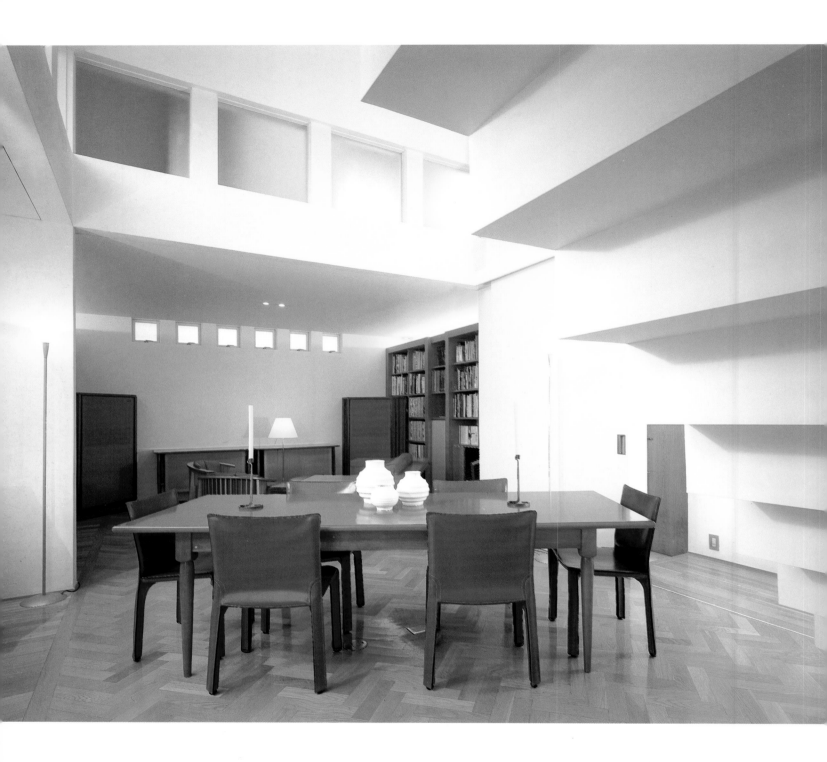

Left: The main room seen from the underside of the stairs. Beyond the dining table is the lower-ceilinged sitting area and music room.

Right: In a fanciful extension of the concept of a second, internal roof, the bedroom has its own internal terrace, reached by a stepladder.

Below: The main room as a blank, Zen-like meditation space, with the dining table removed. The doorway at left can be sealed tight shut with a massive sliding door.

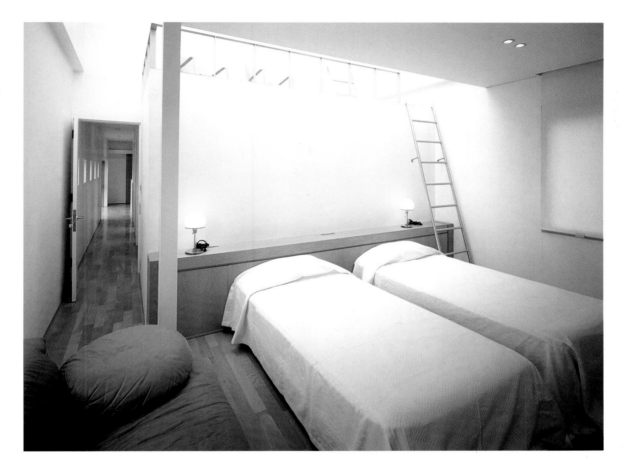

Miniature House
A tiny home that has everything

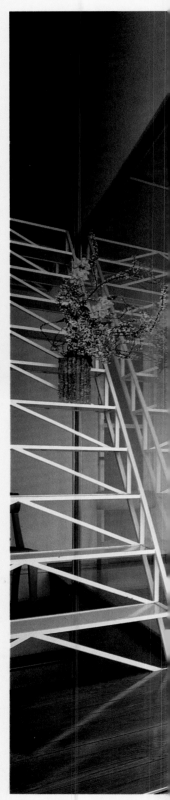

Even by central Tokyo standards of small homes, the land available for this house close to Harajuku was minute — essentially the area of two parking spaces. Appropriately named the Tiny House by the architect Denso Sugiura, it is remarkable not only as an exemplar of space micro-management, but for the wealth of features that he was able to pack into the volume.

The owners, a couple approaching retirement, wanted to live in the heart of the city, although the astronomical land prices around Harajuku restricted their choice to this plot of 31 square metres. Even so, they wanted not only the basic living spaces, but some semblance of a garden, also a bedroom for guests, and even a traditional tatami room and *o-furo* — a Japanese bath.

Compounding the difficulties posed by the tiny plot, building regulations in the city required that 40 percent of the area be exterior space — an attempt by the planning authorities to limit the wall-to-wall density of housing. Sugiura's solution was ingenious: a second-floor terrace with a deck draining onto a tiny courtyard below fulfill the legal requirements, while an outer 'wall' of expanded steel lathing maintains privacy yet admits light. A *keyaki* tree (Japanese elm) that rises the full height of the building brings nature right into the house, yet takes up hardly any room due to its close-packed minimal spreading branches. As Sugiura says: "In the early days of the boom, when land prices were soaring, people just wanted to have as many rooms as possible. Now there's a greater appreciation of the quality of environment."

Above: **Like its neighbours, the house, situated in a narrow alley, has a frontage of just 4 metres and a depth of 8 metres.**

Right: **The second floor living area achieves a remarkable sense of space, partly by means of folding glass doors that open completely, and by revealing the upper branches of the tree, which grows the full height of the building. This, surrounded by a bench, suggests that there is more room to play with than in fact there is, but the actual area lost to it is minimal.**

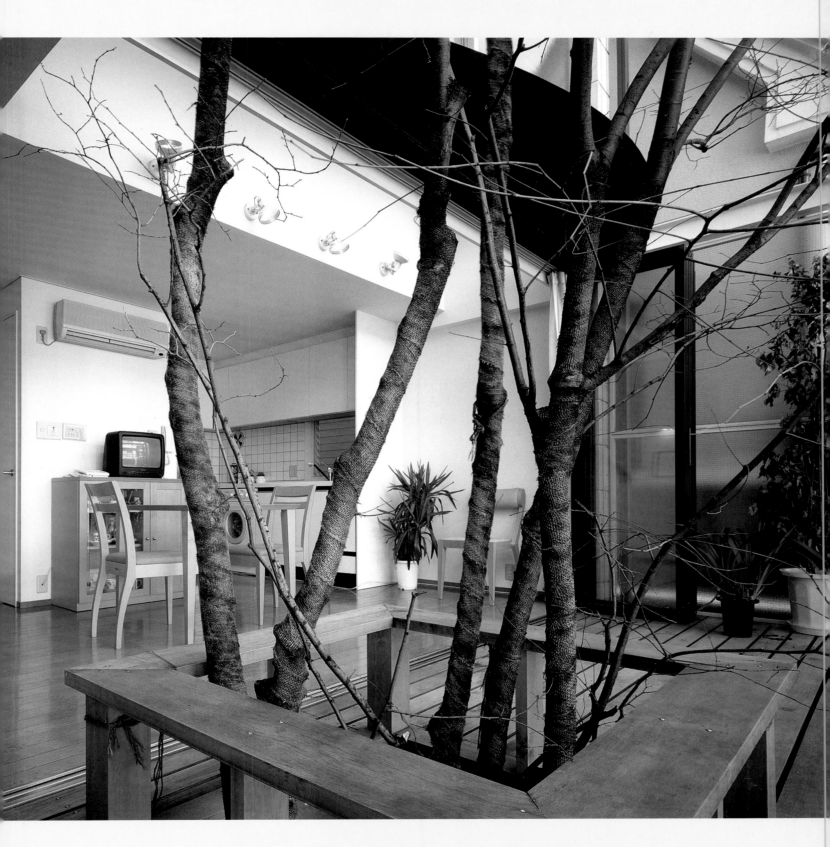

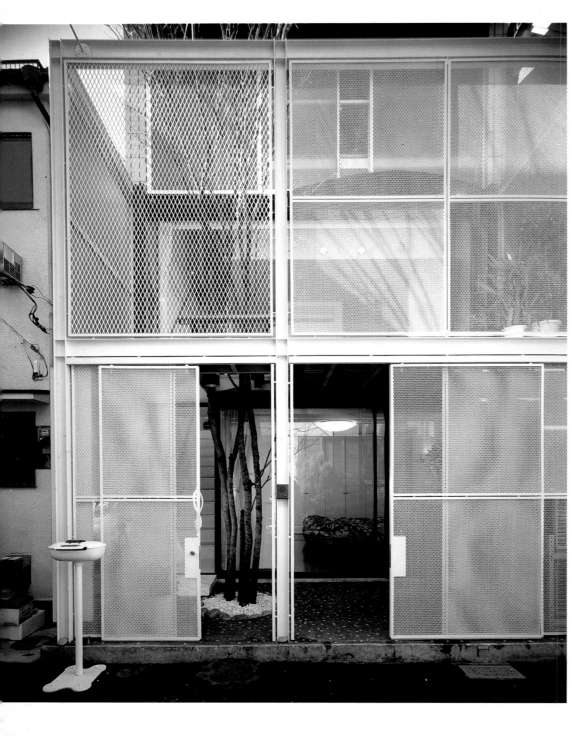

Left: The façade uses two sizes of expanded steel lathing, in fixed panels above and as sliding doors at ground level. Painted white, it reflects sunlight back onto the second floor (the house faces north) and admits light reflected from the houses opposite, while maintaining some privacy.

Below: Selected water-worn pebbles in grey and white give an ordered simplicity to the vestibule.

Bottom: A sliding screen of polycarbonate covers the shoe storage shelving.

Right: A *keyaki* tree inside the door occupies very little of the plot's valuable space, but the visual effect is expansive and liberating. Although enclosed by steel lathing, this cobbled area meets the legal requirements of an 'outside' space.

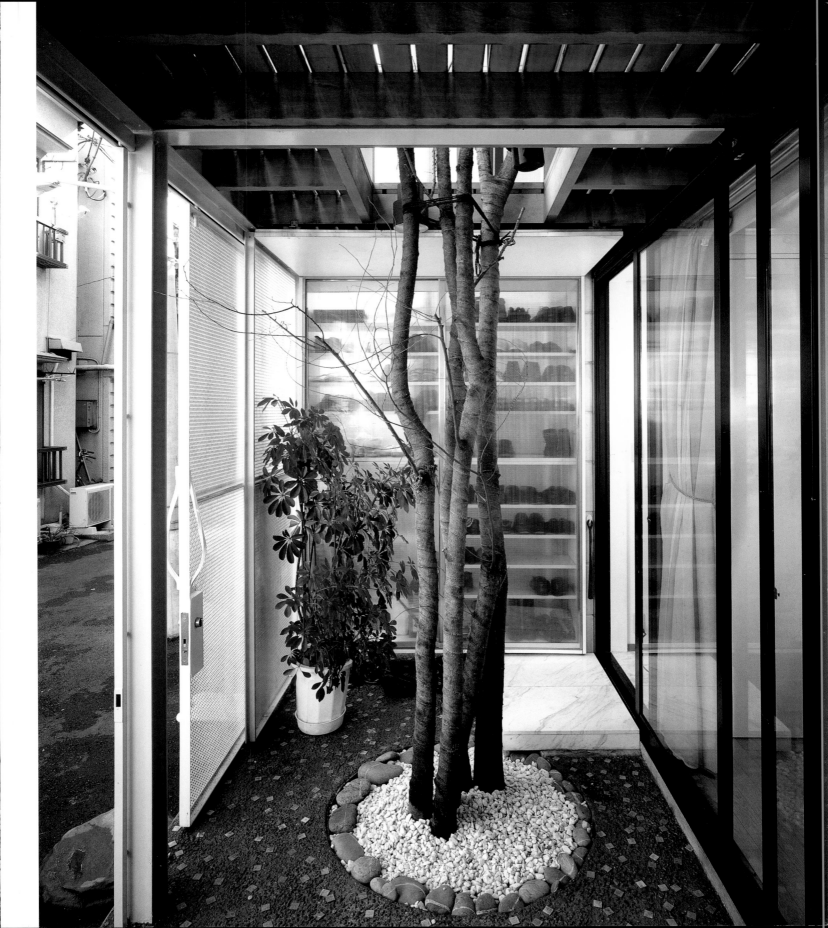

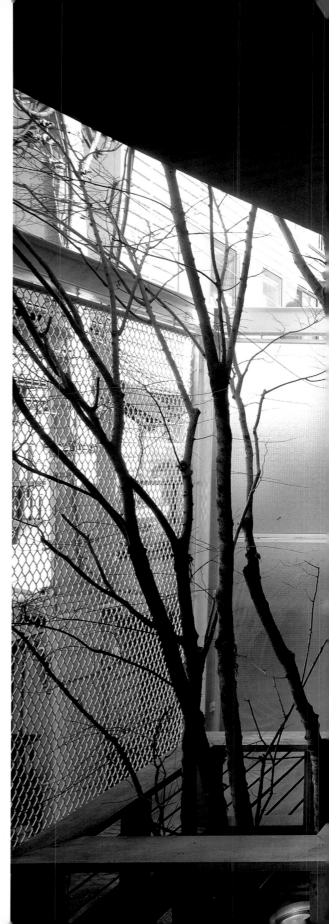

Below: Spotlit recesses in the side walls of both floors allow for typically Japanese understated display.

Right: The second floor space, the principal living area which includes the kitchen, expands outwards and upwards. With the folding glass doors fully back, the terrace becomes one with the interior, and the outer skin of expanded steel and translucent glass both enclose and illuminate it. More light, from the third-floor windows, filters down from above.

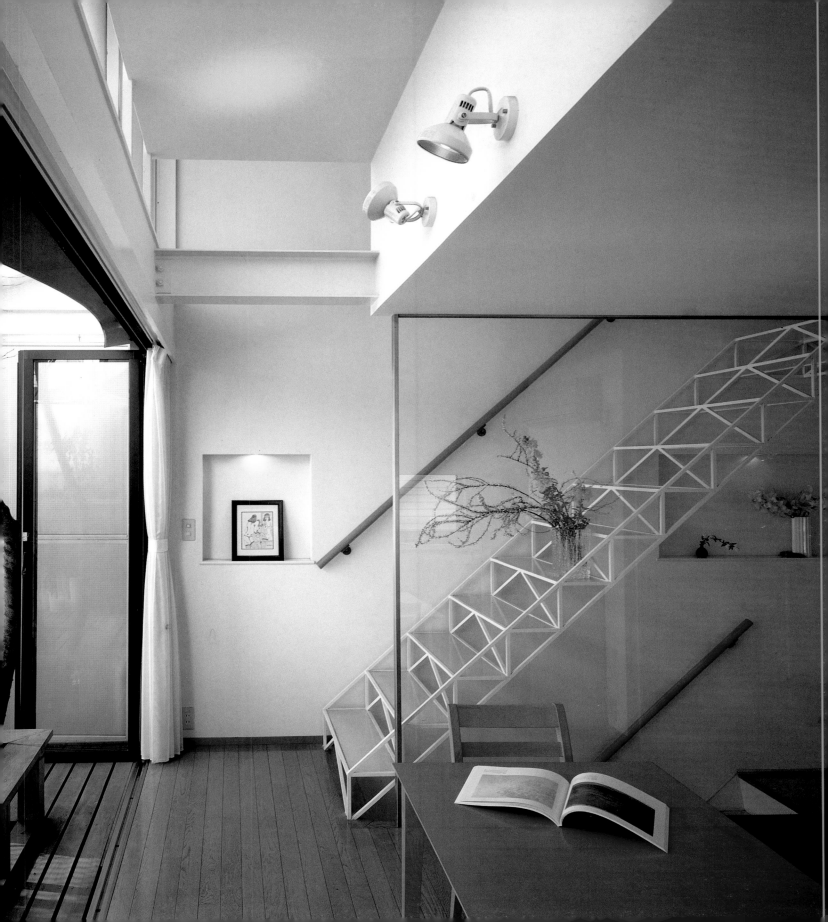

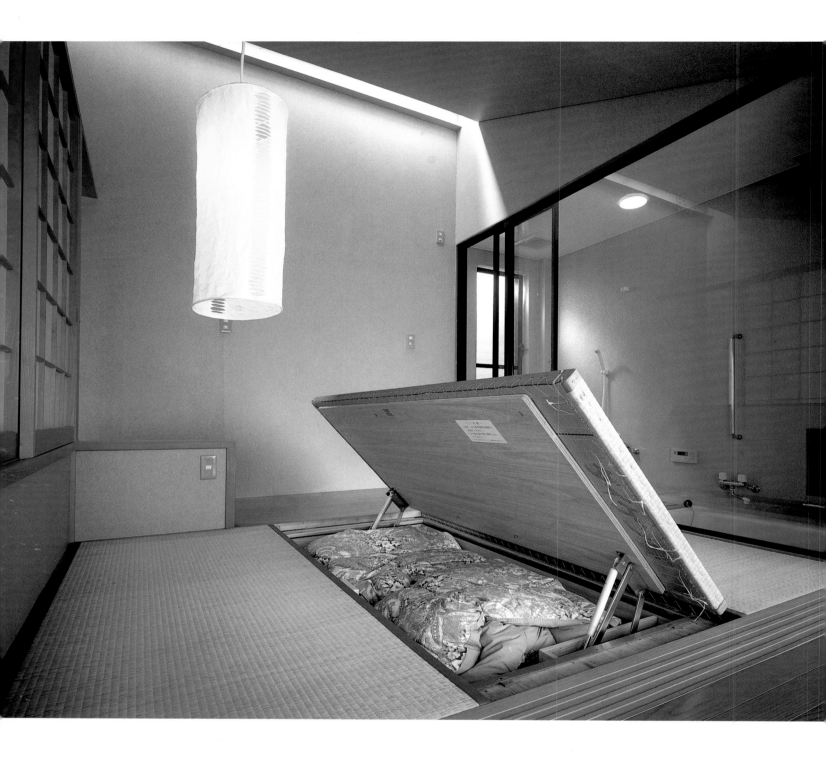

Left: As the tatami room is used to accommodate guests, futons are needed for nighttime. A specially designed electrically-operated jack lifts the central tatami to expose hidden storage space.

Right: By an imaginative dovetailing of function, the top floor manages to contain the essentials of traditional Japanese living. Unusually, one tatami width out of the four available has been made into a bathroom, separated by sliding glass panels. Shaving a little more of the area to make a window-side corridor screened by *shoji* panels further increases the visual space.

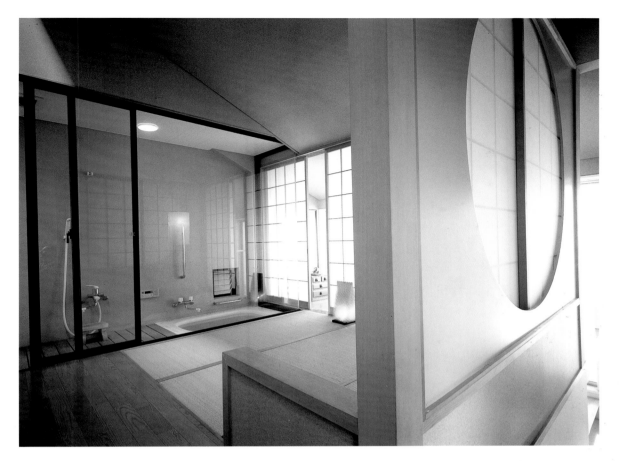

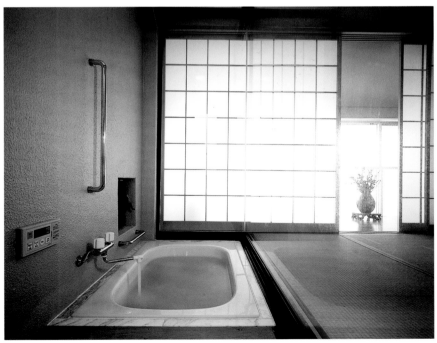

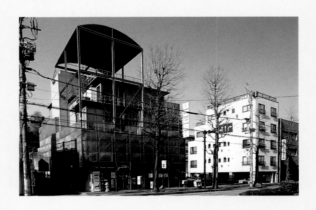

Penthouse Courtyard
A rooftop escape from urban development

Above: The setting of the property, commercial on its lower floors, in an area that was developed with no consideration for the local community, is "not the most pleasant place to live" admits owner-architect Yamamoto. Removing his family to the roof-top was the only way to recreate a pleasant environment.

Right: The bedroom and bathroom wings form two sides of the penthouse, their glass doors facing out onto the wooden decking of the courtyard. The space they contain is at the same time intimate — shielded from outside views — and yet open.

Downtown Yokohama, close to an expressway exit, lacks the human scale of a residential neighbourhood, but for Riken Yamamoto living there was a matter of necessity. Owner of a mainly commercial property on a busy thoroughfare, he designed a penthouse with a difference for himself and his family above the shops and offices located below. He chose to turn his back on the unattractive urban setting, and instead assembled a cluster of rooms around the four sides of a wood-decked patio, sheltered by teflon awnings.

The family has the privacy of a courtyard house (an old Asian residential principle dating back to Han dynasty China) combined with the openness of a sunny rooftop setting. The windows on three sides face in towards each other, giving a comfortable intimacy within the context of family life, while the single-storey construction further excludes the surrounding city. Like the gazebo for which it is named, the assembly sits on top of the building; structurally separate, it creates its own small world.

As Yamamoto drily comments: "In my neighbourhood, signs of community life are most evident at a height of about four storeys." Like many other areas in the country, it suffered in the mid-1950s from the Land Readjustment Law that allowed indiscriminate road widening — in this case from four metres wide to 25 metres. "The people who used to live on this street now live on the top floors of these buildings," he adds.

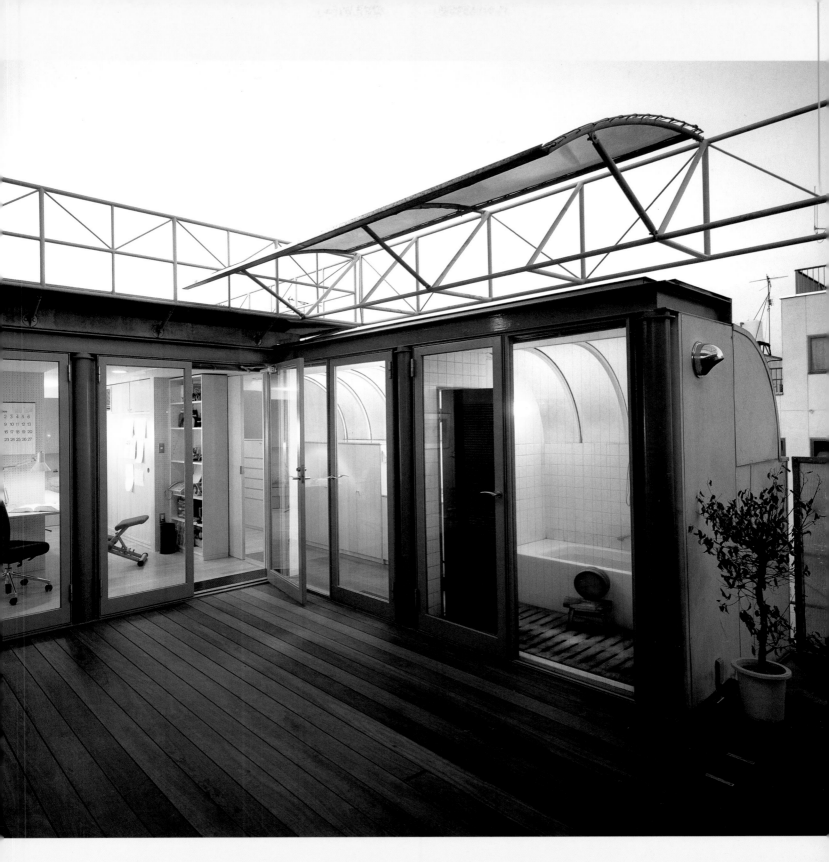

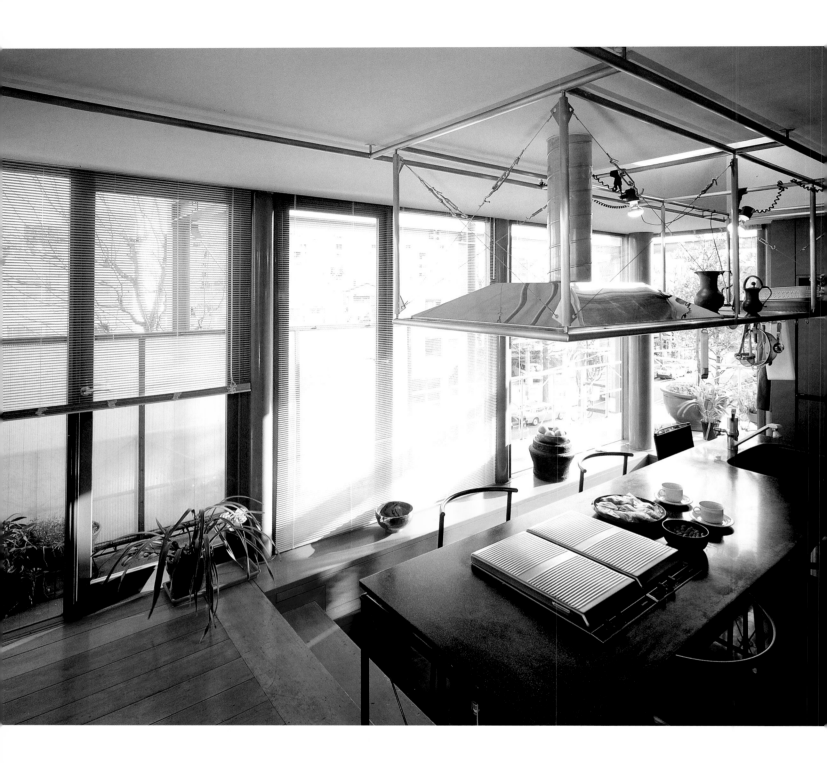

Left: Full-length sliding glass doors and windows surrounding the dining-and-living wing give out onto a narrow terrace shielded from the street by a translucent glass wall.

Right: The living room seen from the bedroom wing. Curved awnings of teflon stretched over tubular steel frames, give practical shelter while preserving an open-air character.

Below: A massive sliding steel trapdoor opens over the kitchen work area for a skylight effect, protected from rain by an awning. Below this, a stainless steel rack for drying and hanging utensils is part of the room's ceiling track system.

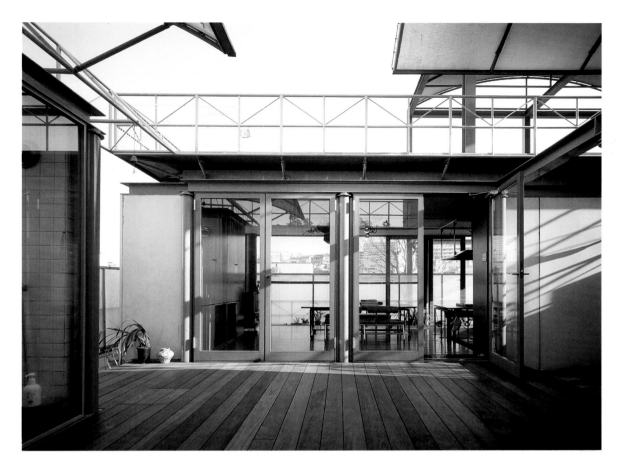

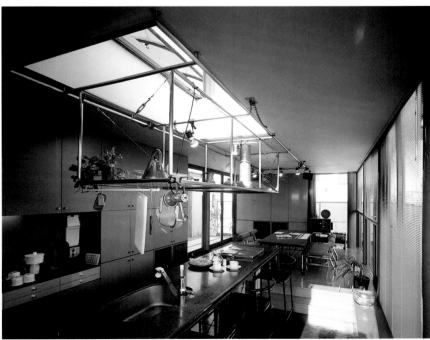

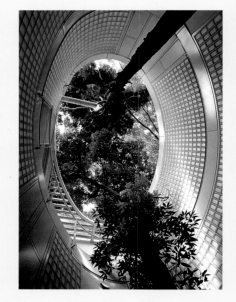

Right and below: Oval wells, some completely enclosed, others truncated by the outer walls of the buildings, contain the trees of the original woodland, and are a living part of the interlocking apartments. Curved walls composed from glass bricks line the wells and filter light into the rooms.

Outside Inside
An interlocking complex of houses and trees

A small copse of 27 trees, known locally as Hanegi Forest, has been a neighbourhood landmark in this part of Setagaya in Tokyo for as long as anyone can remember, but higher taxes from rising land prices in this fashionable area of the city threatened its existence, even though the landowner himself loved his rare patch of woodland. To find a compromise between preservation and making sensible commercial use of the 1,000 square-metre plot, he approached architect Shigeru Ban to design a complex of 11 apartments (one of which Ban eventually took for himself).

The first condition was that none of the trees on the property should be cut down, but the budget was restricted. Ban opted for a steel-frame construction that could be assembled in and around the trees without touching or harming them, but for reasons of cost he could not simply follow their random positions. Instead, he settled on a triangular grid of steel pillars, each 4 metres apart. Structurally, this modular system was affordable but rigid, and it hardly interferes with the living spaces. In fact, the four dozen round white pillars rising through the three storeys of the complex create their own little forest that mirrors the natural one, most obviously at ground level.

The spaces around the trees were cut into the plan in the form of ovals and circles of different sizes, some completely enclosed, others truncated at the edges. The whole effect is to intermingle nature with the man-made components, and by including wooden-decked terraces in irregular positions, mainly on the second floor, the residents were given the full benefit of living among the trees.

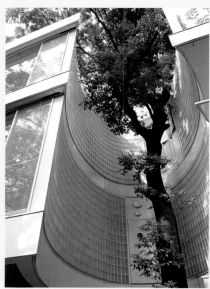

Right: The second floor and main living space of the architect's own apartment. A wood-decked terrace, accessed through sliding glass doors, curves around one of 27 trees that determined the configuration of the housing complex.

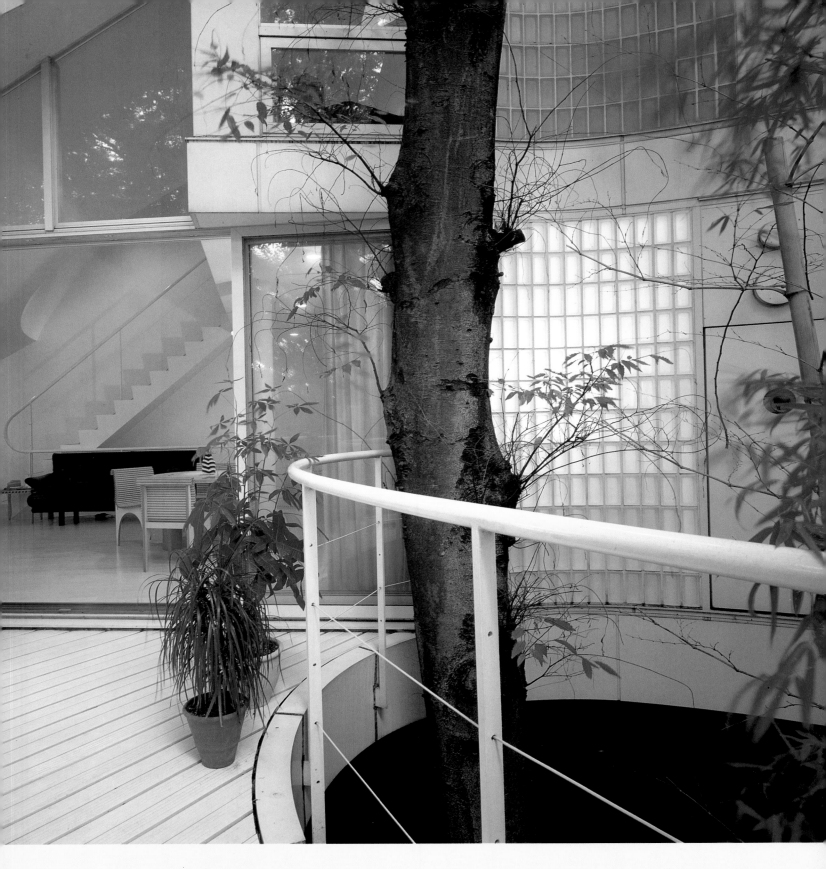

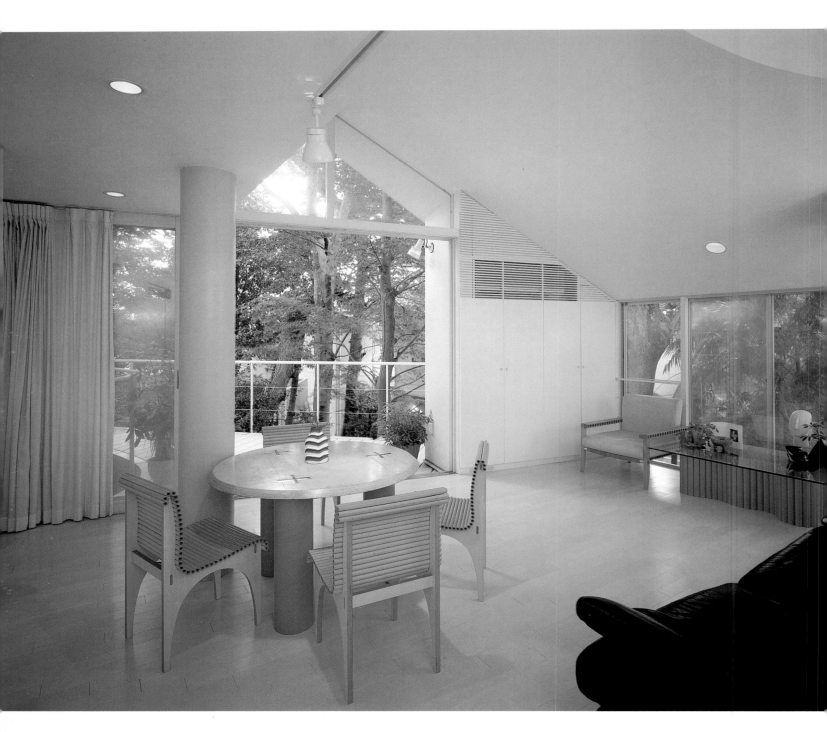

Above: **The main living room on the second floor looks out in two directions onto the mid-levels of the wood- land, giving a continuity with nature rarely found in Tokyo.**

Right: The bedroom on the third floor occupies a mezzanine overlooking the living room to the right; alternatively, hinged and sliding panels that conform to the curved ceiling can seal it off completely.

Below, left and right: One of the architect's signature inventions is the structural use of cardboard tubing, which he has developed for houses and public buildings by means of a reinforced concrete filling. In addition, he has designed furniture using narrower diameters. Examples of a chair and low table are shown here.

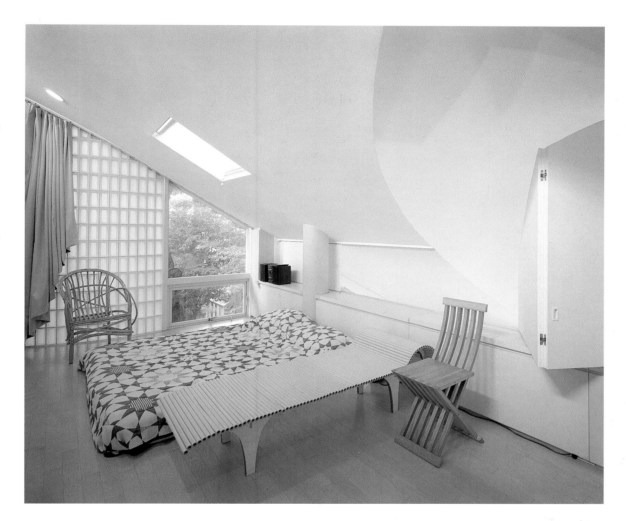

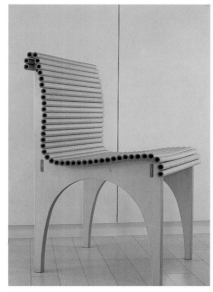

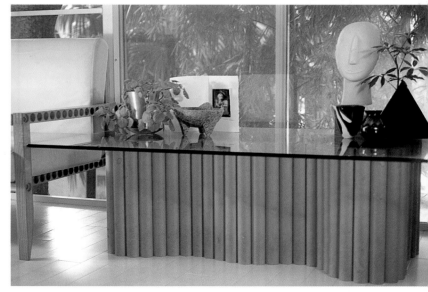

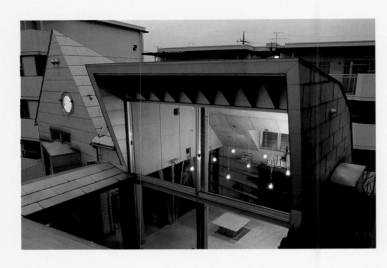

Folding Space
Different volumes and views around a central terrace

In a residential part of Tokyo that is sub-divided into very small plots, the house of architect Enryo Furumi is an exercise in both maximizing the apparent space, and in maintaining privacy in a neighbourhood where the surrounding buildings are both close and tall.

The key idea was that the house would open inwards on itself in such a way that the family could enjoy open-air living and spacious views all within the confines of the small property. To achieve this, Furumi organized the house as a set of linked units that rotate round a small central garden terrace on the first floor. Although small, the wooden deck gives a comfortable, private breathing space, while the galvanized aluminium-clad units that surround it have individually strong shapes that create an interesting, dynamic geometry.

Furumi began with the living room, adding the other units later. Its entire south wall is glass, with sliding doors that open onto the terrace, while the north wall curves over in three sections to form a cowl-like roof. Across the deck is a wedge-shaped unit with a barrel-vaulted roof, containing bedroom, bathroom and garage. The third building block containing kitchen, dining room and the second bedroom, rises to a pyramid roof. A glass-walled bridge alongside the deck connects the units. For anyone walking around the house, there are a surpising variety of views and the house seems much larger than it is. The sense of being closed to the outside yet open internally is enhanced by the galvanized external cladding, while the textures inside of wood and cork tiling give a warm, natural contrast.

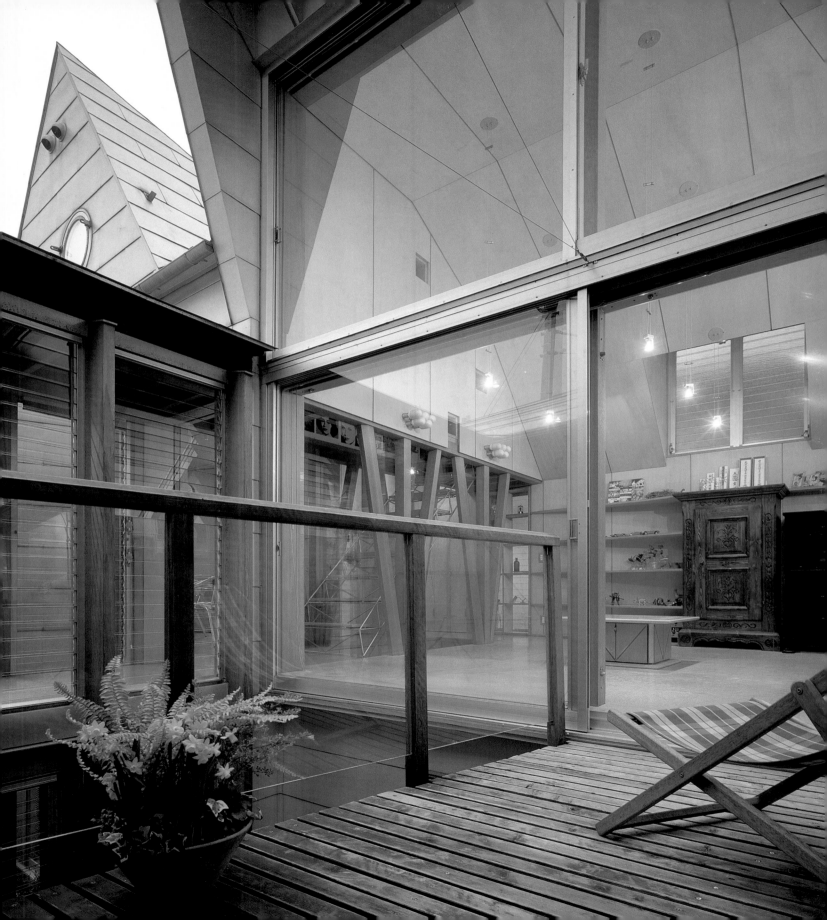

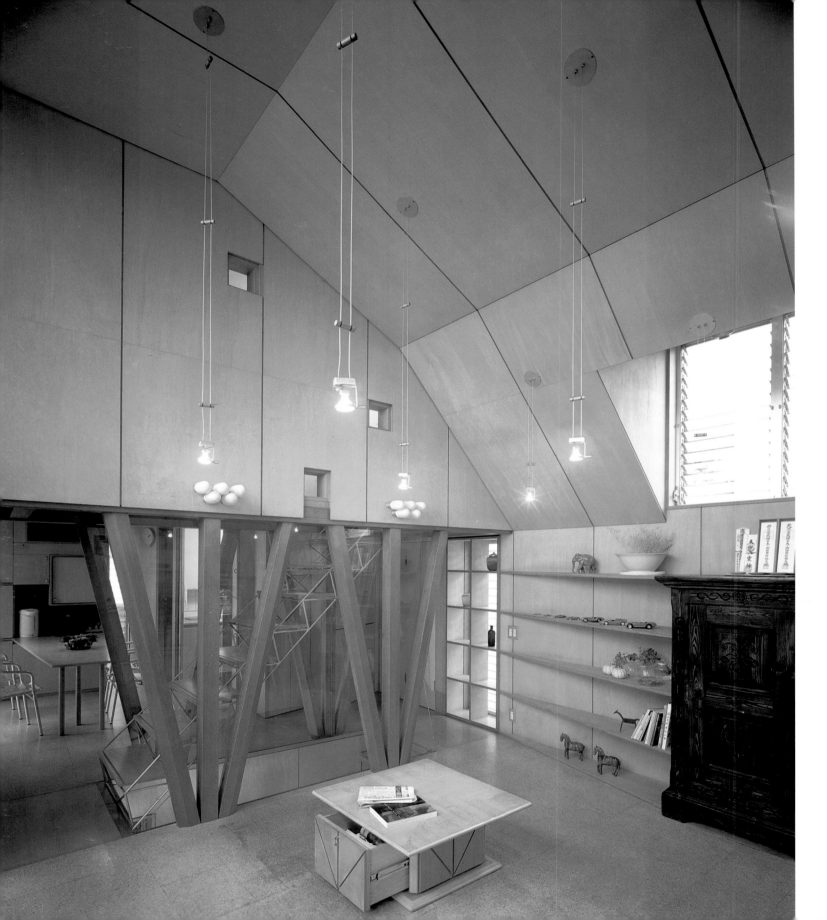

Left: The three-sectioned slope of the living room's ceiling, following the cowl-like shape of the metal-skinned roof, gives a dynamic elevation. Finishing the entire inner surface in wood panelling helps to give a feeling of natural warmth and comfort.

Right: The terrace at the heart of the house is its visual focus and a private outdoor space in a densely populated district. Sliding glass window panels give access to the children's bedroom at the front, while the narrow staircase down to the garage was built specially for the family dog.

Right below: The living room seen through the fan of timber braces that support the pyramidal attic area. The use of diagonals in these, the shelving and ceiling add to the liveliness of the views inside the house.

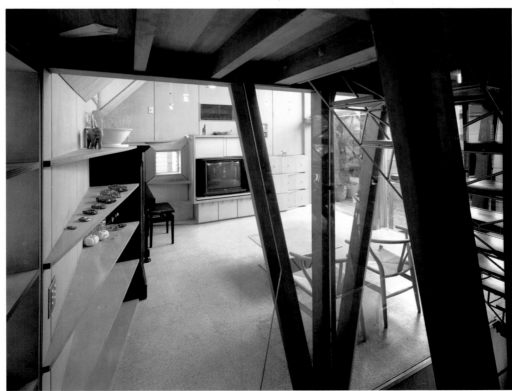

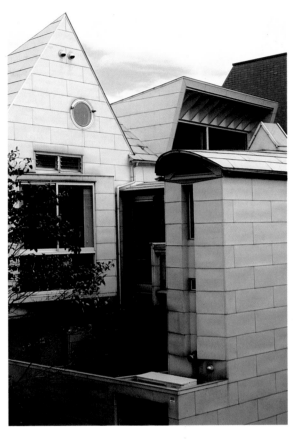

Left: The ground floor entrance corridor, like that on the second floor, is lined with louvred glass panels that open onto small open spaces: to the garage area on the left and to a tiny garden on the right.

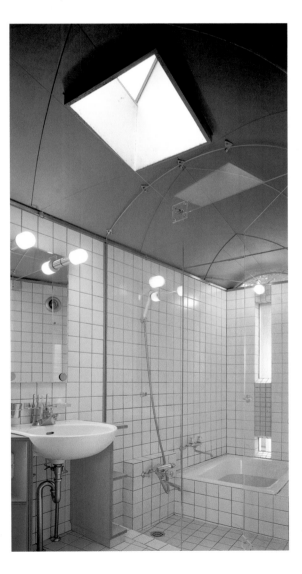

Above: Completely clad in galvanized aluminium plates, the exterior of the house is an assembly of differently shaped blocks and roofs, including a pyramid, a cowl and a wedge. The bathroom occupies the thin end of the wedge-shaped unit at the front of the building.

Left: The bathroom, under a barrel-vaulted roof with a skylight in the form of a miniature pitched glass roof.

Spiral Connections
A vertical house structured around its staircase

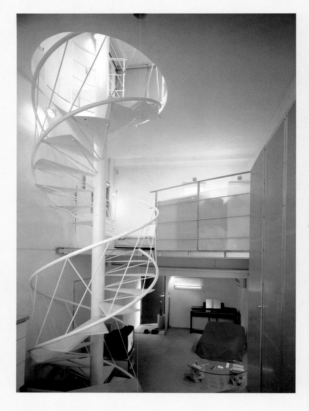

Norisada Maeda, responsible for the radically inventive home designed around a bathroom (page 200), chose for his own house a vertically-proportioned space without any complete partitions — indeed, without interior walls. Instead, the divisions are created by differences in level and by glass. The interior's core, both functionally and visually, is a single spiral staircase in white-painted steel that ascends the full height of the house. While the basic function of most spiral staircases is to save space by means of their small footprint, Maeda here uses the device to co-ordinate the entire living space of the house.

Also running the full height of 10 metres is the south-facing window, which effectively replaces the wall. As in most of Maeda's designs, glass plays an integral rôle both in distributing and modulating light and in dividing space. As he puts it, "glass is the skin of the house" and this transparent wall provides natural lighting for the entire house. Only on the top level, where the main bedroom is located, is there a north-facing window in addition.

A translucent glass panel on the mezzanine, above the living room, gives privacy but also light to the young daughter's bedroom. On the top level, the walls of the bathroom are also of glass, and, as well as being partitions, act as a window for the bedroom. Glass doors open out onto a roof terrace from the bathroom, and onto a garden terrace from the kitchen and dining room.

Above: From the ground floor, the staircase rises past the slightly elevated kitchen and dining room, then past the daughter's bedroom on the mezzanine, to disappear through a circular hole in the top floor.

Right: The ground floor, at the base of the spiral stair-case, is divided into two levels, connected by a short flight of concrete steps — the sitting area in the fore-ground and the kitchen and dining room leading out to a small garden terrace. Textural contrasts play an important part in the interior; here, the exposed underside structure of the second floor in silver-painted bolted girders is set against raw concrete walls.

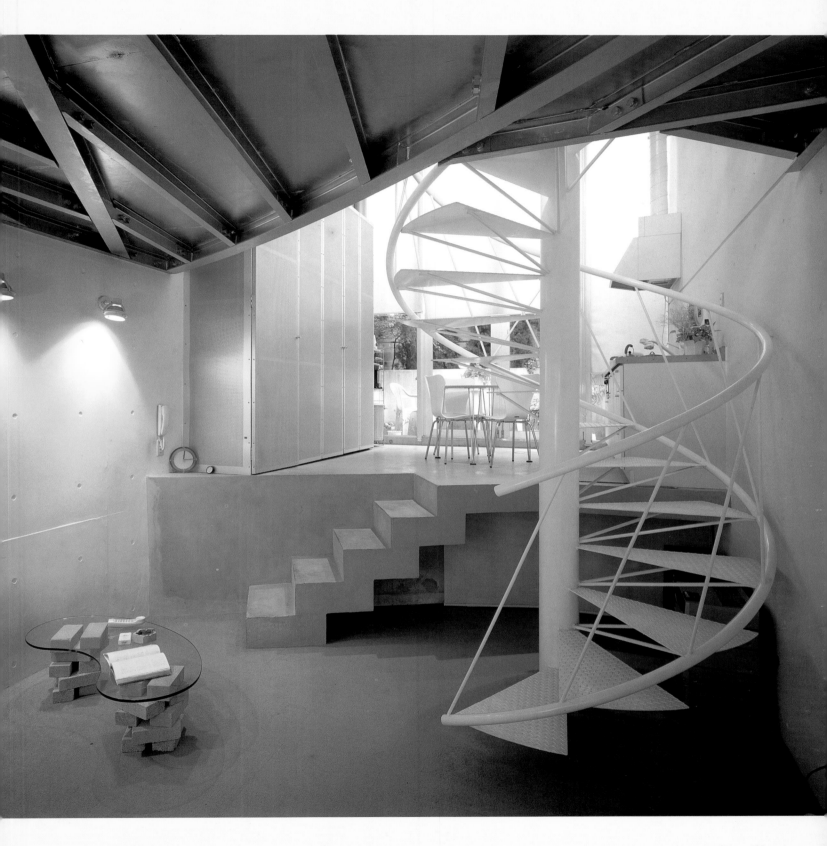

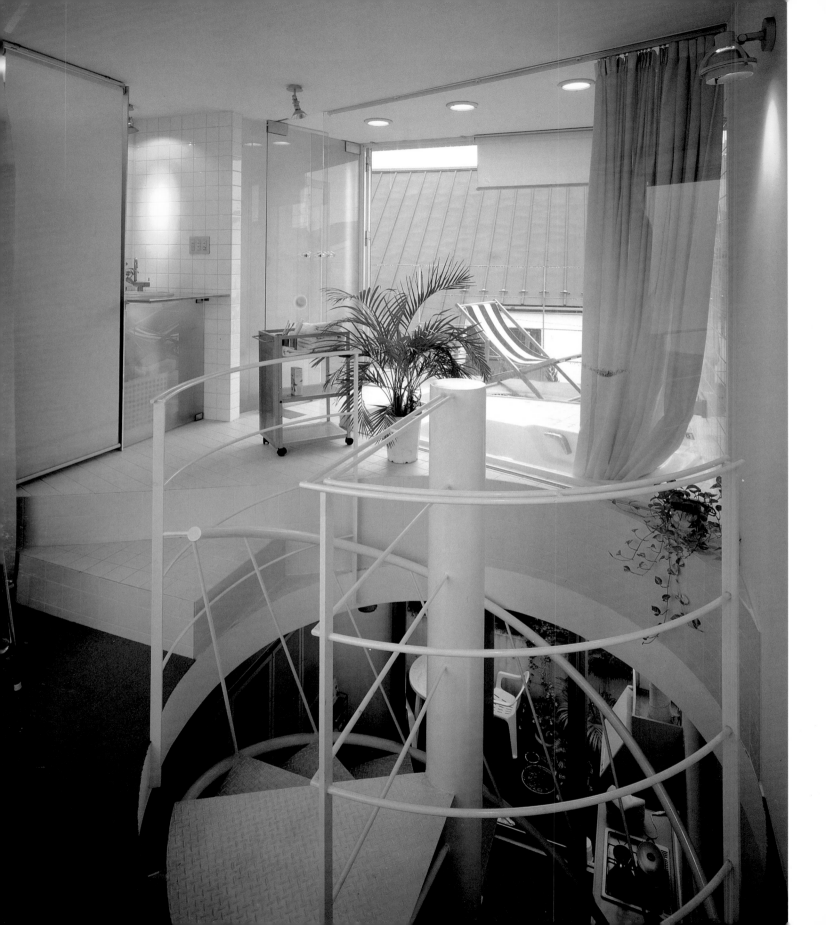

Right: The view from the mid-level down towards the kitchen and garden terrace. Angular decorative panels in yellow and black provide a colour accent to the otherwise restrained finish in white and metal. The cupboard space below is faced with tall panels of perforated aluminium.

Left: The top floor, looking from the main bedroom over the circular stairwell to the bathroom and roof terrace beyond. The bathroom's glass walls feed light from the terrace to the top floor.

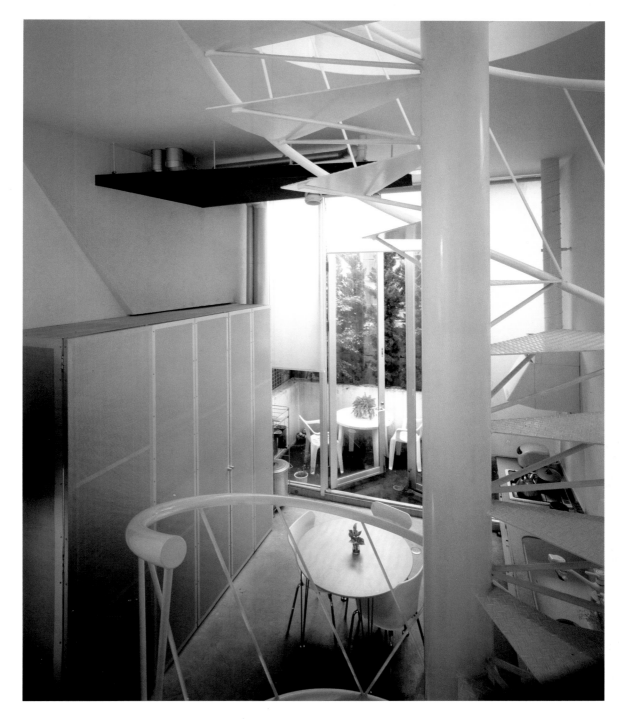

Experimenting with Materials

One of the persistent and unique features of Japanese crafts-manship has been its reliance on the beauty of functional simplicity rather than decoration. In turn, this has promoted a respect for the materials themselves — an appreciation that is now being updated to include the entire modern inventory of materials, from all sources.

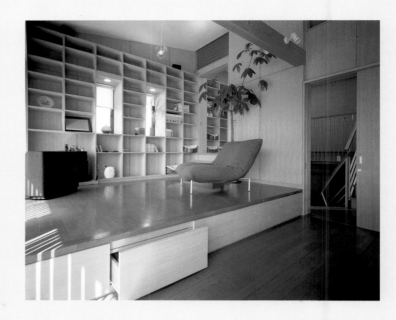

New Economy
Combining wood, steel and industrial plastic

Although the exterior of this low-cost house in Chiba is unremarkable, a clever juxtaposition of industrial materials with wood creates a striking impression as soon as it is entered. Architect Shintaro Hanazawa designed the two floors to provide a contrast in light and shade, so that as the visitor moves from the ground floor to the second, the house opens up in brightness and volume. He designed two strong features to connect the spaces — an imposing and stylish staircase in steel and wood, and a kind of corner bridge in industrial plastic.

These two elements dominate the entrance, and create an impression of spaciousness. The staircase, set at an angle and painted dark blue and white, has elegantly curving wooden handrails supported by light steel struts. The 'bridge' above connects the bedrooms with the living room, and for this feature Hanazawa chose a grid made of FRP (fiberglass-reinforced plastic). Its strength and lightness made it perfectly suitable for an open walkway, and also allow light to permeate through it to the entrance area below.

The walls in this whole area are composed of a light wood that gives texture, as well as a subtle design accent to the space. Behind the staircase is a huge, concealed walk-in cupboard used by the owner for storing books. It cleverly utilizes space that may otherwise have been wasted.

Above: The living room on the second floor, which opens both to the kitchen and to a verandah, features a raised platform for the sitting area. The space below houses drawers for storage.

Right: The steel and wood staircase, with a styling that suggests the gangplank to a large private yacht, makes an imposing feature of the entrance. The wooden grating above partially conceals the plastic 'bridge' above.

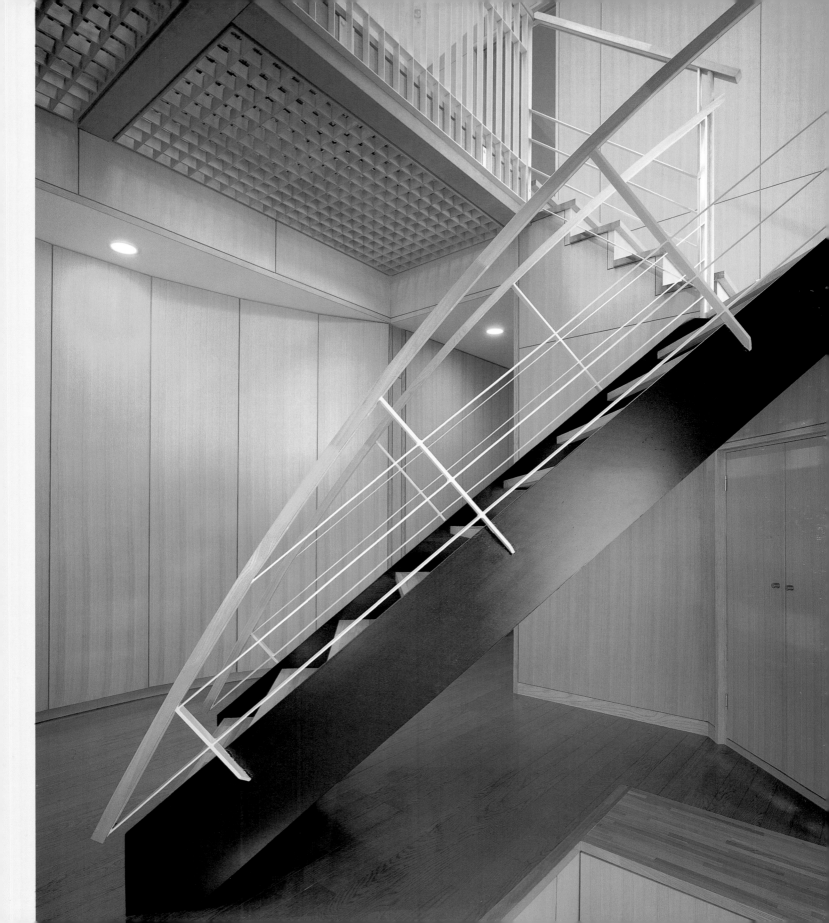

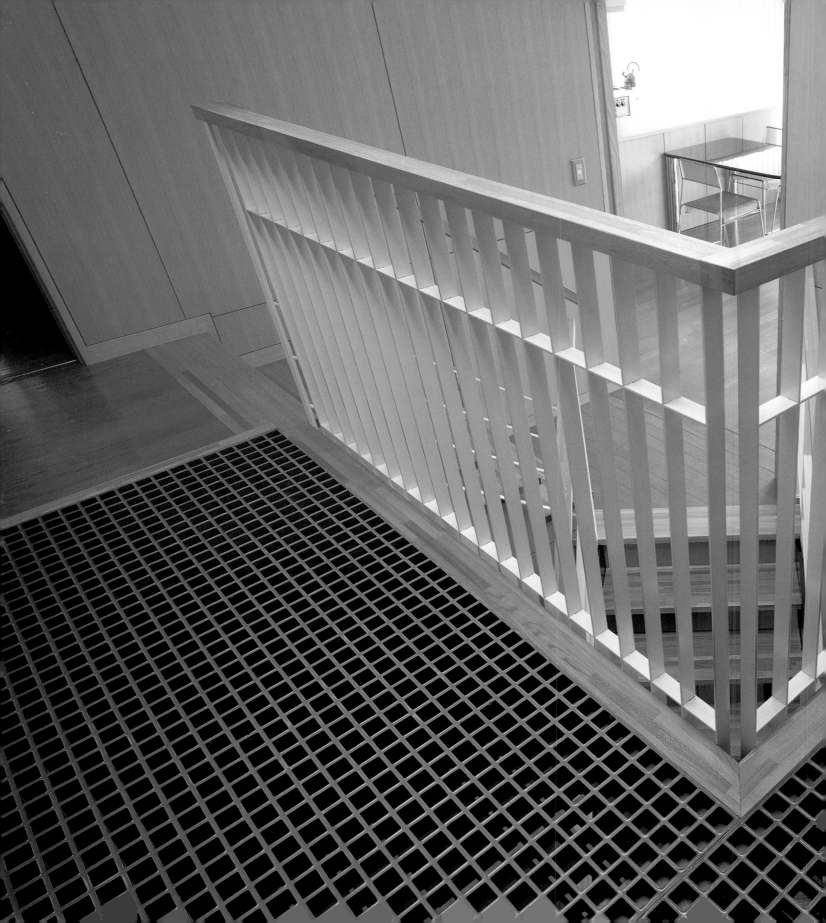

The angled grating of industrial plastic on the second floor, with the living room and kitchen beyond.

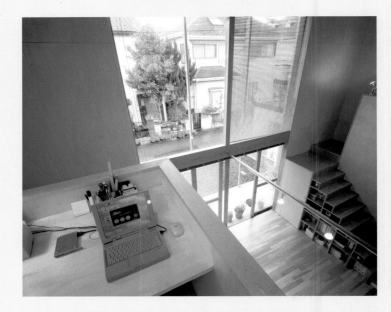

Plywood Simplicity
Shaker-like treatment of a modest material

In this house in Chiba, about an hour west of Tokyo, the architect Kazuhiko Namba has created a warm, simple but elegant family home by using throughout one of the cheapest of materials — ordinary plywood — without trying to disguise it in any way.

The first consideration was that this should be a low cost house, but Namba was determined to do this without compromising style and comfort. In the long Japanese craft tradition of respecting the qualities of the material, he worked the characteristics of plywood into the design, allowing the panels to create a rectangular sub-division of walls and ceiling, and displaying rather than hiding the multi-ply edging. Even the nail heads, though small and neatly hammered in, are left exposed. The inconsistencies in tone and grain that are normal for this inexpensive material give a subtle variety to the surfaces within the house.

Costs were kept down in two other ways, by eliminating 'useless' walls and by planning the furniture and storage spaces from the start. "It depends on the family," says Namba, "and in this case it was appropriate, but I very much wanted to keep the space open." Fitted cupboards, beds and other furniture all in the same plywood enhance the open, uncluttered feeling. Little surprise, then, that this highly functional simplicity reminds the owner of the Shaker interiors of which she is an enthusiast.

Top: The study, perched close to one corner over the main entrance, looks out over the ground-floor living space and the street. Full-height glazing at the front floods the house with light.

Above: The entrance to the home is decorated with a pattern of glass marbles set into the concrete.

Right: A modern rendering of the old-fashioned *kaidan-dansu*, or stairway-chest, makes a striking feature out of the lower section of the staircase. Unlike the traditional furniture, however, the units are not closed off.

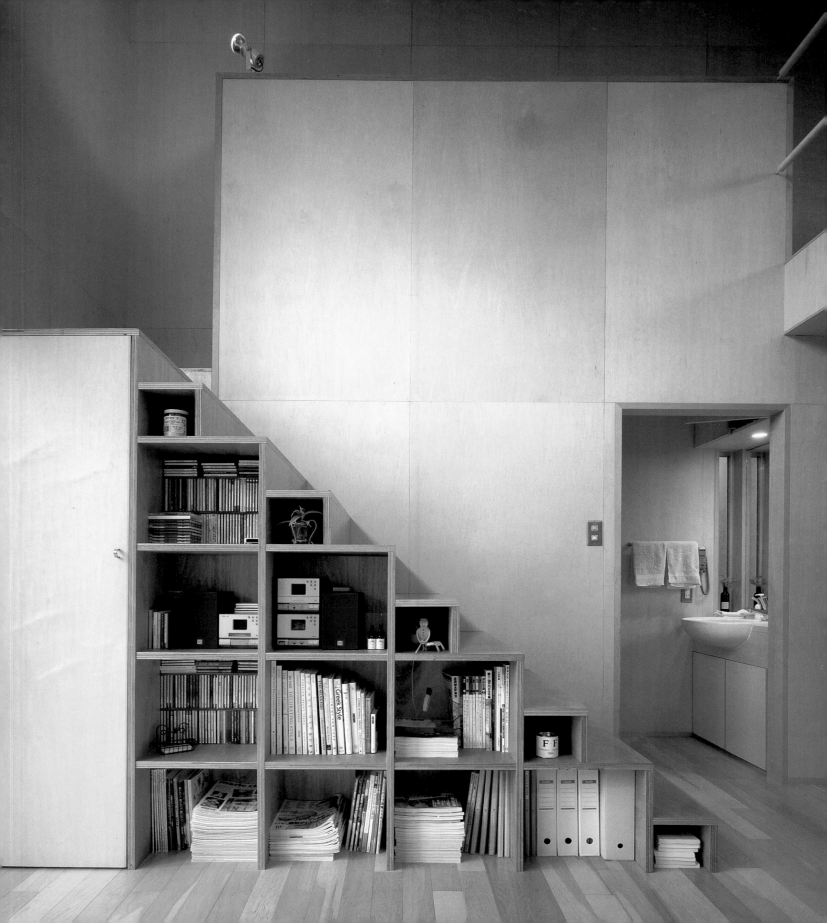

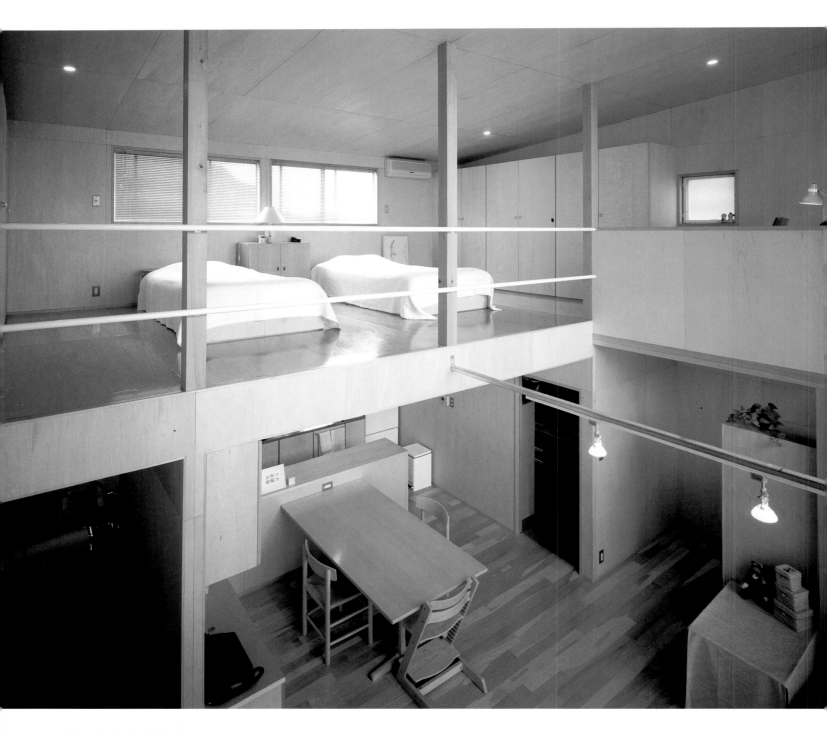

Above: By placing the bedroom on a mezzanine with an open-fronted balcony, the architect has opened up the interior to the full.

Right: A lighting track runs half the depth of the interior.

Below: With no attempt at concealment , the interior displays the plywood honestly, with even the bare nail heads left exposed.

Far below: Simple handles for the cupboards in the form of steel half-rings.

Bottom right: Fitted furniture in plywood throughout gives the bedroom a clean, even austere, simplicity.

Overleaf: The view from the kitchen towards the front of the house.

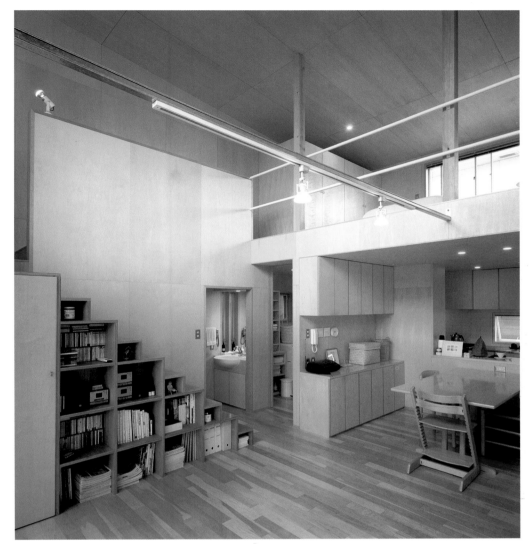

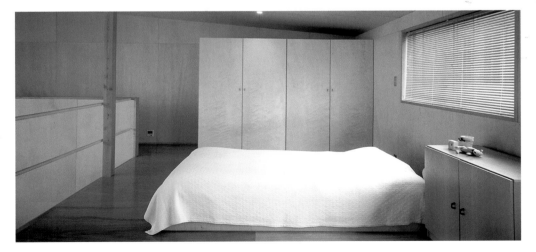

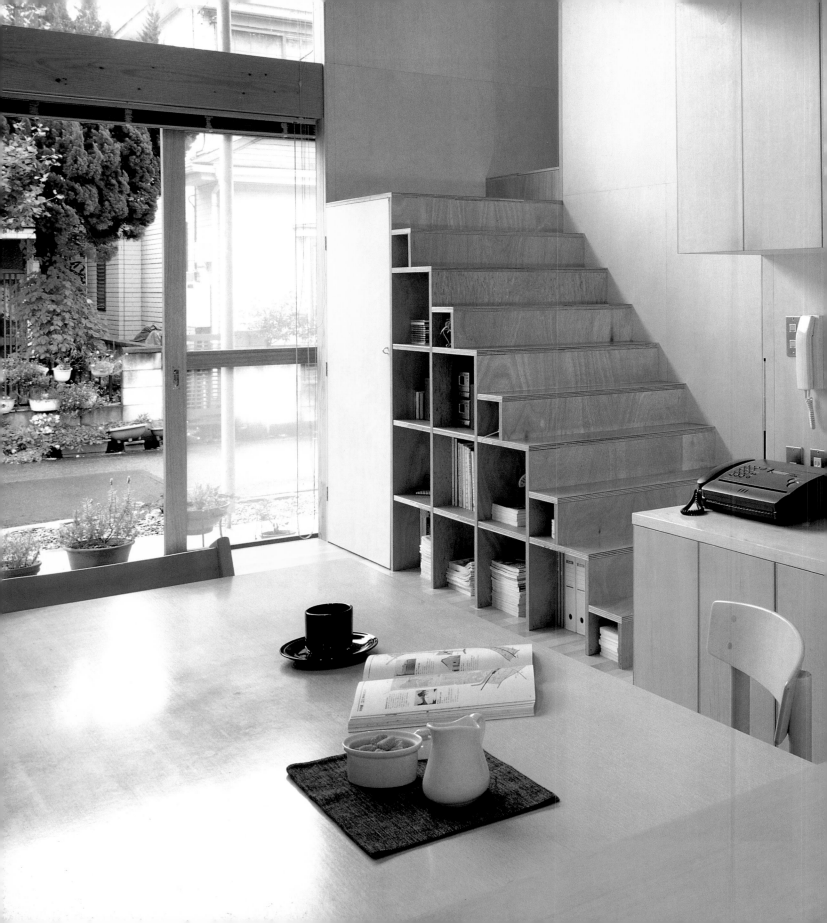

Industrial Retro-Fit
An apartment built of water pipes

This minuscule apartment in a nondescript apartment block had little to recommend it other than its convenient location, and even though only 29 square metres in area, had actually been divided into three rooms. Despite such unpromising circumstances, the owner determined first to open it up, and second to inject some radical decoration that would at least give it a striking character.

He turned to commercial interior designer Toshihiko Suzuki, who is also associate professor of art and design at Tohoku University. Firstly, Suzuki had the room entirely stripped of wall and ceiling coverings, and of its interior partitions. In such a small volume this already freed up significant storage space. Suzuki then chose to fit the entire room with water-pipes to create shelving, light tracks, the one necessary partition for the bathroom, even the single chair. Translucent corrugated plastic sheeting clads the partition, while shower curtains appropriately shield the storage space. In keeping with such a forcefully industrial character, he recommended leaving the walls and ceiling completely untreated.

"I chose water pipes not simply to invent a new idea," he says, "but because plumbing design technology is reliable, strong and cheap. It's the ultimate in functionality." A plumber did the fitting, and Suzuki softened the severity of the concept with some light touches, such as the recycled faucets used to terminate horizontal pipes in the shelving and lighting tracks.

Above: All the shelving utilizes glass and waterpipes, and second-hand faucets are used as stops.

Right: The use of piping everywhere creates a unified and visually striking theme for what would otherwise be a typically banal small apartment.

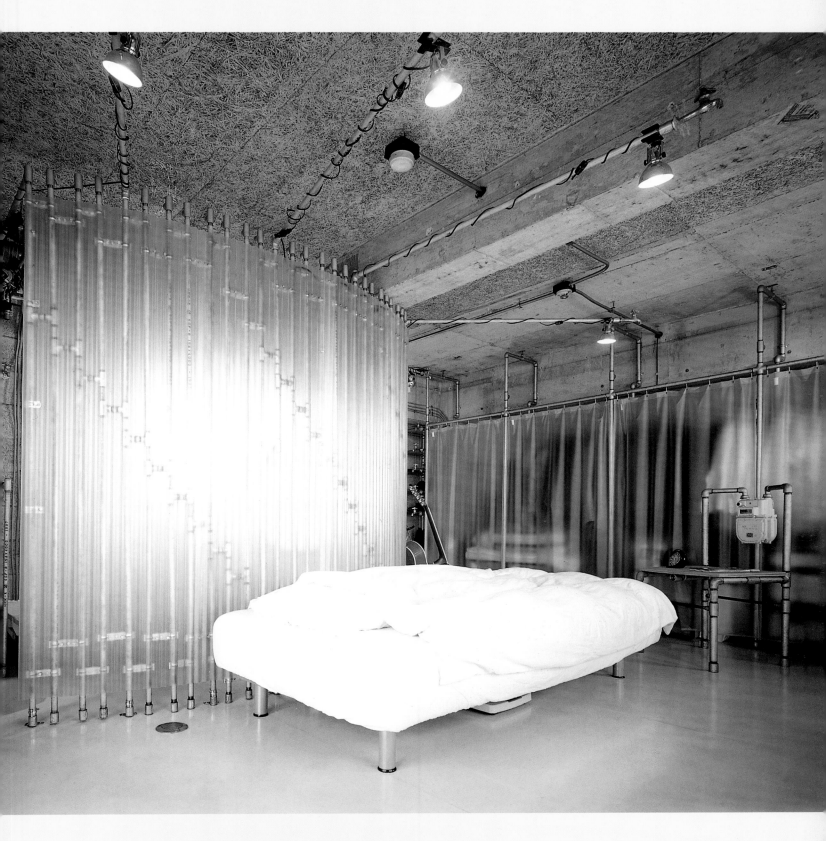

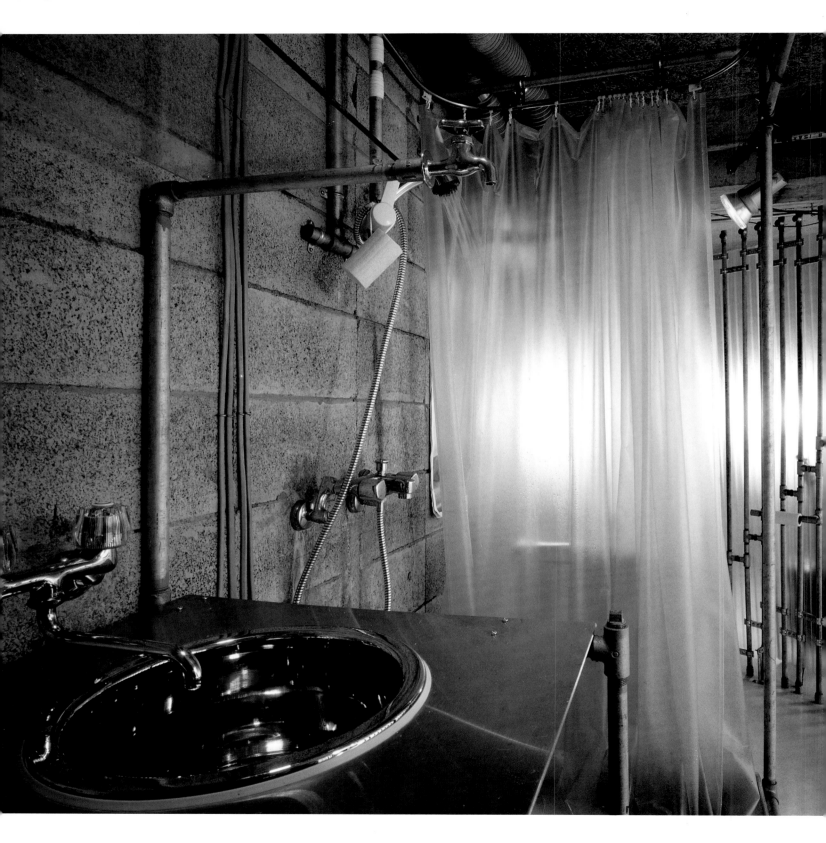

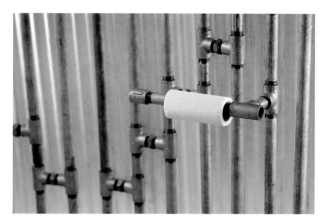

Far left and left: The bathroom, partitioned by a curved screen of vertical pipes supporting corrugated plastic sheeting, is a playful mix of functioning and non-functioning plumbing. The tap next to the shower head is simply decorative, while even the toilet paper hangs from a short pipe extension.

Below: In another view of the apartment, pipes have been used to create the one piece of free-standing furniture — a chair with a plywood seat and a back featuring a re-cycled electricity meter.

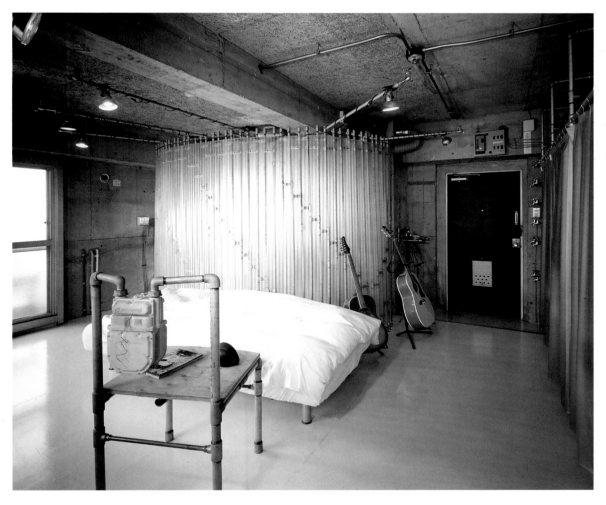

Prefab Style
A new regard for factory-assembled living

Few people would feel any enthusiasm for a '70s single-storey prefab, assembled from factory parts on a plot of land with no view to speak of. Prefabs like this, built in 1973, were never intended as more than temporary housing, to be pulled down as soon as the family could afford something more substantial.

For young architect Arata Naya and his wife Satoko, however, it represented a challenge in both construction and design. Satoko was born and spent her childhood here, and when the family moved, the original plan was to lease the prefab. Yet Satoko retained a sentimental affection for it, and Arata began to see an unmannered plainness to the prefab that appealed. "Prefabs from those days were different from now. Very simple and straight, and I wanted to keep this while at the same time re-making it with some new ideas."

One of these ideas was to extend the living space (the size of the plot allowed this) with modern pre-fabricated materials, and in such a way as to fuse the two periods. "We had no plans of the original, so I just broke through at both ends and inserted extensions of ribbed galvanized steel." But most of the Nayas' energy and style went into the interior. For them the idea of a factory-made prefab was not something to be despised, but celebrated. They first exposed the old framework, painting the girders blue, and then sought out a medley of modern industrial materials as a way of extending and updating the prefab ethos.

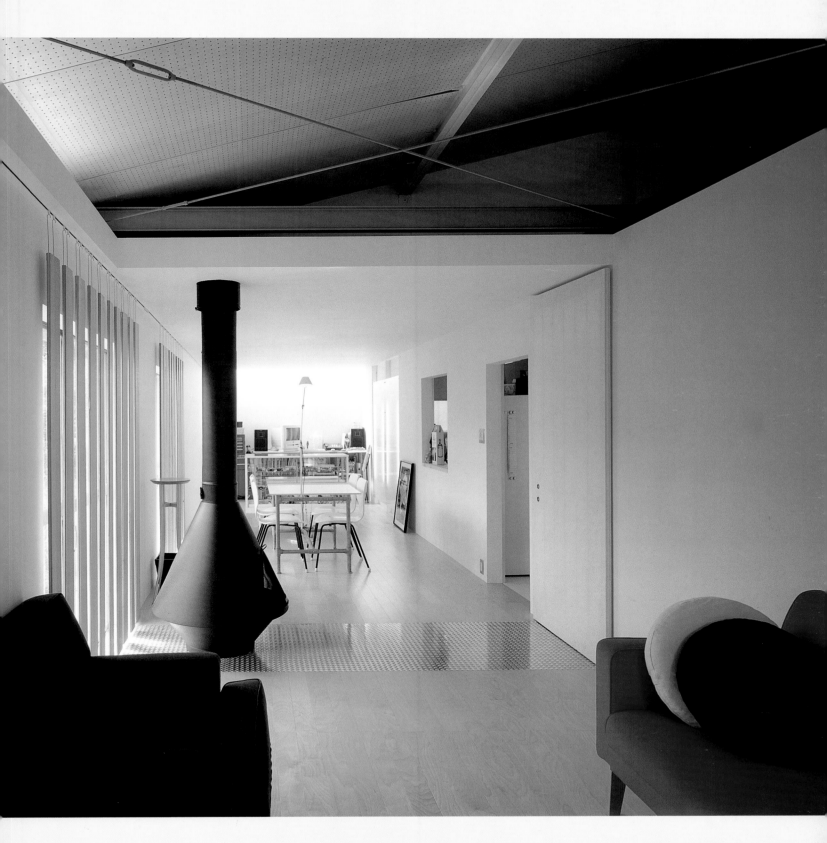

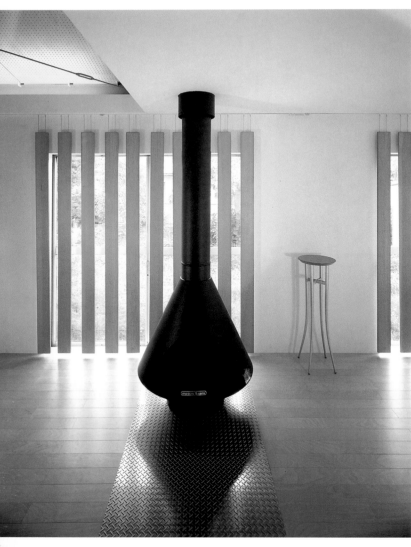

Left and left below: Searching for an interesting and inexpensive way to screen the living area's unattractive original windows, the architect hit on the idea of suspending wooden floor planking from the curtain rails.

Below: Traditional Japanese doors are sliding screens called *shoji*, consisting of a frame covered with *washi* paper. Between the bathroom and kitchen, however, the *washi* has been applied to a western-style hinged door, and on both sides for insulation in a technique known as *fukuro-shoji.*

Right: One of the more striking features of the decor is the juxtaposition of textures — mostly the untreated and unpainted surfaces of industrial and basic materials that include vinyl flooring, wood, compressed board, metal plate and *washi* paper (covering the sliding door). Concealed floor lighting enlivens the narrow hallway beyond.

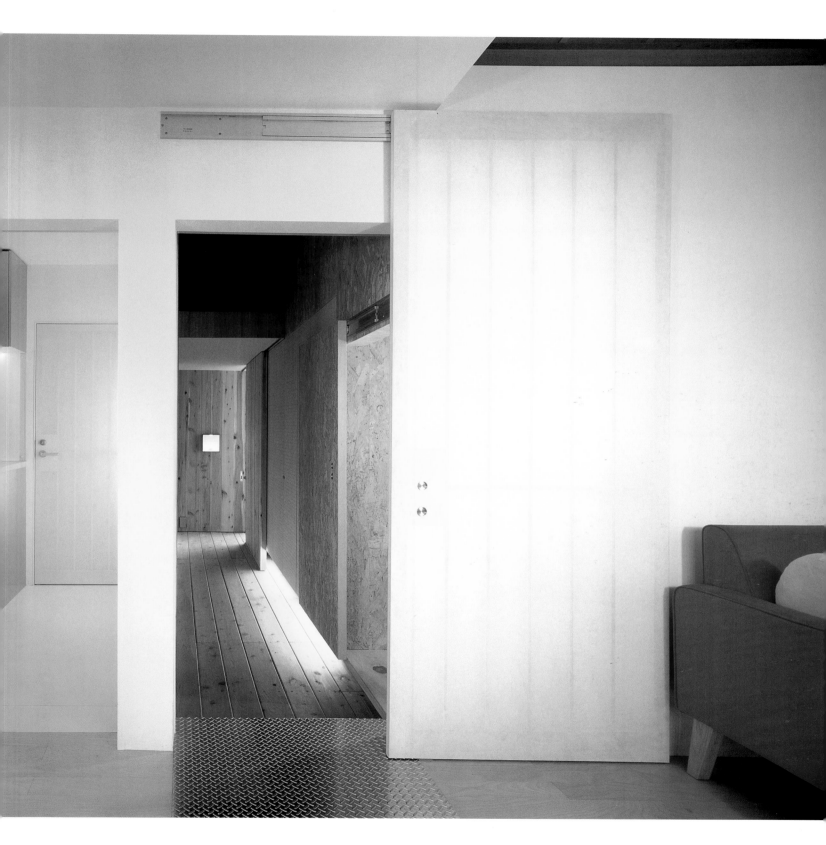

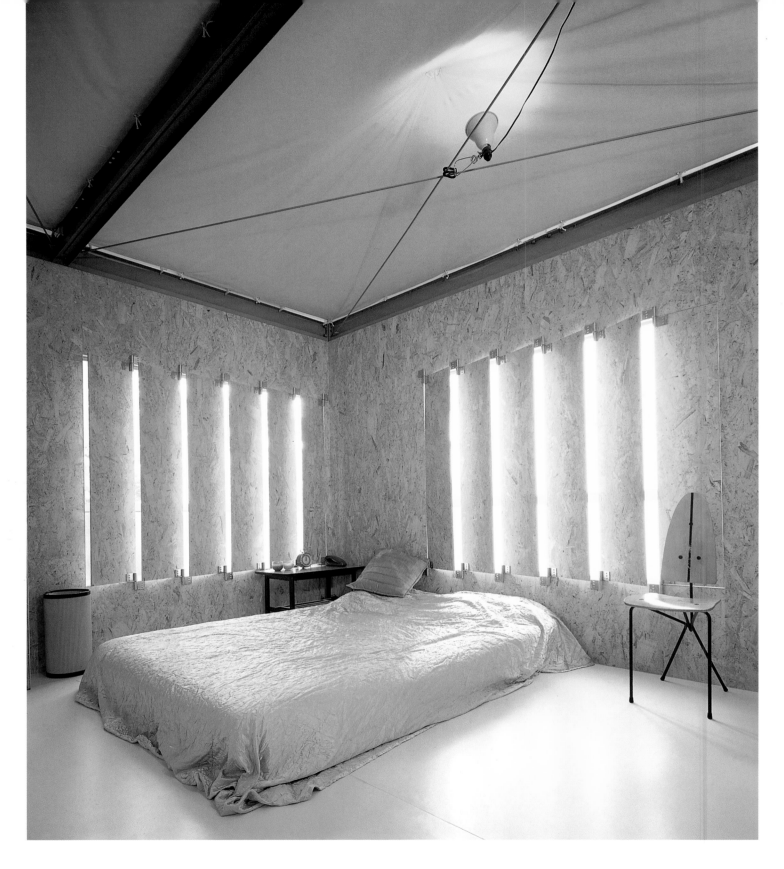

Left: Untreated OSB — boarding of compacted wood chips normally used for shipping containers — has been used for the two exterior walls of the bedroom, which is suffused with a warm natural glow when the pivoting window slats are opened. The tent-like ceiling is of undyed canvas, and the flooring is hospital vinyl.

Right: The ribbed structure of the house extensions is left in its plain galvanized form for one of the interior bedroom walls. A galvanized dustbin is used for storage.

Far right: A steel washbasin set in pegboard in the bathroom. Hinged *fukuro-shoji* panels cover the shelves and the original prefab windows.

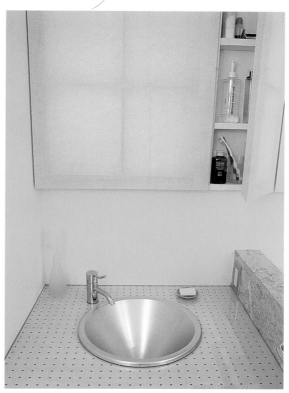

Right: A detail of the unpainted OSB window slats.

Far right: Polystyrene insulation between the kitchen and hallway is turned into a decorative element by means of fluorescent backlighting and a pattern of circular holes on the wooden wall.

Material Contrasts
Rustic interiors in a metal skin

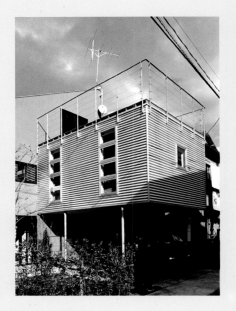

For this low-budget house in Shinjuku, Tokyo's largest downtown area, the husband-and-wife team Akira and Andrea Hikone had been asked to use as much as possible of what the owners called 'honest' materials, meaning non-proprietary. They were also asked to capture some of the open, exposed-timber atmosphere of a *minka* farmhouse, just as they had for the Casa Kimura (page 40).

The principal living area is on the second floor, where the open beamwork and rafters of a *minka* link the kitchen and dining room with the bedroom and living room. The timbers are American pine stained a deep brown for a rich, aged effect, and a lattice screen of bamboo painted the same colour extends the dividing wall between the dining room and bedroom up to the rafters. The walls, in contrast, are in unpainted white mortar.

On the ground floor, the entrance hall and two rooms leading off from it each has a unique character from a specific material. A pale concrete floor set with pebbles — a modern version of a *doma* or earth floor — and glass doors at either end that fold right back give the hall an open spacious feeling. Next to it, the tatami room has stained pine timbers for its ceiling and walls covered with genuine *washi* paper. On the other side is the *o-furo*, a traditional bathroom, and here the usual economies were abandoned. For the tub, walls and ceiling, Japanese cypress was used; it is considered one of the top materials for its fragrance and warm, blond tone.

Above: The exterior, in deliberate contrast to the rustic and craft elements inside, features an elevated wing of corrugated galvanized steel and concrete, supported by pillars over the open garage. The Hikones felt it needed to feel more 'urban' and would better suit the surroundings if such materials were used.

Right: The ground floor entrance, entered through full-width glass doors, faces a second set of folding glass doors that open onto a screen of bamboo planted in the narrow strip of earth between the house and the wall. The floor is concrete set with hand-picked pebbles, while handmade children's stilts in traditional style — the walking height is adjustable — lean against the mortar wall.

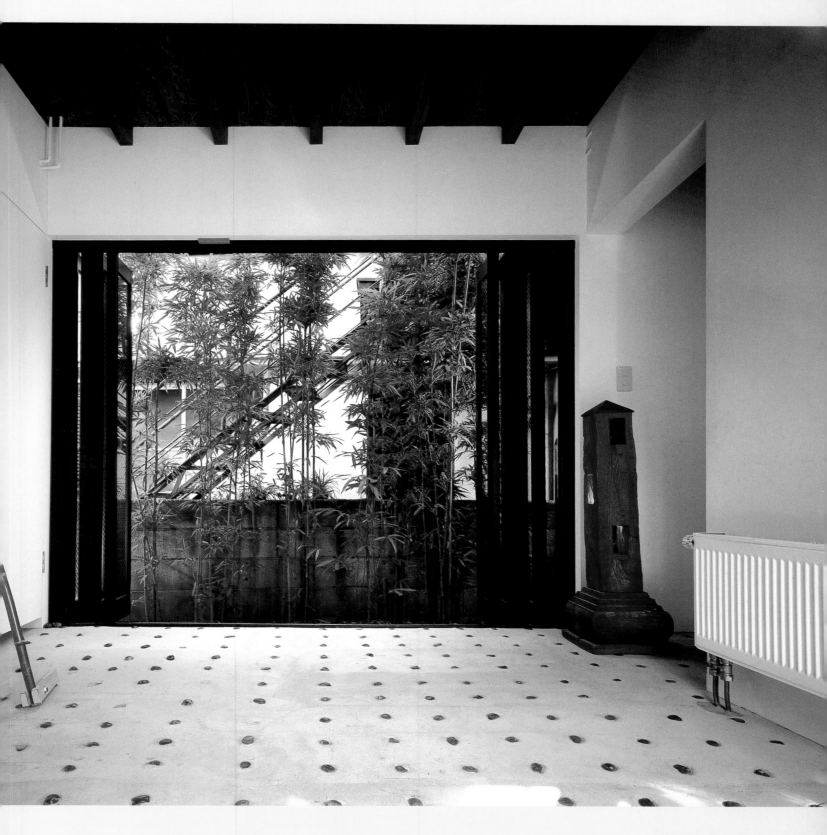

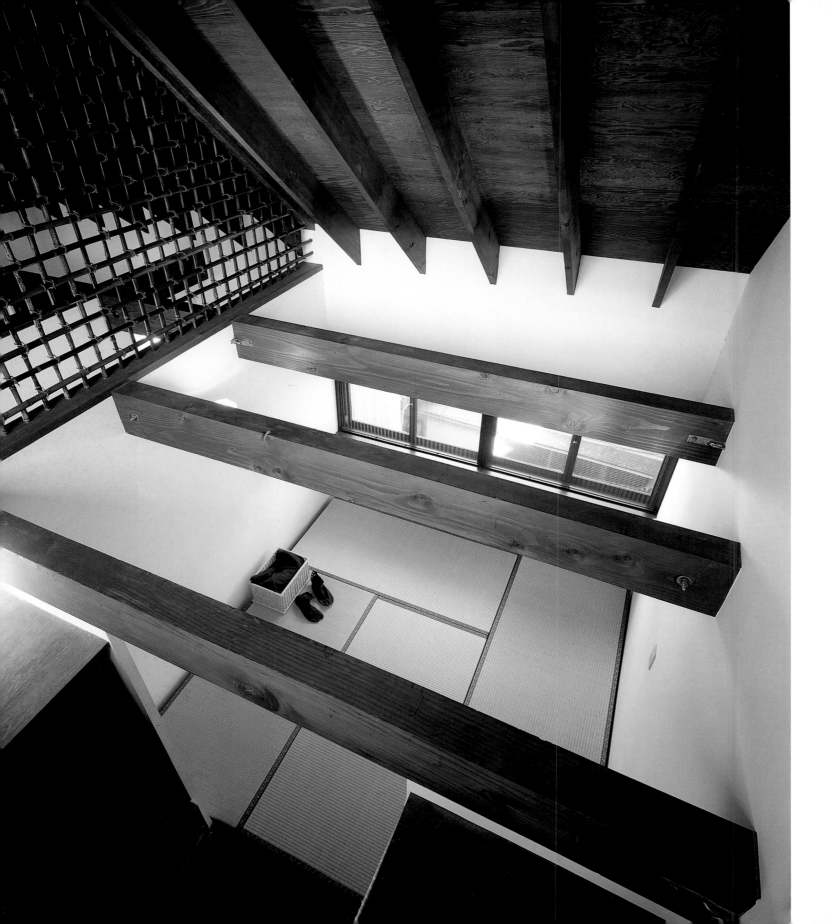

Left: Open beamwork and rafters capture the essence of the traditional *minka* farmhouse style. From a small gallery opening to the roof terrace over the metal-clad wing, the view down to the tatami-floored bedroom takes in the stained timbers of imported American pine.

Right: The *washitsu*, or traditional tatami room on the ground floor also has exposed stained ceiling timbers, and the sliding door opens directly from the entrance hall. A pair of *hina-ningyo* — dolls for the annual March girls' festival — have been placed in an innovative style of *tokonoma*, set against a low window.

Below right: The traditional bathroom, on the other side of the entrance hall from the *washitsu*, uses Japanese cypress throughout, and glows in the sunlight filtering through the *yoshizu* reed screen over the window.

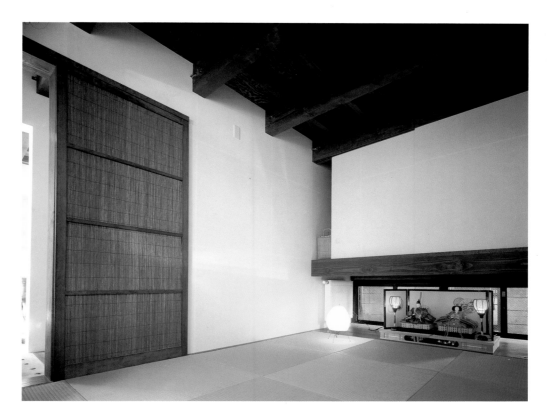

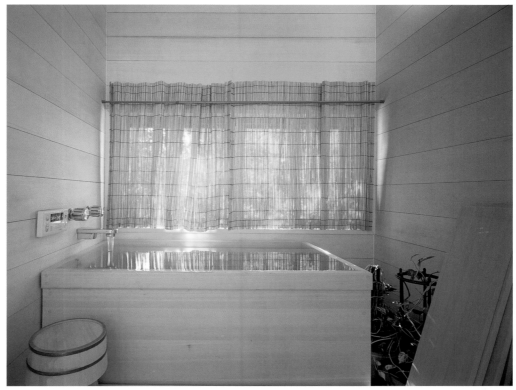

Left: The owner deliberately chose a regional type of *washi* paper with a pronounced wrinkled texture, applying it on top of an undercoating of regular smooth *washi*, for the walls.

Textured Walls
Displaying the character of handmade washi paper

When architectural photographer Koji Kobayashi planned the building of a studio and living accomodation in Musashino, Tokyo, he had very particular ideas about the surfaces inside. He wanted only what he called 'real' materials: that is, natural and not proprietary interior design products. For the upper-floor apartment, he and architect Michimasa Kawaguchi decided on paper and ink — handmade *washi* paper for the walls and ceiling, and calligraphy ink to stain the wooden floors. The combination would also serve as a display setting for his idiosyncratic antique collection.

Washi paper, being hand laid, is available in a wide variety of styles, and Kobayashi settled for a regional variety from Nagato in Nagano prefecture with a strongly crumpled texture. To retain the wrinkled effect, the *tateiwa-washi*, as this paper is known, was laid in overlapping sheets over ordinary smooth *washi*. Kawaguchi incorporated a narrow lightwell at one end of the living room to display the texture to advantage. For the flooring, Kobayashi went through several experiments to find the perfect colour and surface, eventually settling on a mix of two shades of *nihon-ga* painting inks, blue-black and grey-black, mixing them casually and brushing them on. Five thin coats of wax finished the effect.

The table and chairs by George Nakashima are an appropriate centrepiece for the naturally-decorated room. Kobayashi so much admired Nakashima's work, that he went to the Pennsylvania studio himself to order the pieces.

Right: Washi paper covers the entire wall and ceiling surface of the upstairs apartment, and even the window at right (in the form of a sliding *shoji* screen), while the ink-stained wooden floor becomes a display area for the owner's collection of antiques and memorabilia. For the floor, chemical paints were rejected for their 'vulgar sheen'; high quality calligraphy ink at $100 a stick was too difficult to grind and India ink was too black. The two gilded carved *kanji* characters in the large bowl are old shop signs from a butcher, meaning 'pork' and 'beef'.

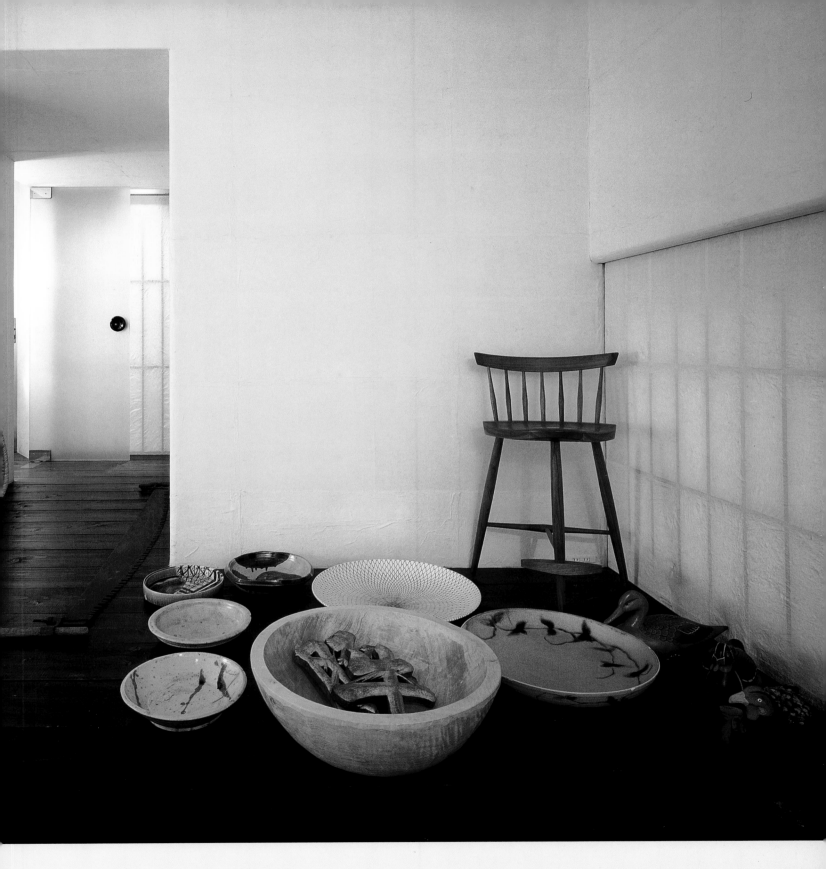

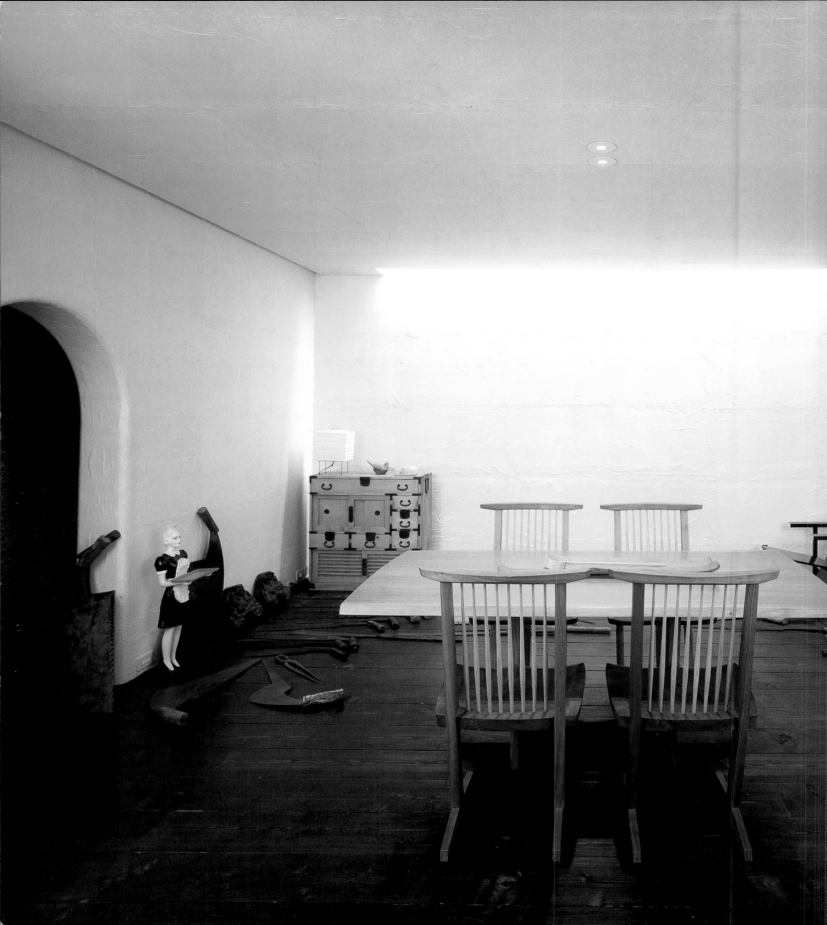

Left: In the principal room, the centrepiece is a table and chairs in modern rustic style by Japanese-American furniture maker George Nakashima, surrounded by a collection of old Japanese wood saws.

Below: More of the owner's large collection of antique saws line the ground floor entrance hall. A low window restricts the view to the small dry garden, surfaced in pebbles which extend into the interior of the hallway.

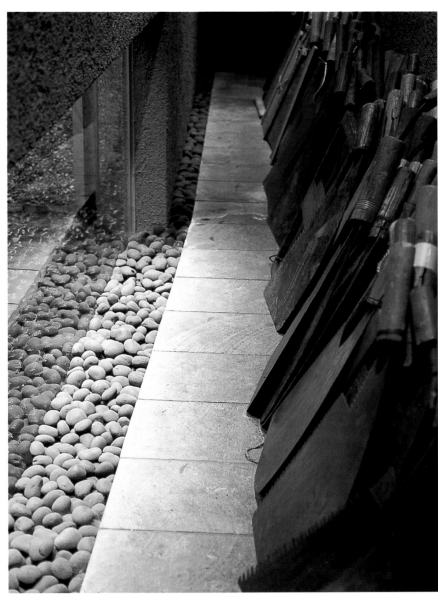

Concrete Geometry
A massive stairwell defines the space

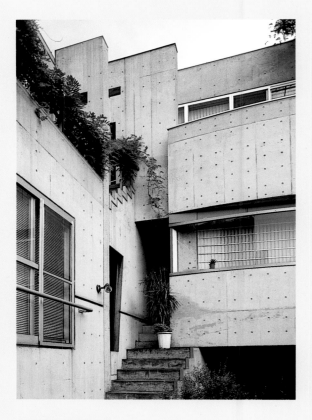

Raw concrete, used as the material of choice by Tadao Ando and the older generation of post-war Japanese architects, has evolved in different directions in recent years. Still popular, it is now used more discriminatingly. The essence of the 'brutalist' technique (its slightly derogatory English name, although in fact derived from the French *brut*, meaning rough or raw) is to leave the texture of the formwork, including the circular indentations of the fixings, untouched, and many Japanese architects adopted and relished this treatment.

For architect Ryoji Suzuki, tactile and visual exposure to the building materials is an essential part of his design philosophy. To have direct contact with the substance of things — including the structure of a house — is a way of breaking what he calls the closed circuit of everyday life. He calls his work in general "Experience in Material"; in the series, this house in the central Tokyo residential area of Hon-komagone is number 25.

A wide central stairwell, with staircases running up from the basement to the roof, is the focus of the house. The concrete surfaces, enhanced by the lighting, the angular faces and colour accents, are entirely appropriate for its massiveness. Suzuki was also responsible for key pieces of furniture, including the dining room table and seating, and the striking steel and wire chair in the entrance hall.

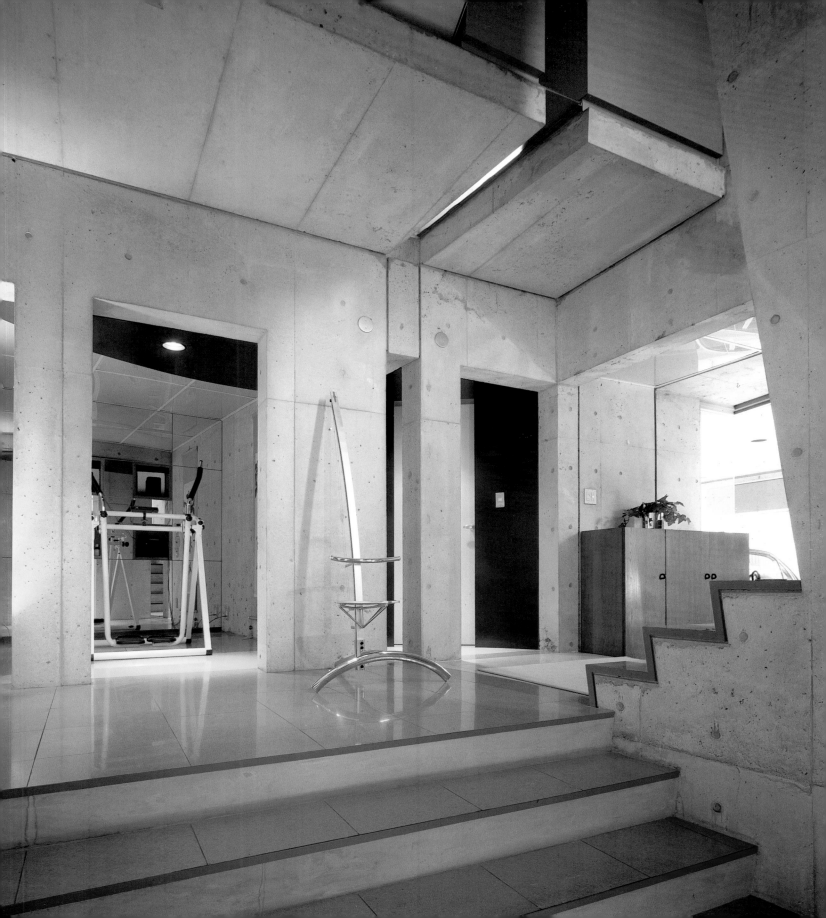

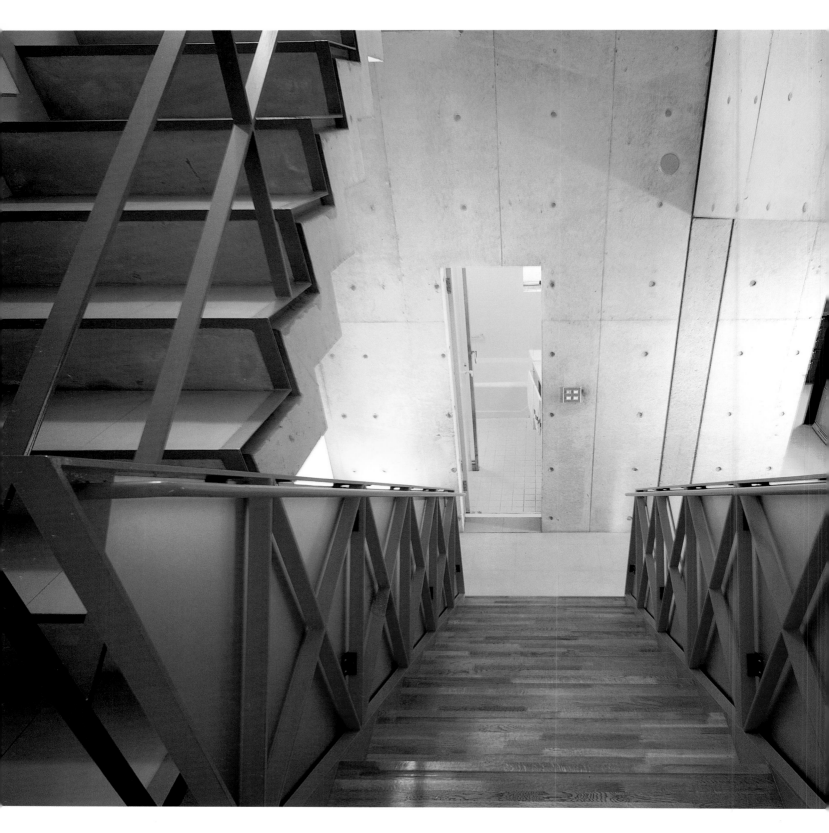

Left: The staircase changes in texture and colour as it rises through the house. Here on the third-floor landing, it turns from wooden steps to concrete and from complex balustrades in diagonally-braced red steel to spare flat rails. The risers are cut back for an angular effect.

Right: Two fitted cabinets on the second-floor landing are deliberately skewed so that they sit on either side of an angled glass strip set into the concrete.

Below: The dining room lies at a slightly lower level than the entrance. The idiosyn-cratic glass table with a frame of rough steel and keel of laminated wood, was designed by the architect.

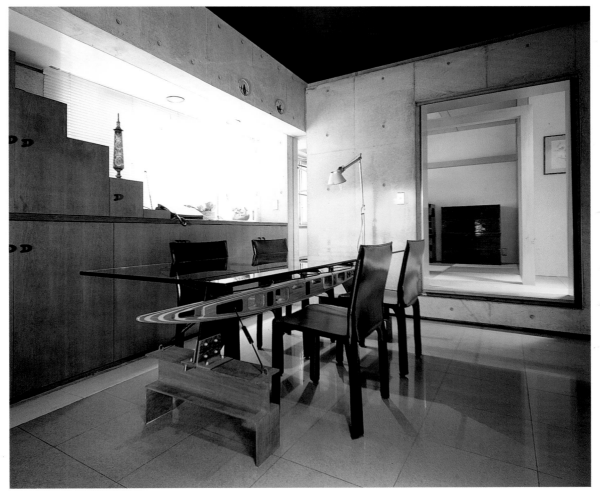

Cinder-block Refinement
Stylish treatment
for a structural material

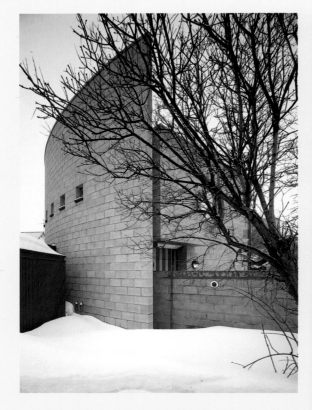

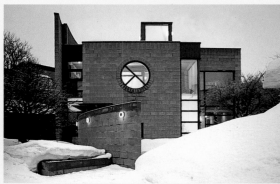

The northern island of Hokkaido poses special problems for living because of its fierce winters, snow-bound for up to half the year. In a country like Finland, which has a comparable climate, housing has evolved over centuries to deal with this, but Hokkaido is so newly-settled (only from 1869) that most dwellings are not ideally designed.

Yoshio Maruyama, one of the new generation of Hokkaido architects working on new and elegant solutions, has succeeded in designing a house that is both heat-efficient and open-plan — a previously largely unheard of concept in the north. Typically, Hokkaido houses are partitioned and, at least in the old days, heating was restricted to one room, so families made great use of the *kotatsu*, a blanket covering a low table with a heater underneath.

For this house, situated in one of the capital's suburbs, he chose cinder-blocks made from local volcanic tufa, with inherently good insulating properties due to the microscopic air bubbles trapped inside. Ordinarily, they have only industrial applications, but Maruyama found a source that would supply them to high specifications, and then employed master brick layers. This enabled him to achieve some elegant and very precise effects, such as the two monumental interior walls of the living room, and the tall sweeping curved outer wall that protects the building from the prevailing winter northwest winds. Furthermore, the blocks were laid in the form of double-thick-ness cavity walls, with an air channel between. With the help of two heating systems, these 40 cm-thick walls retain enough heat to allow the interior to be open — and warm throughout.

Above: **A sturdy but delicately proportioned wall curves around the northwest side of the house to deflect the worst of the winter winds — and also contrives to be a striking visual element.**

Right: **The cinder-blocks have a surprisingly warm, well-finished surface that fits with the concrete beams, wooden floors and ceiling. A large circular window feeds light across the two-storey entrance to the bathroom.**

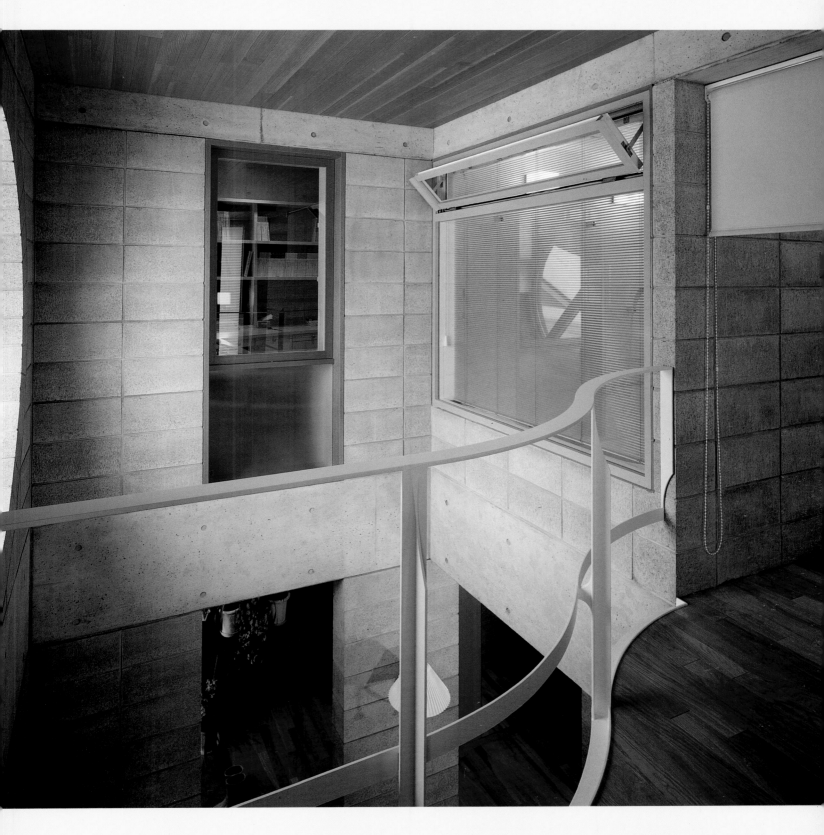

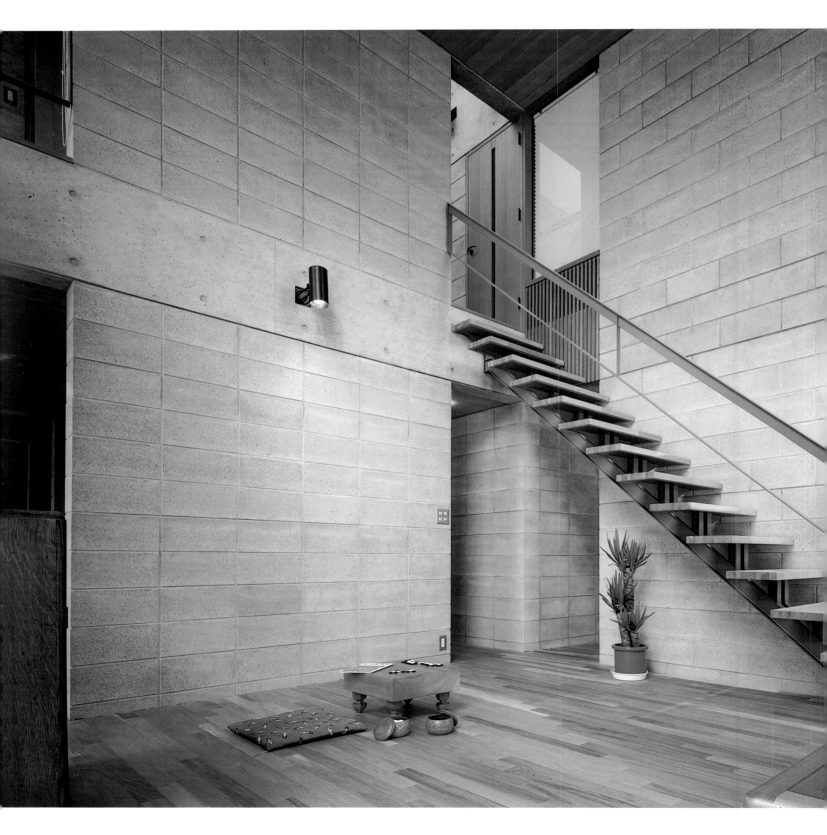

Left: In a part of Japan accustomed to small rooms of which many remain cold, these open spaces are a luxury. Two single-thickness slabs of wall dominate the living room, cut through by the open staircase rising on a single girder.

Above: A central walkway at the top of the stairs gives access to the bathroom and an interior balcony. Three strategically placed blinds can be lowered to isolate the bedroom-to-bathroom access from the rest of the open-plan space.

Right: Detail of the textured surface of the cinder-blocks.

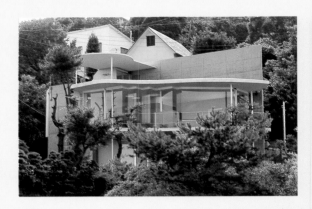

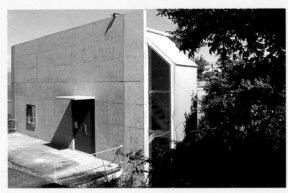

Open and Closed
Contrasting façades from concrete and glass

Of all the late 20th-century building materials, reinforced concrete and glass have been the most ubiquitous, but the proportions in which they are used have begun to change. As one commentator on the Japanese architectural scene, Terunobu Fujimori, has remarked, "during the past 10 years or so, the major trend in architectural expression among the... materials... has been the shift from concrete to glass." This is what he calls the 'white school' of architecture.

For a hillside home on the Izu Peninsula, overlooking the sea of Ajiro, Ken Yokogawa has followed this trend, but in a different way, by allowing the concrete and the glass to dominate opposite sides of the building and give it two contrasting personalities. The approach to the house, down a steep, winding hillside road, reveals what looks like a free-standing white concrete wall. Hidden behind this, however, projects an airy and transparent dwelling, its two floors completely fronted in glass, with a spectacular view.

Many of the houses around here are vacation villas, but this building is the owner's primary residence. For this reason Yokogawa searched for a framework (earthquake-proof, of course) that would be more interesting than just a simple set of pillars. The solution was a single large wall that could take heavy loads, and floors extending out from this over the steep drop, made of deckplates welded to angular pipes. Yokogawa says: "Facing the sea and totally covered with glass is a vast plane with great freedom", and the impact of this is all the greater after entering through the blank, unrevealing wall.

Above: The house has two completely different characters that derive from the contrast in materials. The uphill, entrance side (above) is an almost blank white wall that gives no indication of what lies behind, while the view from below (top) is of a large expanse of redented glass.

Right: The dining room, with the living room beyond, looks out over steep hillside and sea in this resort area a couple of hours' drive from Tokyo. The kitchen is behind the wooden unit at left, which also houses the air conditioning.

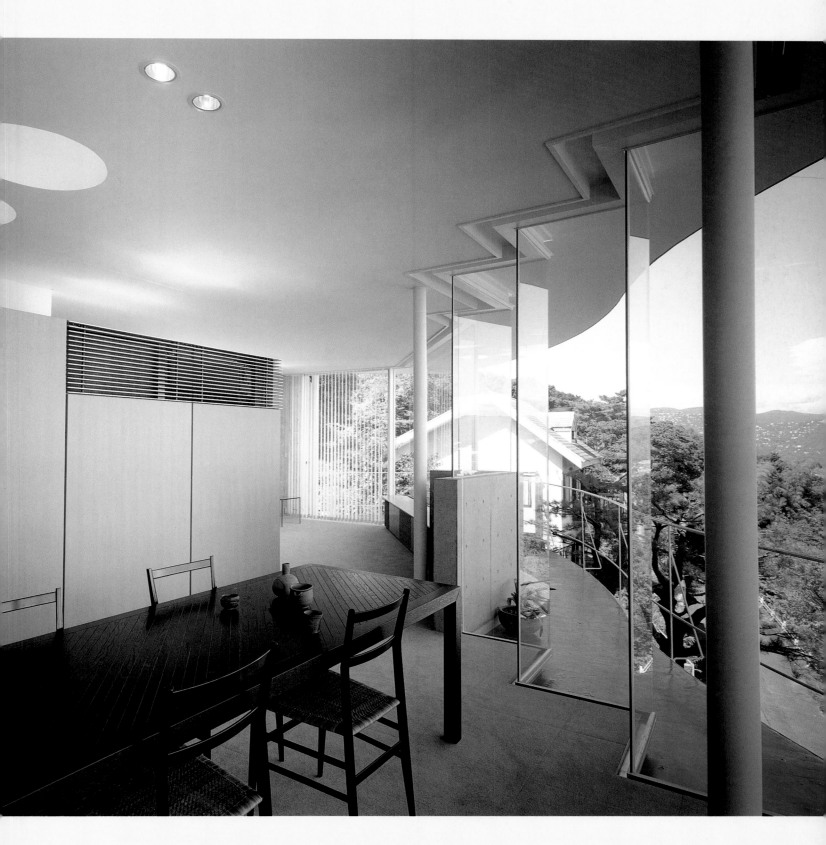

Left: The switchback roads that climb the precipitous hillside on which the house is built are shored up by traditional stone retaining walls. One of these is exposed in the downstairs study for textural interest — and to waste no space.

Right and right middle: The great white concrete wall carries just two features on its otherwise blank surface: a carefully positioned small square window that looks straight through the house to the sea, like a painting hung on the wall, and the stained wood door.

Right below: The view over the headlands and sea, of which the small frame above is just a hint, is a sweeping panorama from the living room.

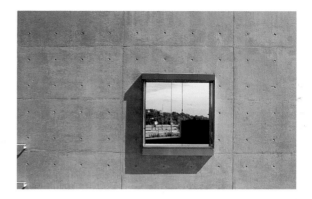

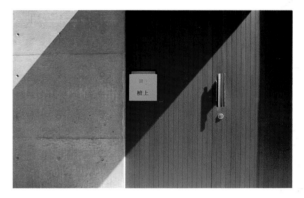

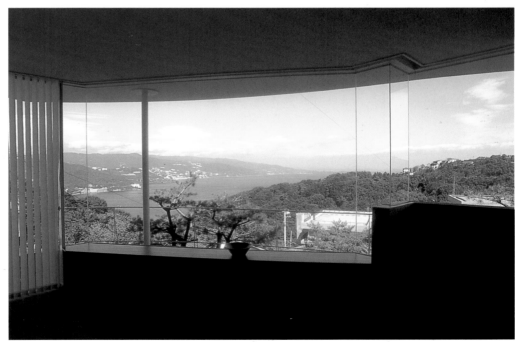

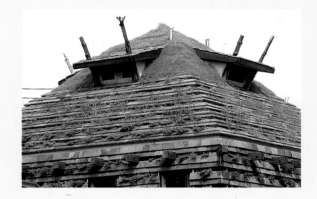

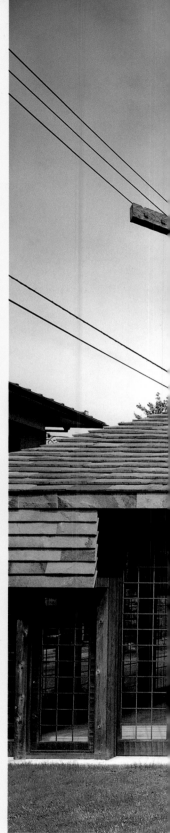

Left: The pyramid roof has narrow diminishing tiers, each containing a stainless steel trough for the soil.

Right: The south façade of the house, with the glass-enclosed verandah running its full length. The formal symmetry is in deliberate contrast to the grasses and dandelions growing on the upper walls and roof.

A Living Home
Structural greening in the Dandelion House

The idea of greening urban buildings came to architectural historian Terunobu Fujimori through his occupation as a "professional watcher" of architecture. He has a special love of buildings that grow out of and into nature, and is also professionally aware of the cold abstraction that concrete and glass introduces to cityscapes.

He experimented first with a house for himself. Concluding that simply adding roof gardens would not work, he says: "The right path to follow would be to actually 'green' the surfaces of walls." More than this, he wanted to find the right relationship between natural and manmade components, and to "avoid the concept of 'symbiosis', a kind of buzzword in Japan at that time". He settled on a parasitic relationship, saying "what I wanted to do was make plants grow from a building in the way soft downy hair grows out of the skin".

He used grass and dandelions (*tampopo* in Japanese), and named the house after them. The walls and roof are clad in alternating bands of stone, selected from the northern region of Tohoku where he grew up, and sunken steel troughs to carry the earth and its crop of grasses and wild flowers. Timbers project on all sides, a few of them as uncut tree trunks from tiny dormer windows.

Fujimori does his own roof and wall gardening, and the result is an artfully tended rusticity of great charm, carried through to the interior by roughly dressed planking — even its natural cracks treated affectionately by a filling of white plaster. His own severest critic, he nevertheless feels that the house falls short of its original promise, and that the building and greenery could still be better unified.

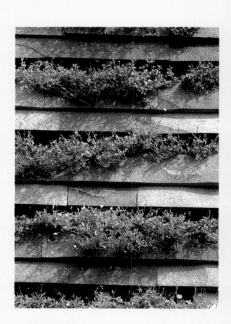

Above: The natural wildness of the plants is contained by troughs. Fujimori says: "If you let greenery thrive freely on roofs... the building and greenery end up becoming detached."

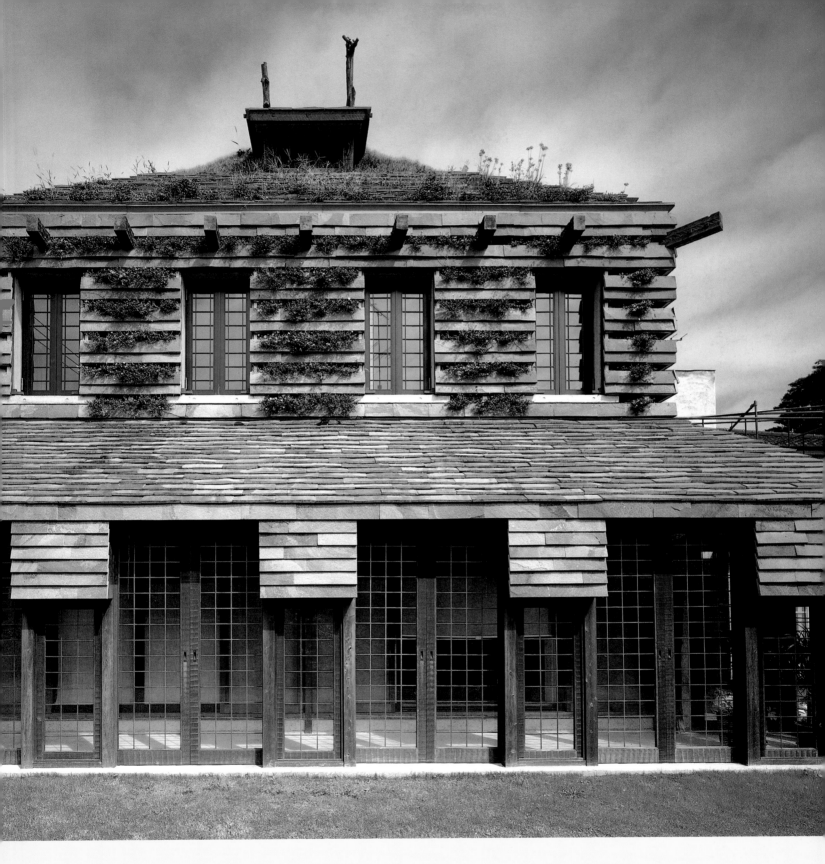

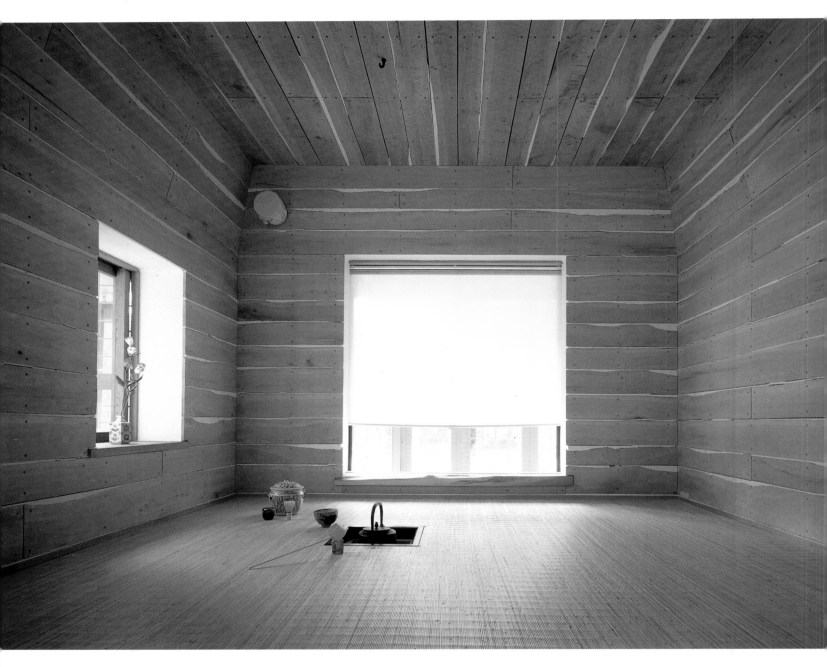

Above: The *washitsu* or
traditional tatami room
occupies a central position
in the house, open to a
corridor behind and facing
out onto the southern
verandah. Rough planking,
its cracks and uneven
jointing highlighted with
white plaster, covers the
walls and ceiling.

Right: The view from the kitchen towards the tatami room, with the dining area at left. A roughly hewn pillar frames the right side of the entrance.

Bottom left: The use of nothing more than natural wood and white plaster gives the principal bedroom an almost puritan simplicity which is exaggerated by the height of the room. Its ceiling follows the underside of the pyramid roof.

Bottom right: Rustic wall finishes include white plaster to fill and draw attention to the gaps in rough planking, and an addition of straw and shavings to the plaster where it is used for continuous covering.

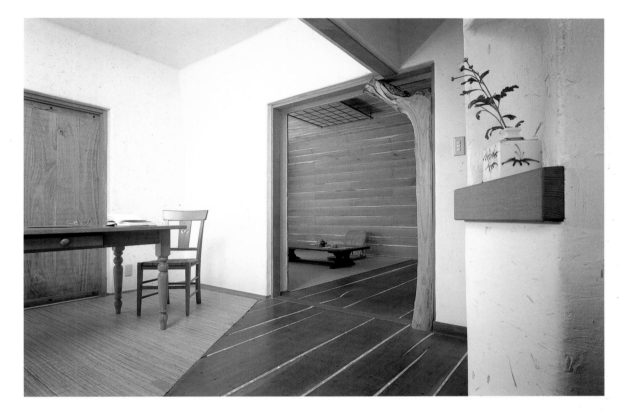

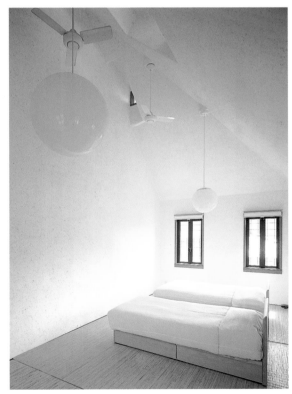

Far right: In the hallway, a massive black slab suspended on metal brackets — in fact, a cabinet for the dining room — makes a striking accent for the pale natural colours of different surfaces. The wall at left is of galvanized corrugated steel, while the floor and steps are of recycled glass.

Right: The distinctive surface texture of this black cabinet was achieved by applying lacquer to compressed OSB board, giving it an unaccustomed elegance.

Materials as Art
The legacy of a modern master

Before branching out on his own, Yasuo Kondo worked in the office of Shiro Kuramata (1934–1991), one of Japan's greatest interior designers. Kuramata's work, which includes such iconic pieces of furniture as the poetic 1989 Miss Blanche chair, took design into the realm of art. It was under his influence that Kondo learned to use materials as a starting point.

In a town house in Yokohama, Kondo was given the opportunity to explore new materials and to incorporate two of Kuramata's own original ideas. Unusually, the owners wanted an uncompromising, pristine living space that they could enjoy specifically for its design qualities, and that would not have a lived-in atmosphere. "I wanted to keep my house like a showroom," said Mrs Kawahara.

Designing from the materials outwards, Kondo went to great lengths to achieve originality. The floor covering, pale green with a slight translucency evident in the staircase, is a recycled glass product used for high-voltage insulators, and is used in it its natural colour. Elsewhere, OSB compressed board is given a refinement not normally associated with this cheap industrial material: in the *washitsu* downstairs where it is treated with clear varnish, and in the dining-room cabinets that hang out over the entrance hall, designed as monolithic black boxes by coating the board with black lacquer. The centrepieces of the house are Kondo's rendering of two of Kuramata's unique material treatments — the cracked glass dining table and the terrazzo counter. For Kuramata, glass was a substance with inherent contradictions and complexities, which he explored in depth.

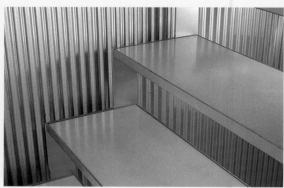

Above: The steps, and all the flooring in the house, are made of Athena-R, a recycled glass product used for insulators, left in its natural semi-opaque pale green.

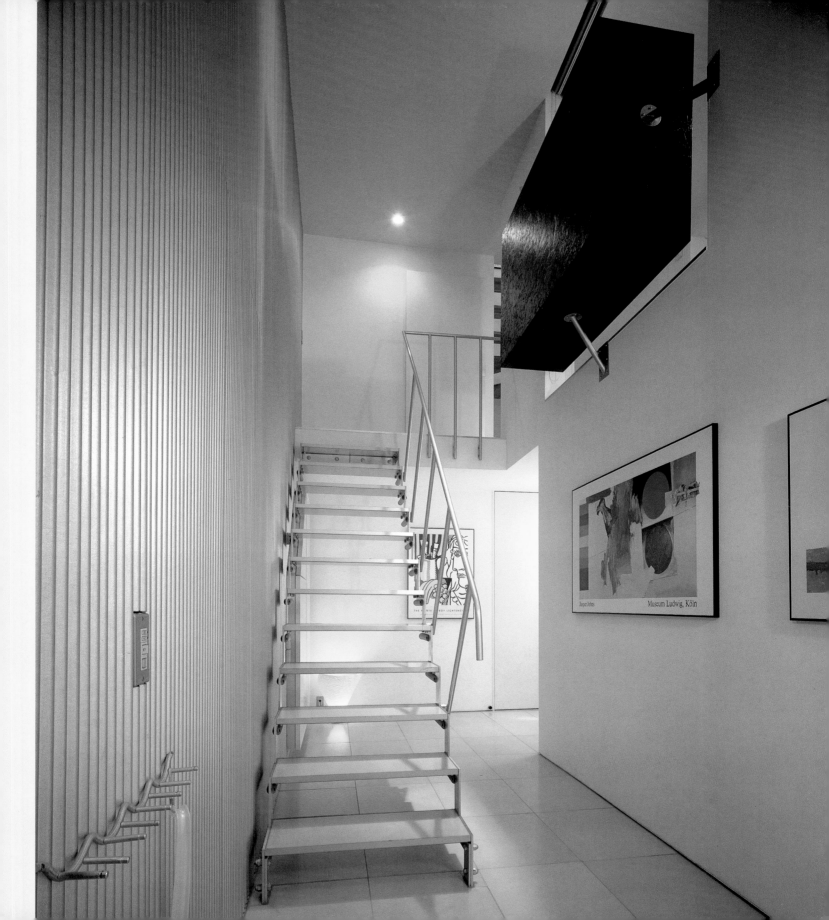

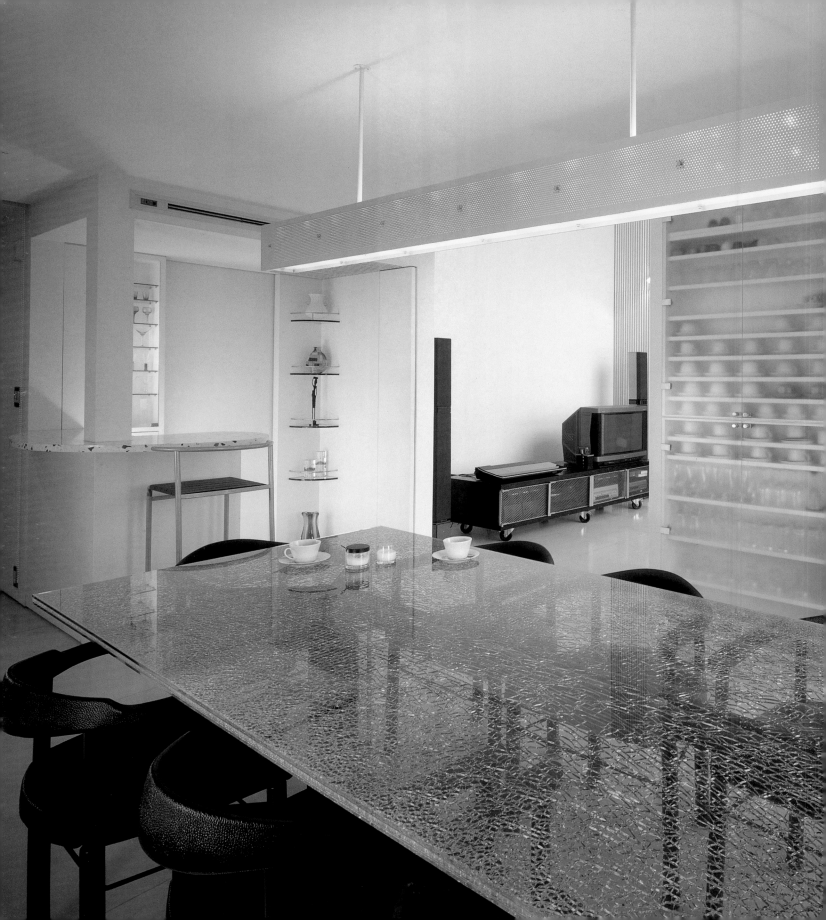

Left: The large glass dining table, made in situ and practically immovable, uses a technique invented by Shiro Kuramata called *ware-garasu* (glass cracking). A sheet of strengthened glass was sandwiched between two other sheets, and then simultaneously cracked at three points along its edges with a hammer. The edges were then sealed with silicon.

Below: Polycarbonate doors for the crockery cupboard give a soft translucency.

Bottom: Close-up of the cracked pattern in the centre sheet of the dining table. The intersecting crazed patterns are impossible to predict, and the technique requires great skill to ensure that they cover the sheet evenly.

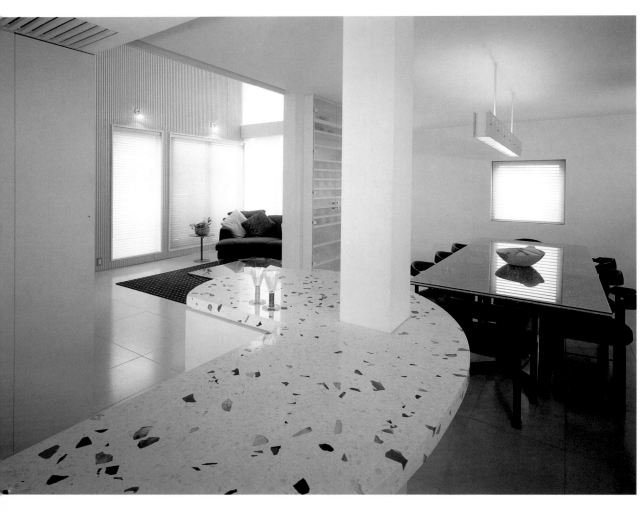

Left and below centre:
Adapting terrazzo technique, Kuramata designed this material as a mixture of coloured glass shards and white cement, polished to a smooth flat surface. The actual counter design is by Kondo.

Below left: In the second-floor washroom, the basin and surface are in clear and blue glass.

Right and below right: To Japanese sensibilities, the use of compressed board on the walls and ceiling of the ground floor tatami room, varnished and set off by a heavy sliding black door, is quite strange, making it look almost Western.

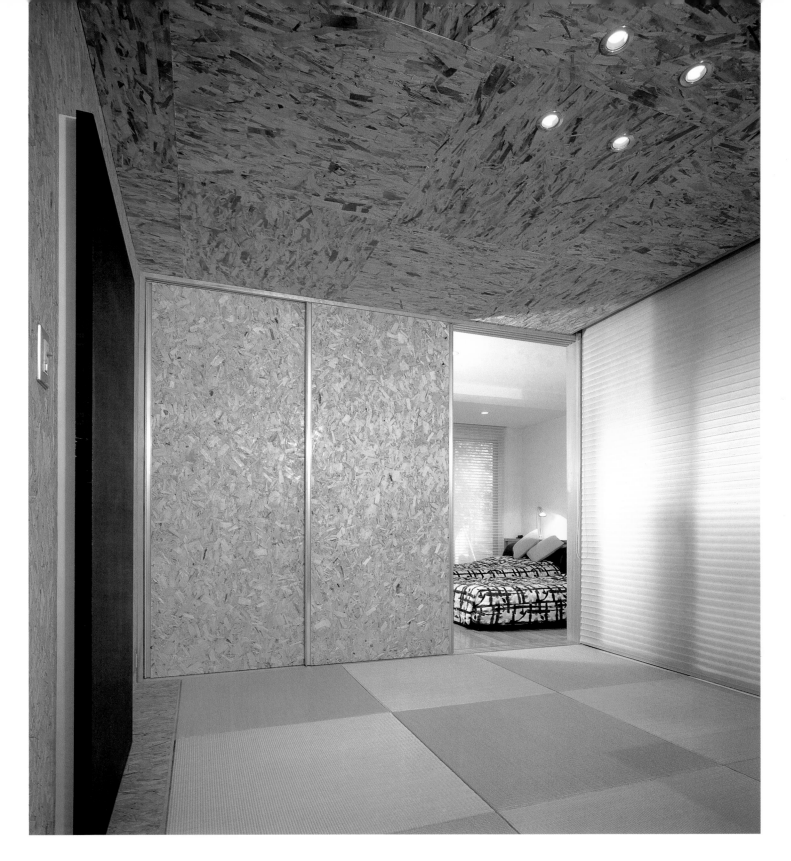

Personal Statements

The Japanese avant-garde is pushing the envelope further than ever before, helped by two new factors. One is the increasing originality of individual architects and interior designers, exploring their own different avenues, rather than following the influence of one school. The second factor is that more and more clients are rejecting conformity. They want an immediate environment specially tailored for their own needs and interests.

Water and Glass
Reflection and translucency in a seaside villa

One of the chief exponents of the glass and metal style that has become one of the signatures of modern Japanese building is Kengo Kuma. On this headland site overlooking Atami, the popular hot-spring resort on the Izu peninsula southwest of Tokyo, he had the opportunity to create a spectacular villa in which water is a key component.

Here relatively free from financial constraints, Kuma has made a visual play on translucency and reflection so as to project the principal part of the villa into the surroundings of sea and coastline. The front of the upper floor of the three-level structure is a canti-levered slab of steel and granite over which water flows to a depth of 15 cm, giving the effect of an infinity pool that appears to merge with the Pacific Ocean below. The two glass-walled bedrooms look out onto this, while from between them projects the striking oval dining room, surrounded by water and accessed by a glass corridor.

Exploiting the 270-degree view to the full, Kuma has created the illusion of floating over the sea. "On the reflecting pool I put three glass structures — two square structures and one oval. There is no edge to the water. Just the water itself." The steel louvred roof extends over all this, helping to control the temperature while retaining the lightness of the structure and adding a distinctive chiaroscuro pattern that shifts across the pillars and surfaces throughout the day.

Top: The oval dining room sits surrounded by water. It is connected to the rest of the structure by a glass corridor, its translucent flooring lit from below to add to the sense of floating.

Above: At the base of the stairwell, sculpted glass boulders in an enclosed pool sparkle in the sunlight.

Right: Sunrise over the Pacific illuminates the transparent dining room with its green translucent glass floor. Beyond the curving glass wall, the surrounding water appears to merge with the sea.

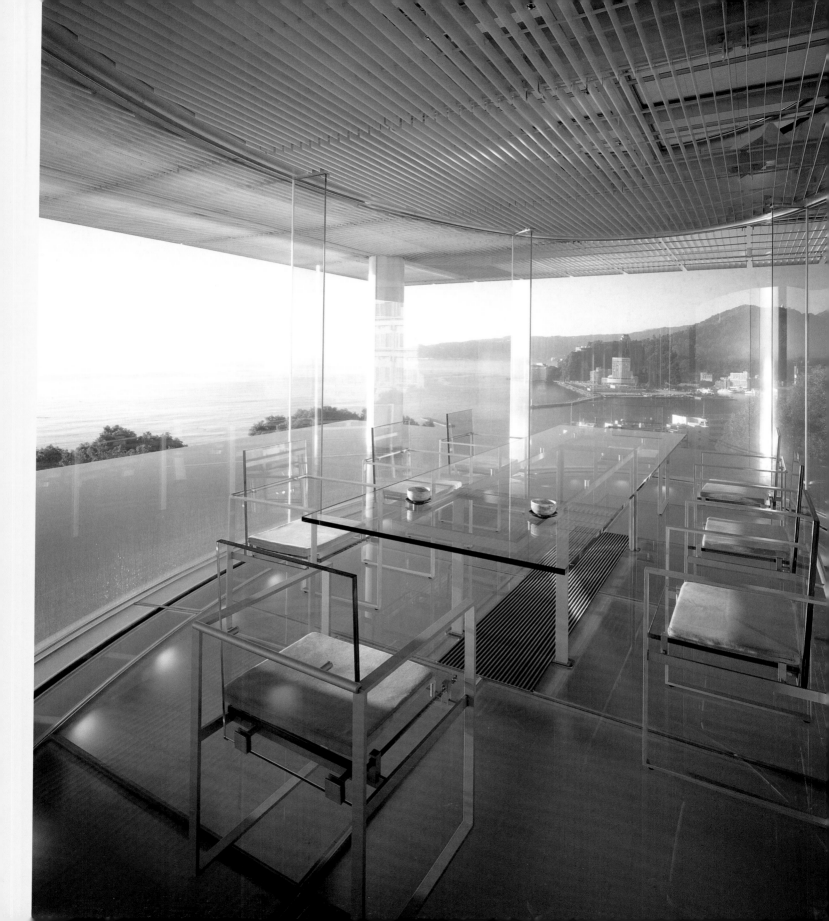

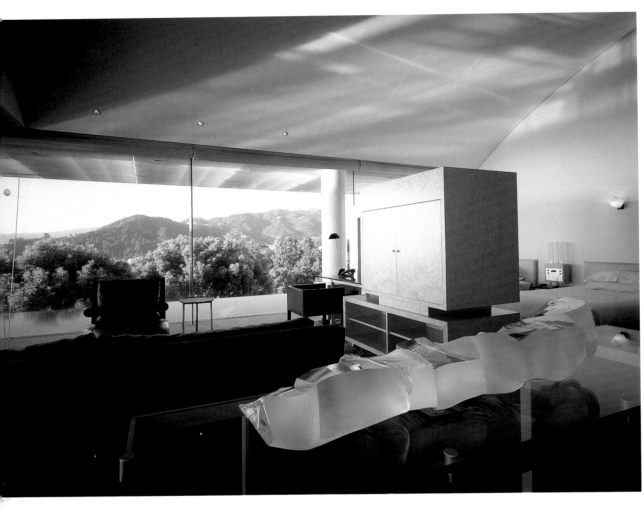

Left: A glass sculpture, its surfaces scalloped to suggest the action of water, occupies a glass table in the south-facing side bedroom.

Below left: The front bedroom at sunrise. It has its own sitting area partitioned from the sleeping area by a simple, free-standing cupboard made from natural wood and a glass and steel dressing table.

Below right: The staircase in steel and green glass, occupying a large three-storey well, is lit both from above and below. A glass footbridge at right leads to the mid-level entrance.

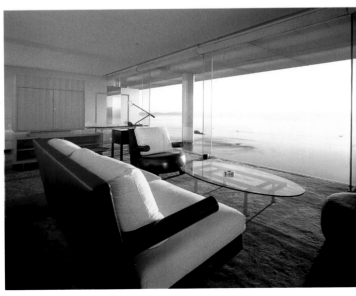

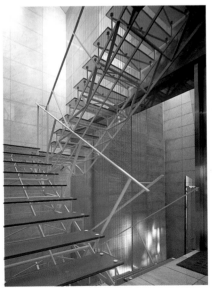

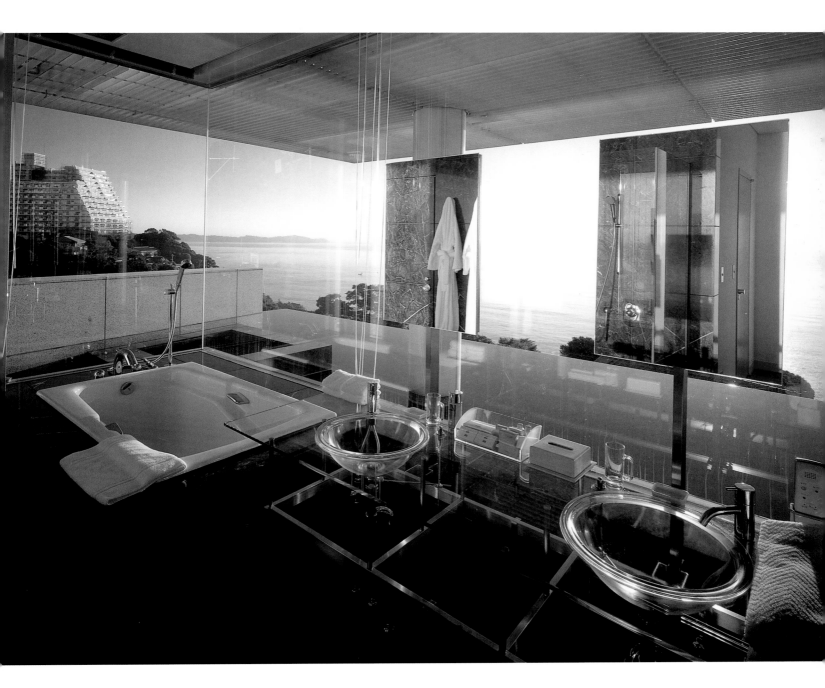

Above: Morning light pours
into the principal bathroom,
and is both reflected and
refracted around the glass
and mirrored surfaces.

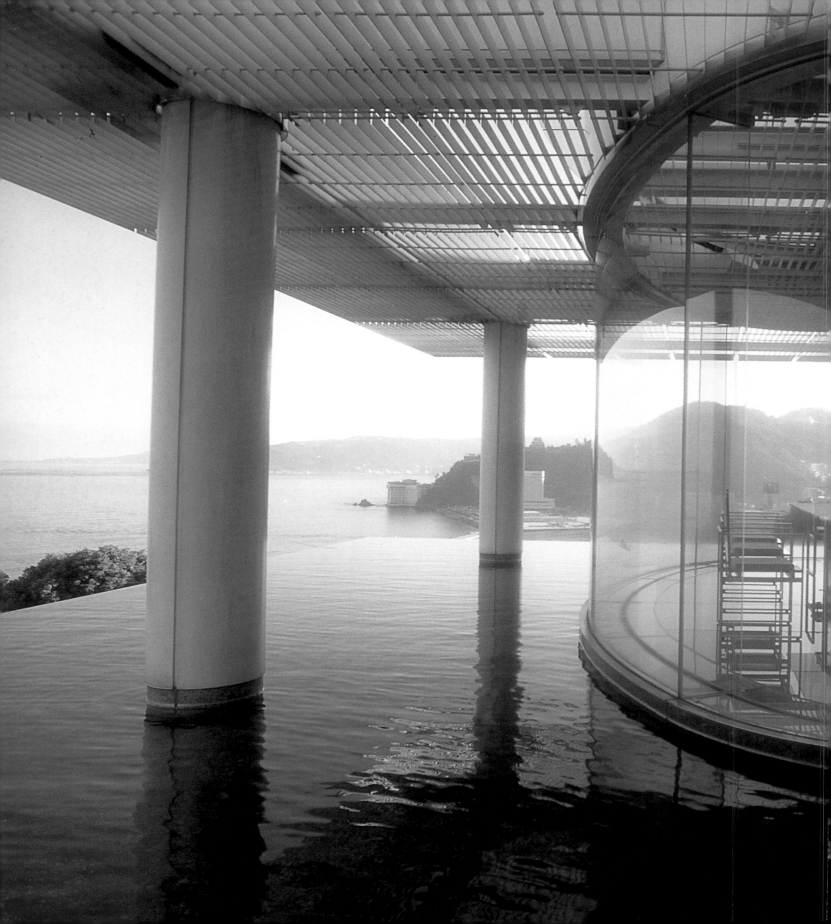

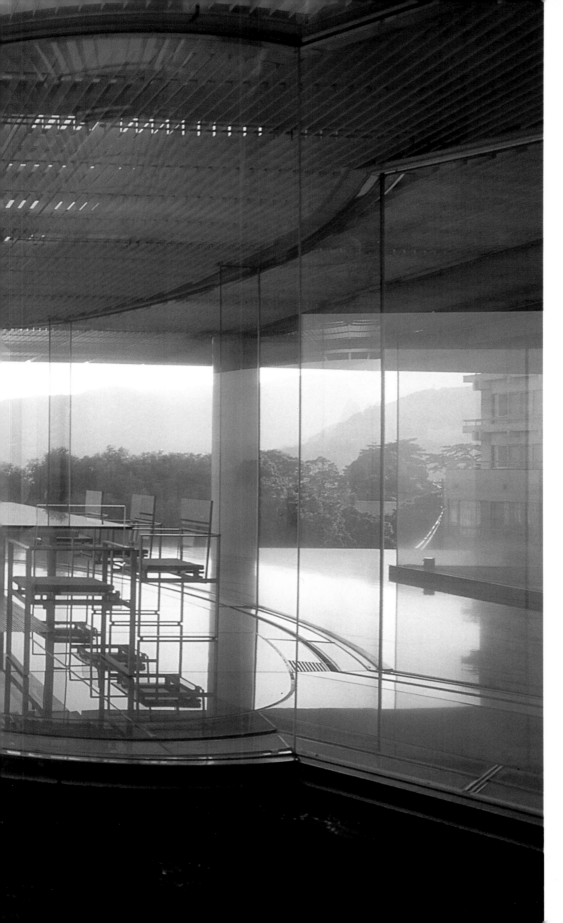

Water flows over the projecting granite slab simulating the movement of an infinity pool; it is shaded by a lightweight roof of metal louvres.

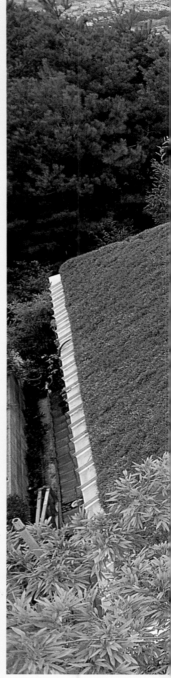

Grass Canopy
Reversing roof and garden, bungalow-style

Above: Thinking that one garden — even if it was on the roof — was sufficient, the architect chose regular Japanese roof tiles as the paving for the ground outside. Tile fragments were used as chips for the planted bamboos.

Right: Despite its unusual location, the lawn is kept in perfect condition by an oscillating spray on the roof ridge. Sectioned stainless steel troughs hold water and soil.

Reviving one of the most ancient traditions in Japanese housing, architect Naoyuki Shirakawa has brought a surprising splash of green to one of the city's satellite towns. Neatly and thickly planted with *tamaryu* grass, the hipped roof of this bungalow-like house recalls the old thatched roofs, or *shibamune*, that long ago dotted the countryside.

For Shirakawa this was a deliberate exercise in both nostalgia and close-to-the-earth solidity, as the commission came from a family that had lost its home in the great Hanshin earthquake of 1995. Shaken by the experience, they wanted their new home to be safe and sturdy. As a result, the architect turned to the idea of a single-storey, single-space dwelling in reinforced concrete. Inside the old *shibamune*-roofed houses, the entire family lived together, and here, too, the owners and their two young daughters lead a close-knit life. Simple partitions divide the living space, but only to half the height of the ceiling and they do not have doors. When the girls are older, their bedrooms will be altered to give them privacy.

The earthquake taught the Torayas to re-think their existing life-style, and they are delighted with their new green home: It reaffirms old traditions by providing a perfect setting for a very nuclear family. They also enjoy the way in which the living roof brings them a little closer to nature ("good for the girls' upbringing," says Mrs Toraya) and the modest fame from a house that has become an architectural landmark of the area.

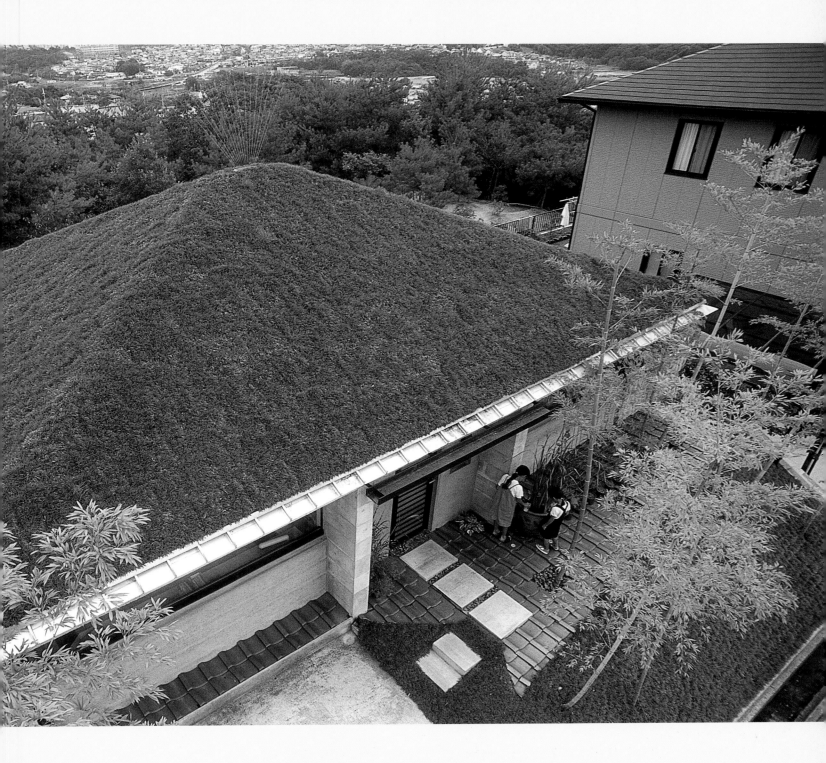

Left: Diagonal wooden partitions, painted black, divide the space without enclosing any one room; the inner surface of the hipped roof is visible to all.

Right: The dining and kitchen area of the single-space home. In one rear corner, there is a view out onto the back terrace which is surfaced in contradictory fashion with roof tiles.

Below: Three square-sectioned wooden pillars face the entrance, with a framework carrying pot plants on either side.

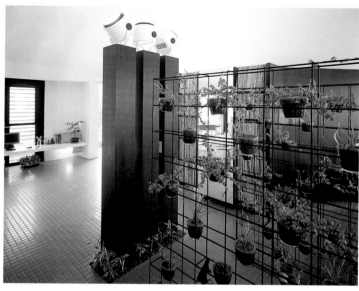

Left: A tiny window in the *chashitsu* looks out onto a small roof terrace equipped with a metal-grille lamp and a basin for tea preparation. The right-hand panel of the frosted plate glass rotates 90 degrees to form a table.

Right: Enclosed in a tiny cylindrical tower with a sloping roof, the *chashitsu* or tea-ceremony room is a remarkable modern expression of Japanese tradition. Exquisitely detailed (even the rounded tatami mats had to be specially made), it uses a powerful geometry and primary colours to achieve an isolated, contemplative space.

Structural Surprises
A two-generation house in Sakuragaoka

A continuing feature of Japanese life is that children often live with parents into early adulthood, so one of the cultural situations that modern houses have to accommodate is the diverging needs of the generations. In the case of this family, the son had already lived in one of Kunihiko Hayakawa's apartment complexes, striking in appearance and famous for their use as television locations, and had found it "very practical, comfortable, not just an original, unconventional design". When the family decided to rebuild on their land in Sakuragaoka, west of Tokyo, they asked Hayakawa to surprise them, but also to meet their needs of privacy, both from the street and internally.

Hayakawa's solution was two houses, one each for the parents and son, linked by a bridge but also intersecting with each other and the garden area. Working mainly in concrete and glass, he allocated a high 30 percent of the exterior surfaces to transparent and semi-transparent glass, in order to "create a sense of continuity between interior and exterior spaces and open the house to the surroundings".

Surprises include what Hayakawa calls "apparatuses", such as a two-storey cylinder in the son's house that encloses the second-floor kitchen and a third-floor *chashitsu* tea-room strikingly interpreted in a modern, mechanical idiom. Access is by means of a counter-balanced steel ladder that can be raised and lowered by a pulley, while on the roof terrace outside are 10 mm-thick aluminium panels and a screen that rotates to convert into a table.

Above: A counter-weight and pulley allow the ladder that leads to the *chashitsu* to be lowered and raised easily.

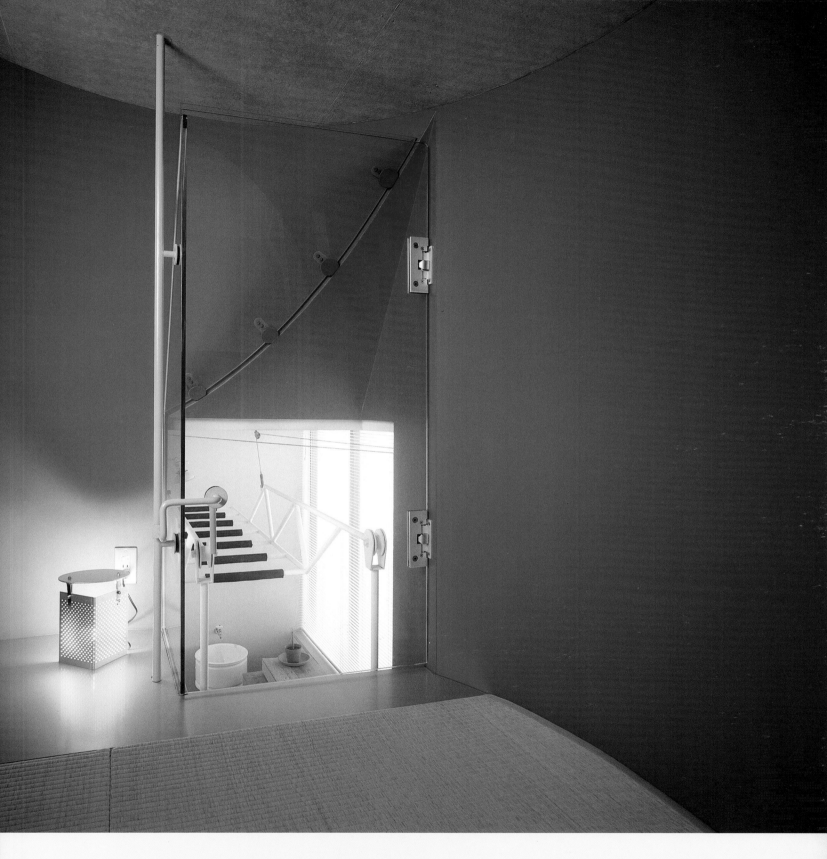

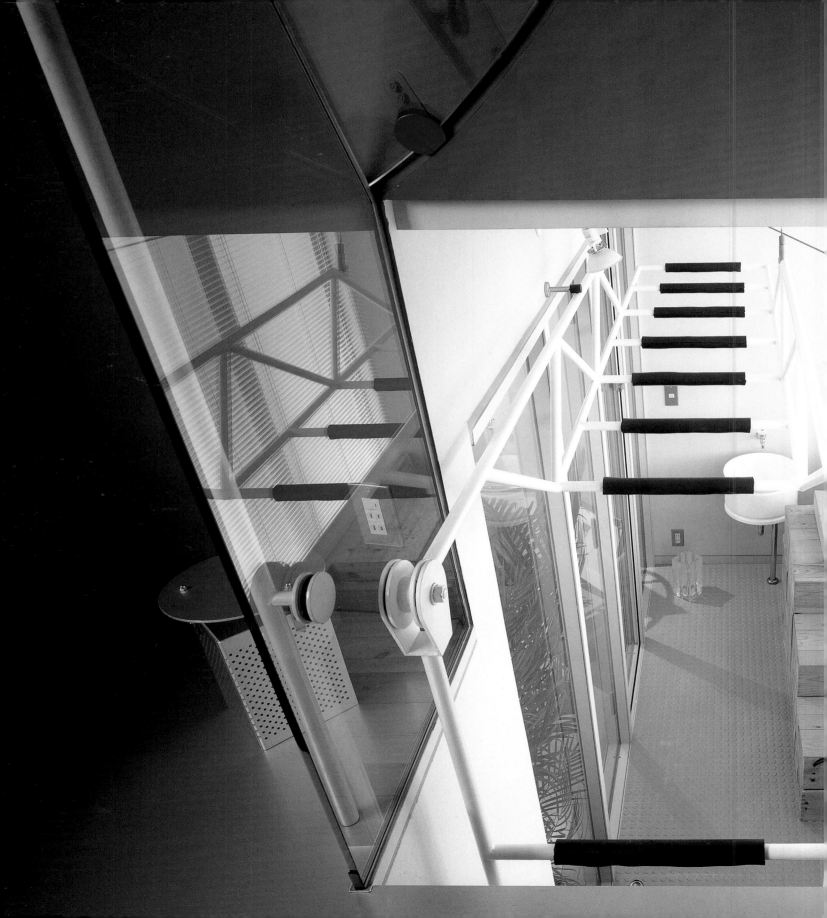

The entranceway to the
chashitsu is, as in tradition,
intentionally tiny (the name
is *nijiri-guchi* which means
'wriggling-in entrance').
Access is by means of a
pivoted step-ladder that
can be raised after entry
like a drawbridge.

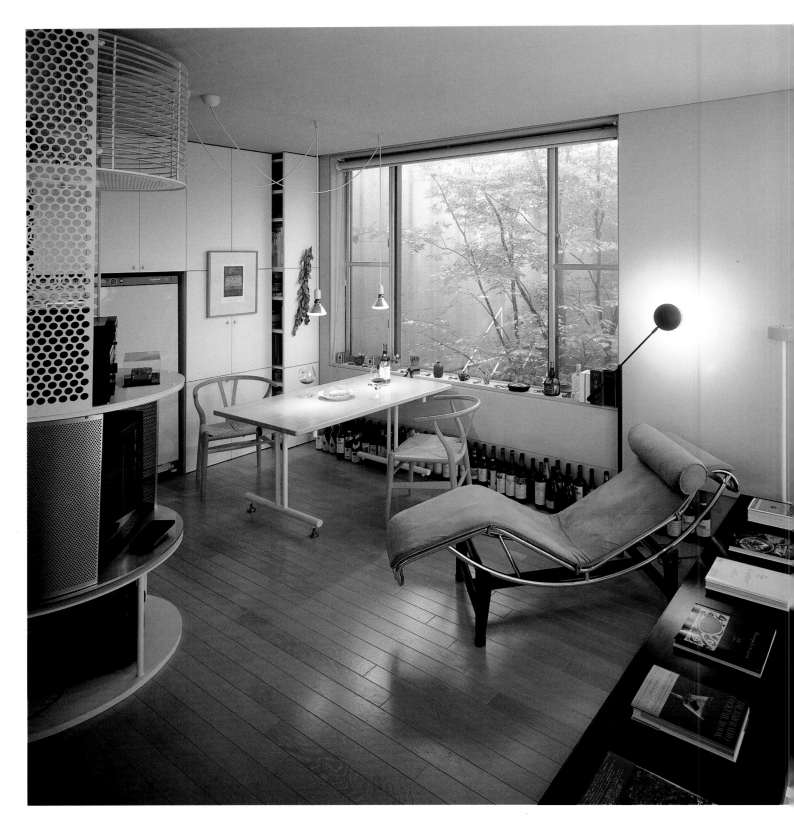

Left: The son's living and dining area occupies the outer wing, overlooking the courtyard and connected to the remainder of the house by the corridor crossing the bridge at right. A cylindrical console at left holds hi-fi and television, encloses the kitchen, and extends to the *chashitsu* on the floor above.

Right: The glass-walled bridge that connects the two wings helps to create a sense of continuity between exterior and interior spaces and opens the house to its surroundings.

Below: The ground floor of the parents' wing opens onto the garden via a tiled verandah. The sliding *shoji* screens that partition the living room from the kitchen and dining area and from the verandah are in poly-carbonate rather than the traditional paper.

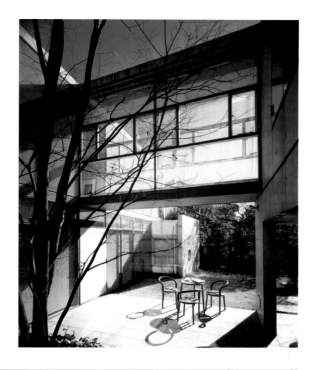

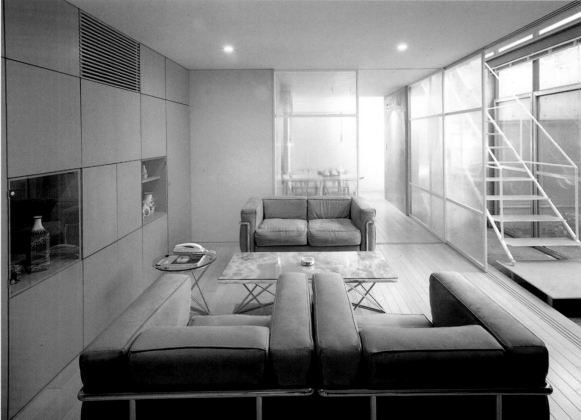

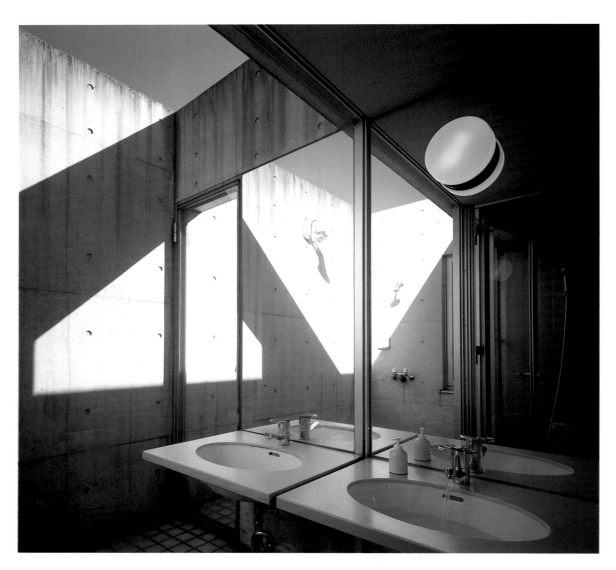

Left: As part of the architect's aim to connect the indoor and outdoor spaces, the upstairs bathroom includes an outdoor shower. A second, identical outdoor washbasin and arrangment of mirrored and glass walls at right angles to each other creates a deliberate optical illusion.

Below: The free-standing concrete wall of the ground-floor bathroom is pierced by a large porthole to give a view over the garden, and extends a few feet to shield a second window looking out to the courtyard.

Right: A cylindrical blue-painted lightwell over the ground-floor bathroom recalls the idiosyncratic *chashitsu* in its small blue tower.

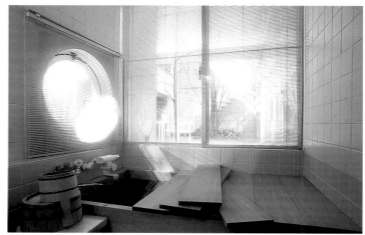

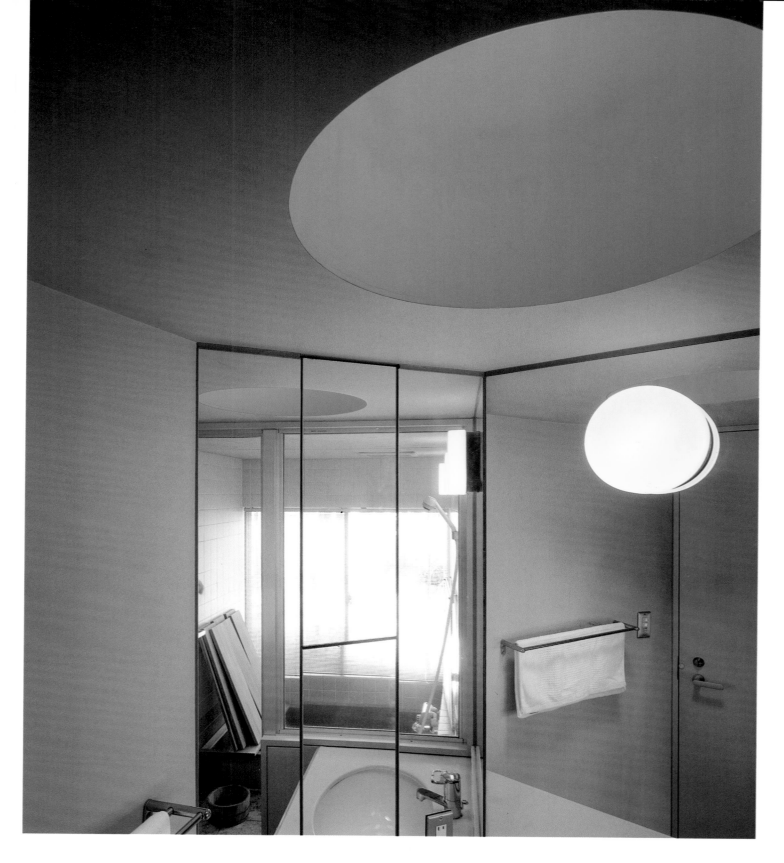

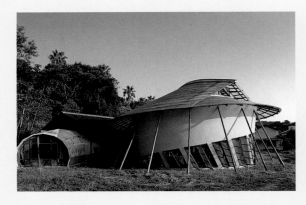

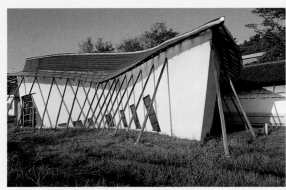

Alternative Style
A hand-built retreat to entertain guests

Akira Kusumi, a skilled plasterer in international demand, wanted a house for guests that would be in keeping with his philosophy — to be handmade from top to bottom, with the minimum of proprietary fittings. In a country where pre-fabrication of parts virtually underpins the economy, Kusumi is an individualist. He engaged a team of young architectural students from Tokyo's Waseda University, and brought them to live and work at the site on Awaji Island, in the Inland Sea near Kobe. Together, they created a pair of buildings that embody natural crafts and are packed with alternative design.

The first decision was to divide the buildings' functions into two: an entertainment space unrestricted by normal household needs, and a living space containing a dormitory bedroom, kitchen and bathroom. By separating relaxation and entertainment from the mundane, each could take the form best suited to it. Thus, the two buildings developed in very different, though complementary, ways.

The structure of the party building, comma-shaped in plan and with outward-leaning walls, was a response to the materials available. Kusumi had at his disposal a large quantity of wooden posts, not thick enough to be used as individual pillars. The solution was to use them in threes to make tripod braces, with one leg outside, hence the leaning walls. Takuto Hiki, in charge of the adjoining building, had to respond to the client's request for somewhere not too bright as he is a light sleeper: he chose a tunnel shape, curving gently around the first building, with access at either end and in the middle.

Above: The entertainment building and its more restrained companion the tube-like living area present continualy changing shapes to anyone walking around. The external poles are each part of the wall's structural support of tripods.

Right: The spacious entertainment area is housed in a comma-shaped building, roofed entirely in semi-transparent plastic sheeting to create an open, bright atmosphere. The sense of an outdoor space indoors is enhanced by the sand floor and the use of natural materials. The pillars supporting the curved wooden walkway are concrete, clad with a hollow tapering shell of wooden slats secured by rope wound around them in a spiral and stapled.

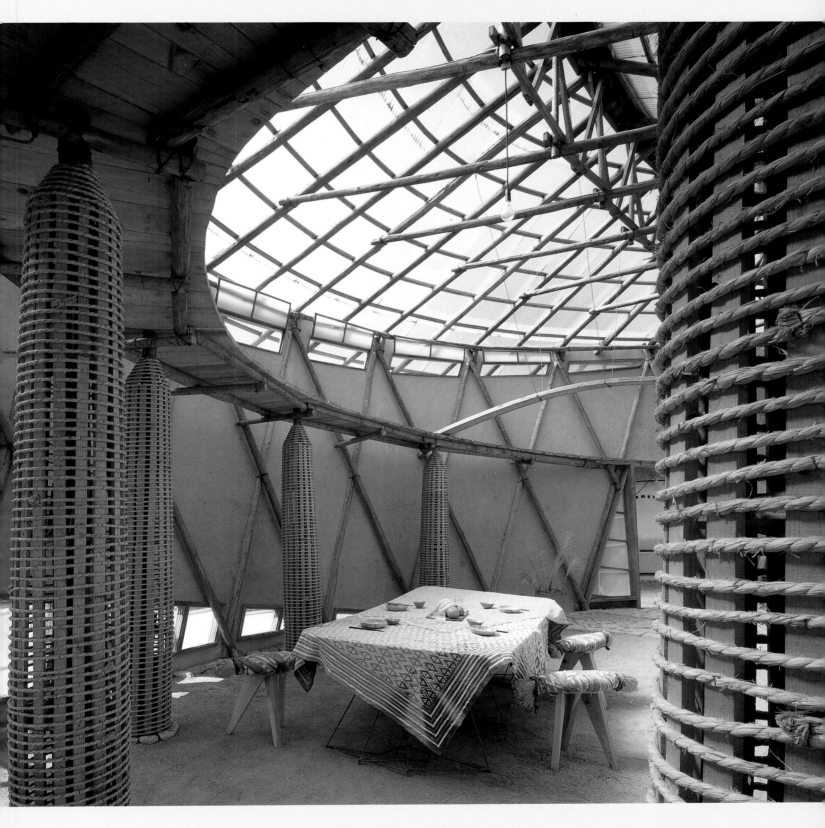

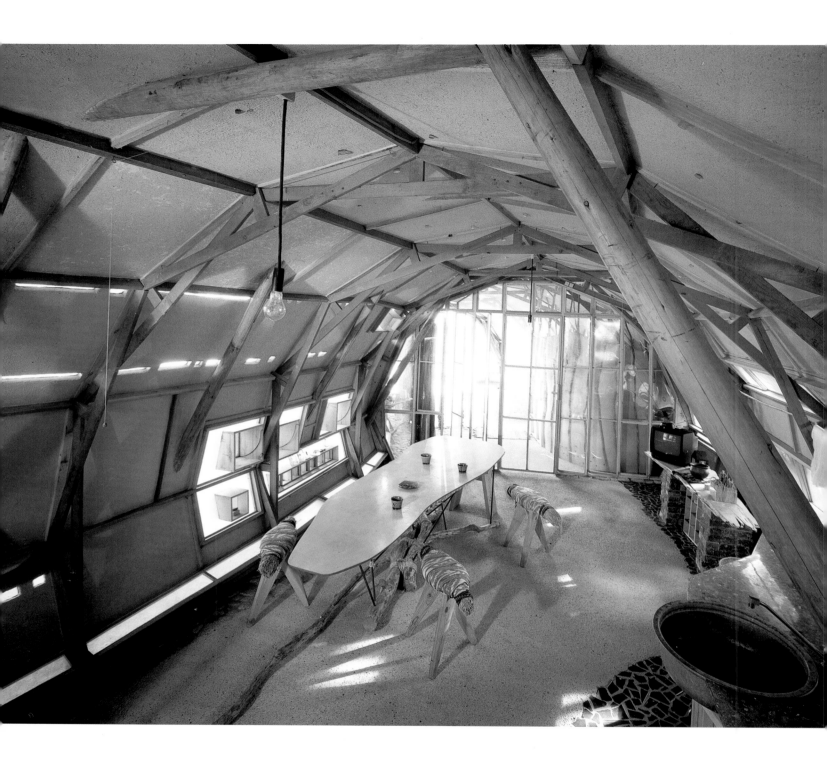

Left: The functional rooms of the guest house are contained in a tube-like structure that curves around the entertainment building. In the diningroom/kitchen as throughout, the wooden frame is left exposed — a series of simple wooden arches made of overlapping braces connected by beams running the length of the building. The bathroom lies beyond, at one end.

Right: At the opposite end of the 'tube' is the dormitory-like bedroom, the individual beds partitioned by sail-like fabric screens. Even the mattresses are handmade, stuffed with locally collected miscanthus and straw. With full-sized windows only at either end, the living module is deliberately much darker than the bright entertainment building.

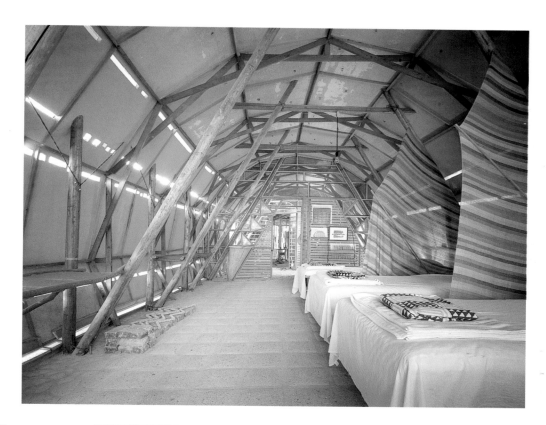

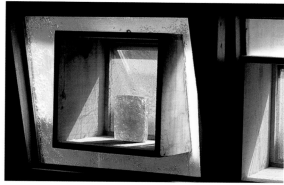

Far left: Simultaneously rustic and naïve, the writing desk consists of a rough-hewn plank supported on rammed-earth adobe bricks. The pencil holder is a mass of thin shavings stacked vertically in a perspex cube.

Left and below: Small low-level windows in the dining room contain built-in backlit display cases for various transparent resin objects.

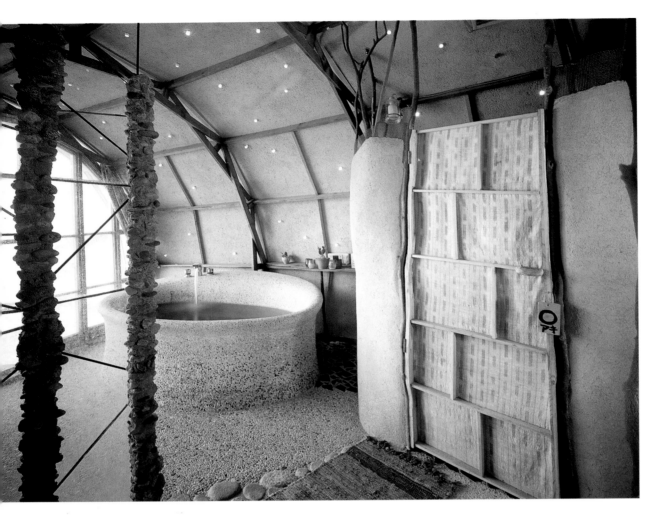

Left: The brightly lit bathroom faces west for relaxation at the end of the day, and combines a variety of found local materials to give it something like the air of a beachcomber's dwelling. The half-height plaster walls of the toilet at right have a framework of branches and twigs that protrude above.

Right: The organically-curved bath and its floor surround are fashioned from concrete made with local sand from the adjacent beach. Short plugs of round-sectioned perspex set into the plaster wall siphon light into the room.

Below far left: The terrazzo base of the bath, using blue ceramic chips.

Below centre: One of the short sections of perspex rod set into the curved wall. Its high refractive index allows it to function as a light pipe.

Below: An upturned glass storage jar is put to use as a lighting fixture.

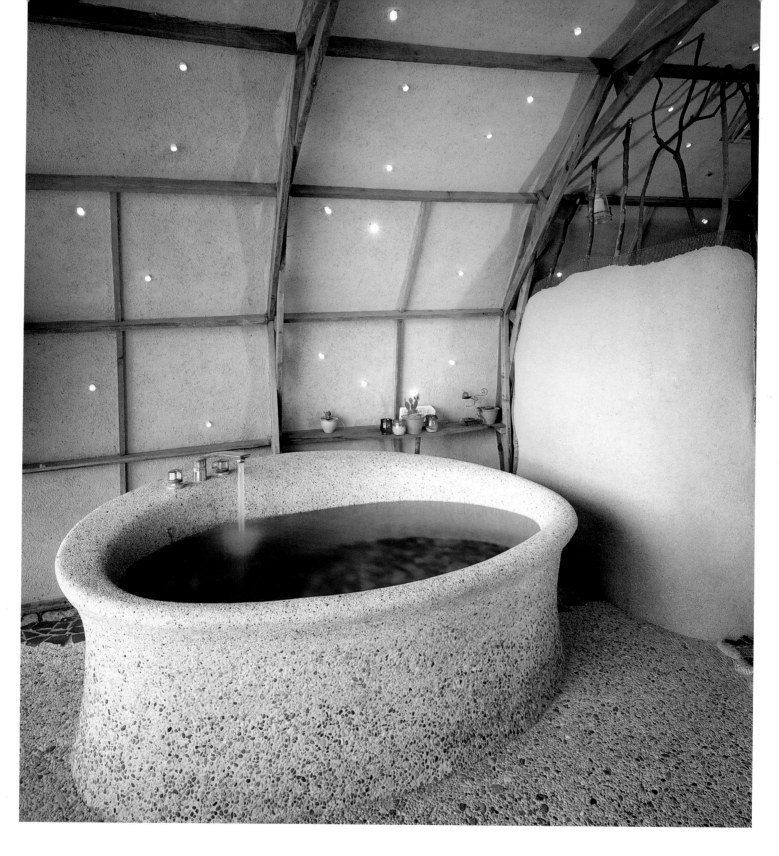

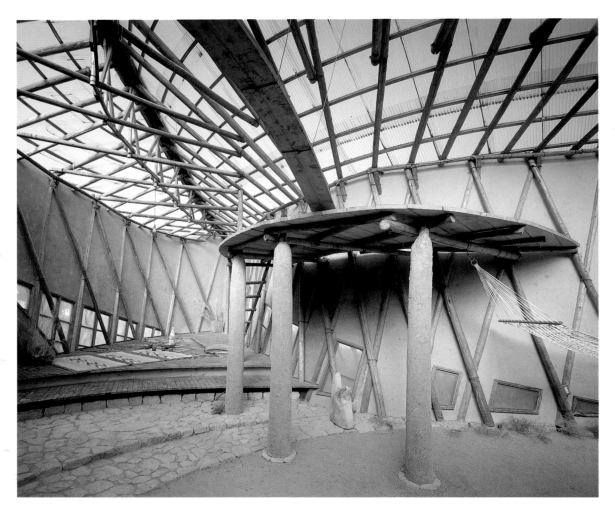

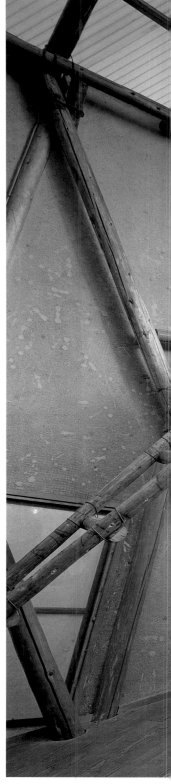

Above and far right: The complex bracing of the sloping curved walls and the roof give the entertainment building a striking visual dynamic. The outward-leaning walls are braced with a series of *sanmata* — tripods of wooden poles. Pairs of these are tied at the top and overlap each other, with the third member on the outside. The platform leading to a mid-height wooden walkway was conceived as a kind of folly, its only practical use being to open and close the window flaps at the top of the walls.

Right: Dubbed the '*natto* stool' because of its resemblance to wrapped bundles of fermented soy beans, the tripod seat is another invention of the architects.

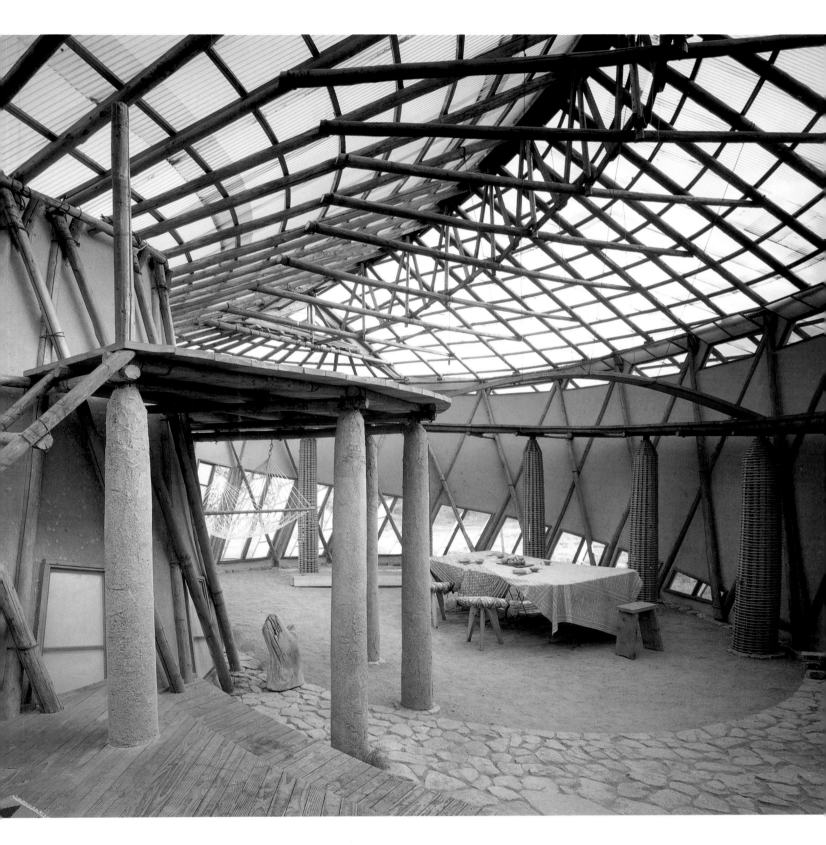

Japanese Post-Modern
Integrated design in strong shapes and soft colours

When Takako and Kazunari Furukawa moved for business reasons to the city of Nagoya, they decided to build a house that would give them Western-style comfort and space, yet still with a Japanese sensibility. They turned to the Tokyo-based interior designer Shigeru Uchida, well known for his elegant and imaginative commercial interiors. Kazunari Furukawa had worked with him years before, and Uchida, who normally declines residential projects, made an exception in taking on this home.

"I was not interested in doing anything extravagant or avant-garde," noted Uchida, "Classical forms create a familiar presence." In structure, this is a one-storey modern courtyard house. Pastel colours demarcate the two wings — the living area in yellow and the guest quarters in green — and a corridor with a circular tower connects them. Uchida's designs permeate everything, to the fitted furniture, chairs and some of the smallest details, such as a desk clock. Simple geometric shapes — triangles, squares and circular sections — dominate, and are carried through from the architectural elements to the detailing. For example, the barrel-vaulted ceiling of the yellow building is reprised in the sofa and chairs. In the main living space, which includes the kitchen and dining area, shiny oak cabinetwork creates a warm, comfortable tone and a background for the muted pastel colours.

Above and right: The front entrance, reached by steps up from the street, is the strongest design element in the structure. A hollow central circular tower has no function other than to pour light down through a cylindrical well. On either side, glazed lattice walls and ceiling in metallic grey line the corridors connecting the two stuccoed buildings.

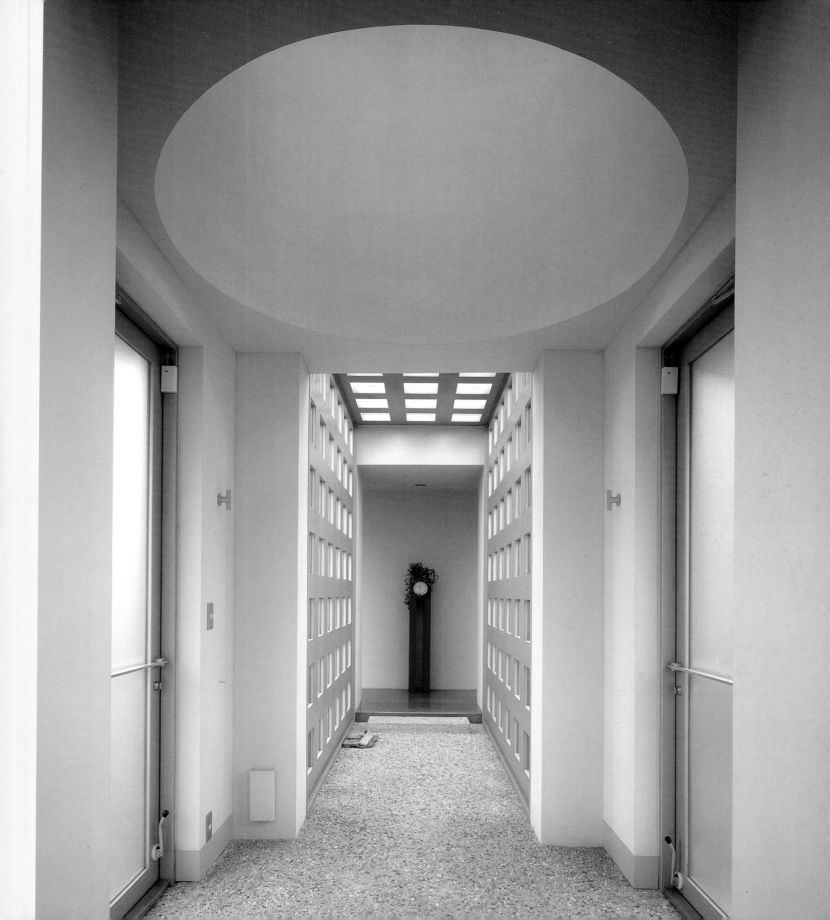

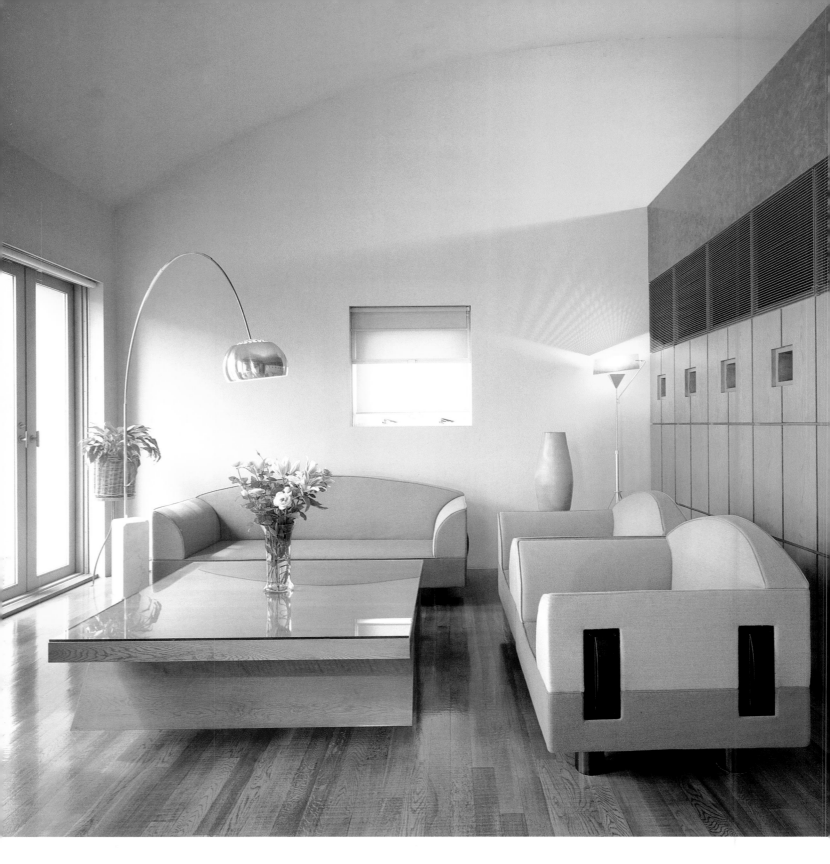

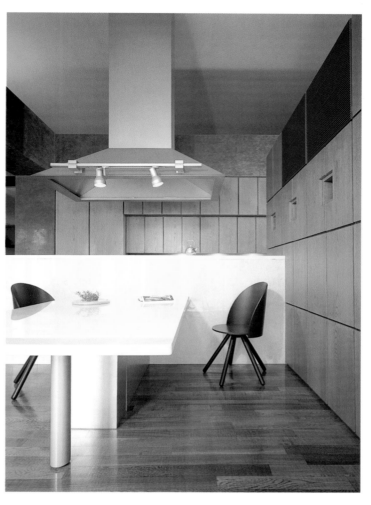

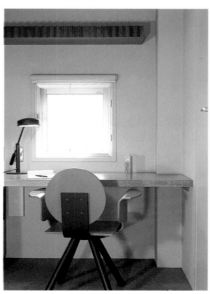

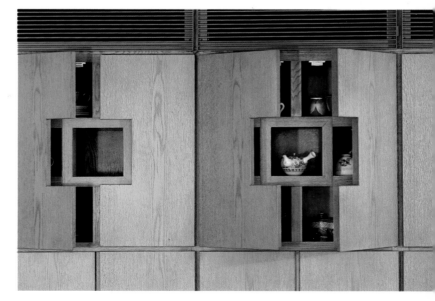

Far left: The principal living area occupies half of the barrel-vaulted main building — a massive wooden wall containing storage space and air-conditioning vents separate this from the bedroom and study. Glass doors at left open onto the courtyard.

Left: An open-plan kitchen and dining area adjoins the sitting area, and has the same oak cabinetry. The extractor above the work space contributes to the assembly of strong shapes.

Below left: Uchida's touch is evident in the study area of the bedroom. The chair is his design (as are those by the dining table) and the sculptural desk clock.

Below right: The owners' collection of ceramics in the storage cupboards built into the central wooden unit.

Overleaf: Triangle, circle and square motifs make a linked geometric theme for the sitting area.

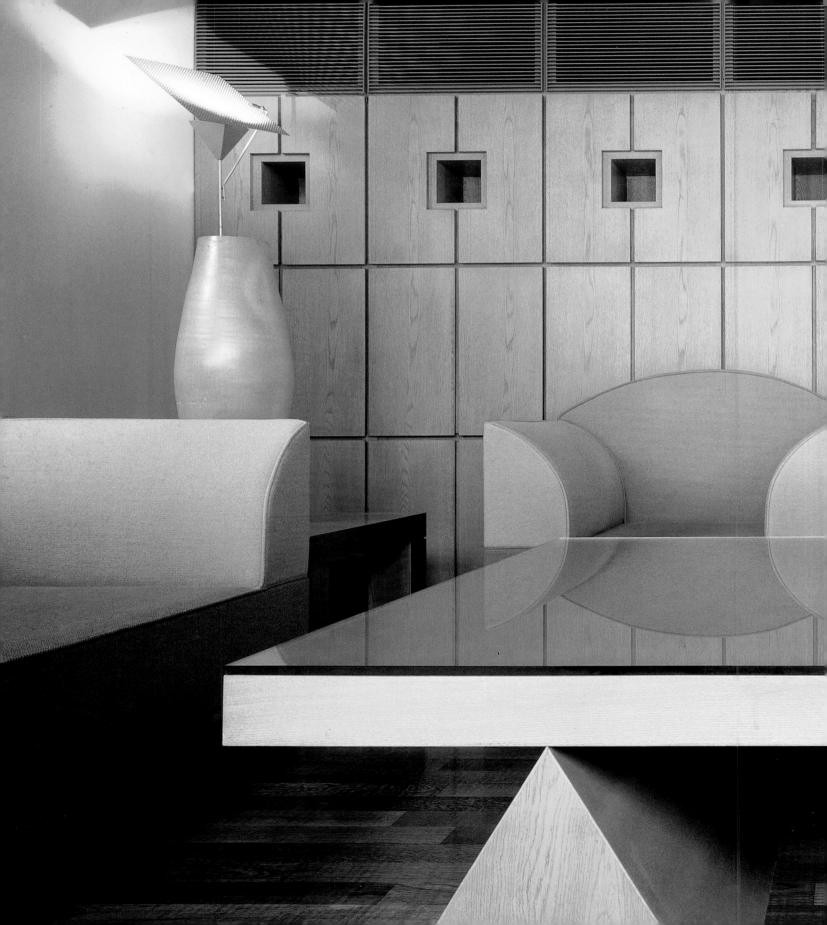

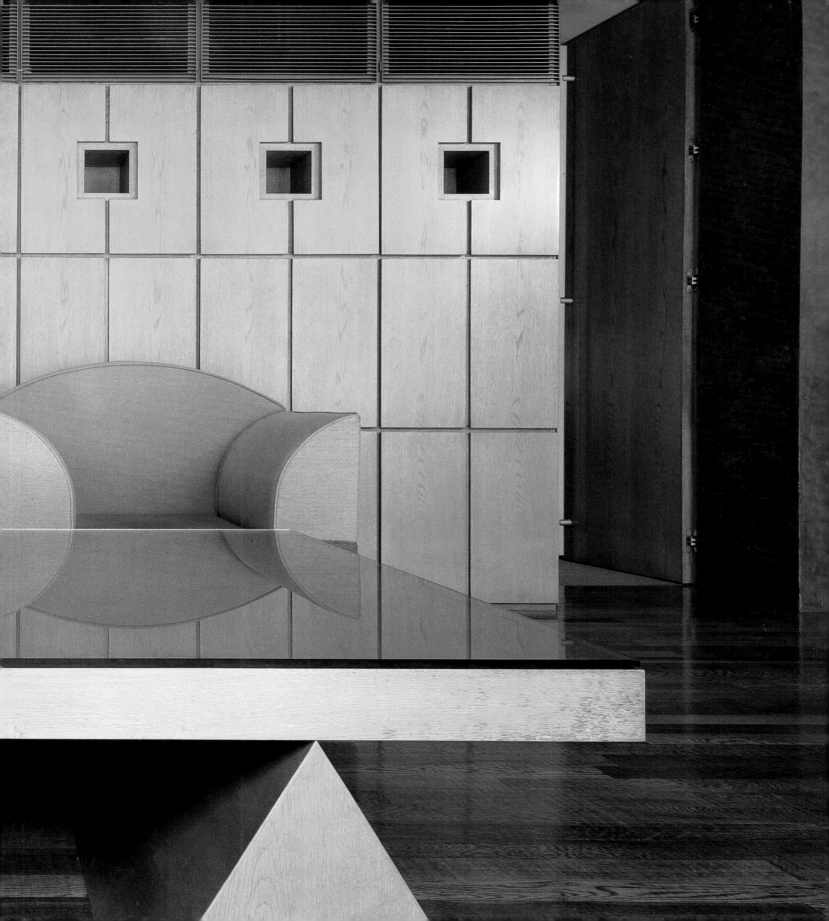

Transparent Living
An all-glass house for recreation

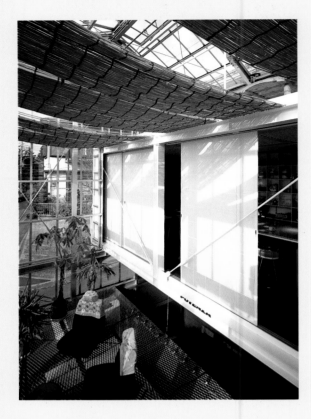

In the F3 House, set on a hillside in Yamato-shi, near Tokyo, architect Koh Kitayama responded in a radical way to his client's request for 'maximum hobby space'. The owner, a single man who enjoys entertaining and cars, had decided that he would make do with the absolute minimum living space in order to give the remainder of the house over to play. With inexorable logic, the architect packed the necessities for living — bathroom, bedroom, kitchen/dining room and study into one long, narrow box, and inserted this midway into the main structure where it sticks out at each side.

As there was no real need for privacy in the remaining hobby and entertainment space, Kitayama decided to open everything up to the surroundings by building the house with the components of an industrial greenhouse — all three storeys of it. On the ground floor is the garage for two cars, the mezzanine above is a grille that serves as an occasional sitting area and as a display space, while the top floor is a large deck with garden furniture and a parasol.

With a commanding view over the populated valley to the west, and as far as Mount Fuji 150 km away, this totally transparent home is a spectacular indulgence. Sliding *shoji* screens at the front of the living 'box' give privacy when needed, but as the owner explains: "People don't look inside on purpose. It's so open that passers-by are too embarrassed to peer in."

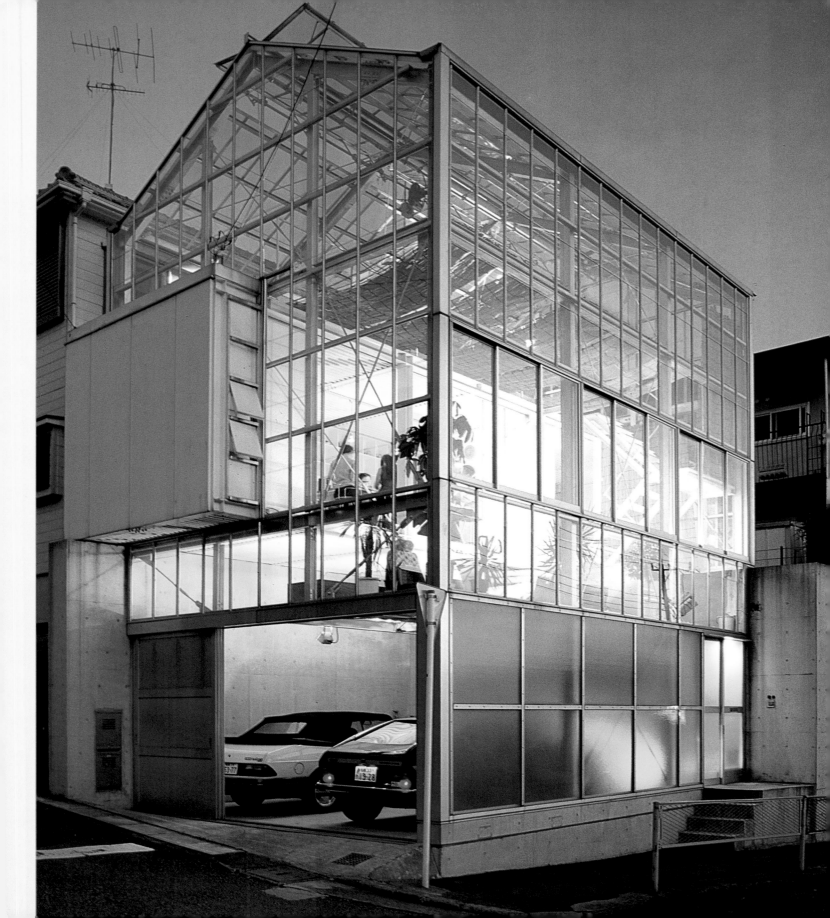

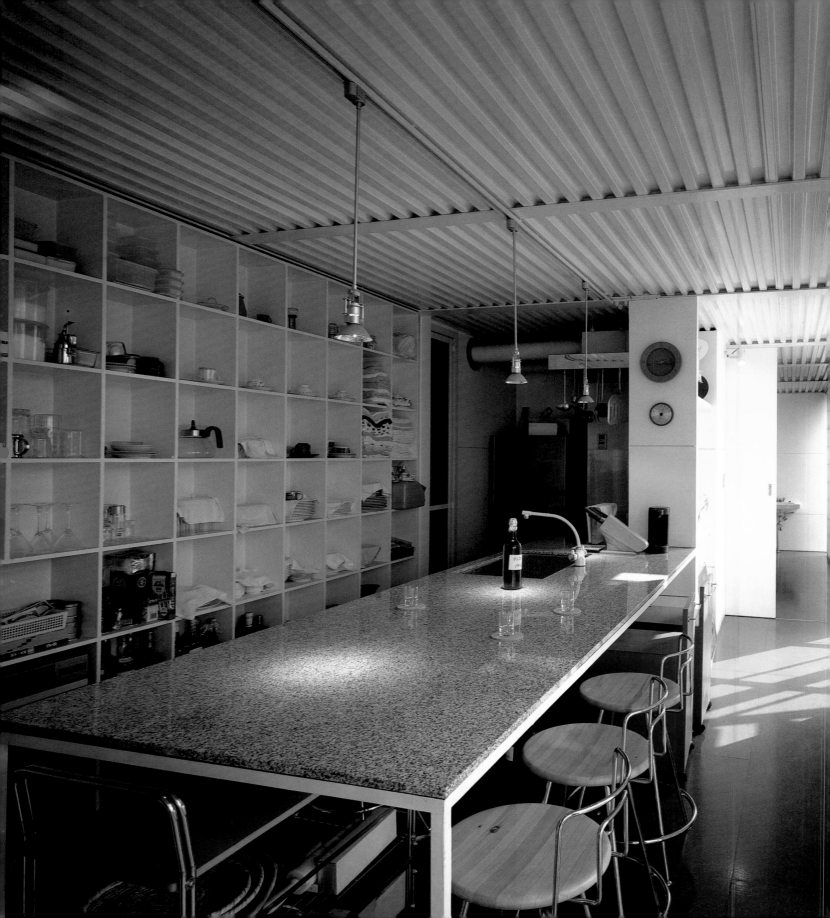

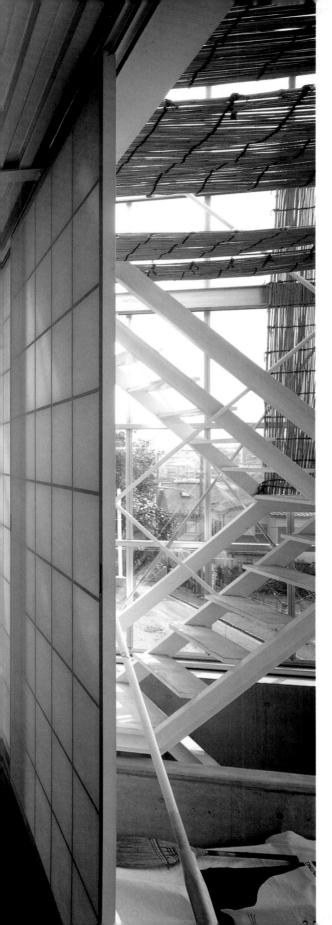

Left: The central section of the tiny living space is used for cooking, eating and just sitting around the counter. Neat storage is essential in such a transparent dwelling, and the box shelves at left are fully utilized.

Below: Sliding *shoji* screens at the front of the living 'container' open fully for a completely exposed view of the remainder of the house, and of the street and valley beyond. Sealed with paper on both sides for insulation (rather than on one side, which is more usual), they are known as *fukuro-shoji*, from the word for bag.

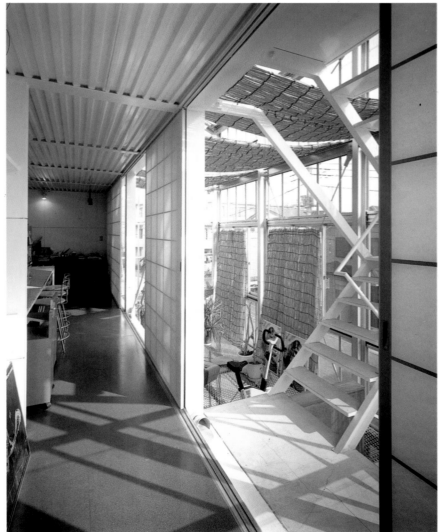

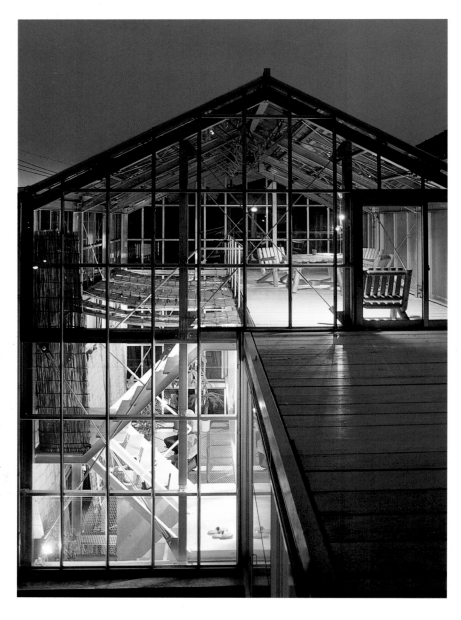

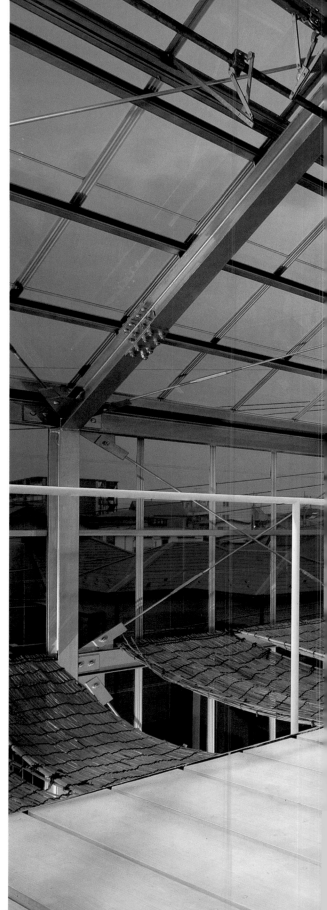

Above: The side of the house at night, from over the extension of the living 'container'.

Right: The upper deck has the most exposed setting of all, and is used in an open-air style, with garden furniture. Industrial greenhouse components include a geared system for opening the roof panels to help control temperature.

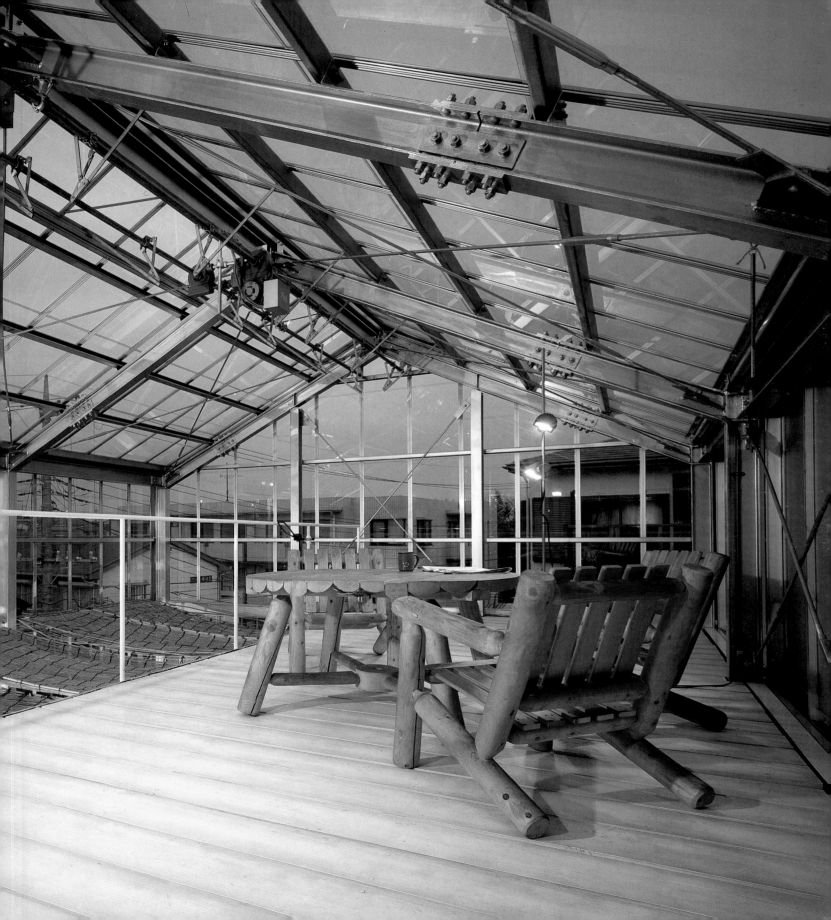

House Around a Bathroom
Challenging the hierarchy of rooms

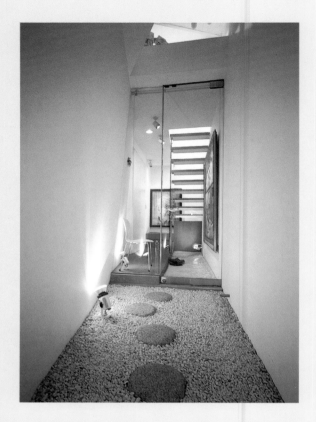

The bath plays a special rôle in Japanese life and it is much more than a functional necessity. From open-air hot springs to the small individual tub, the *o-furo* is a place to soak, relax and restore a sense of well-being after a long day. When Hideo Itoh planned his new house in Funabashi, he specified above all a good bathroom.

Already familiar with the work of architect Norisada Maeda, he was prepared to be surprised, but when he was presented with a design that revolved around a 10-foot-tall multi-angled plate-glass bathroom, he was delighted. "Maeda far exceeded our amateur imagination. Who could dream up the idea of a bathroom as the centre of a house?"

Maeda's design was not created out of a desire to shock, but rather to escape the western-influenced hierarchy of rooms that is the legacy of Japanese post-war reconstruction. Railing against the notion of 'LDK' (living room-dining room-kitchen) that is commonly accepted as the basis for planning a home, Maeda placed the bath centre-stage. The play of refracted and reflected light within the two-storey living (and bathing) area contribute to the subtle changes of atmosphere and sense of space that occur throughout the day.

As for the owner, he relaxes in the bath as family life goes on around him, and on Sundays he likes to finish a detective novel while soaking. In the summer, his 10-year-old daughter and her cousin use it like a swimming pool. And, as he says: "When we're just sitting on the sofa relaxing, I like to look at it. To me, it's like a work of art!"

Above: Circular granite stepping stones set among white pebbles lead from the front door to the vestibule's plate glass wall and door. The steps lead up to the living area.

Opposite: Raised as if on a pedestal, the plate-glass bathroom, 10 feet at its tallest point, is the centre-piece of the entire two-storey living area. Its inward-tapering walls enhance its impression of height.

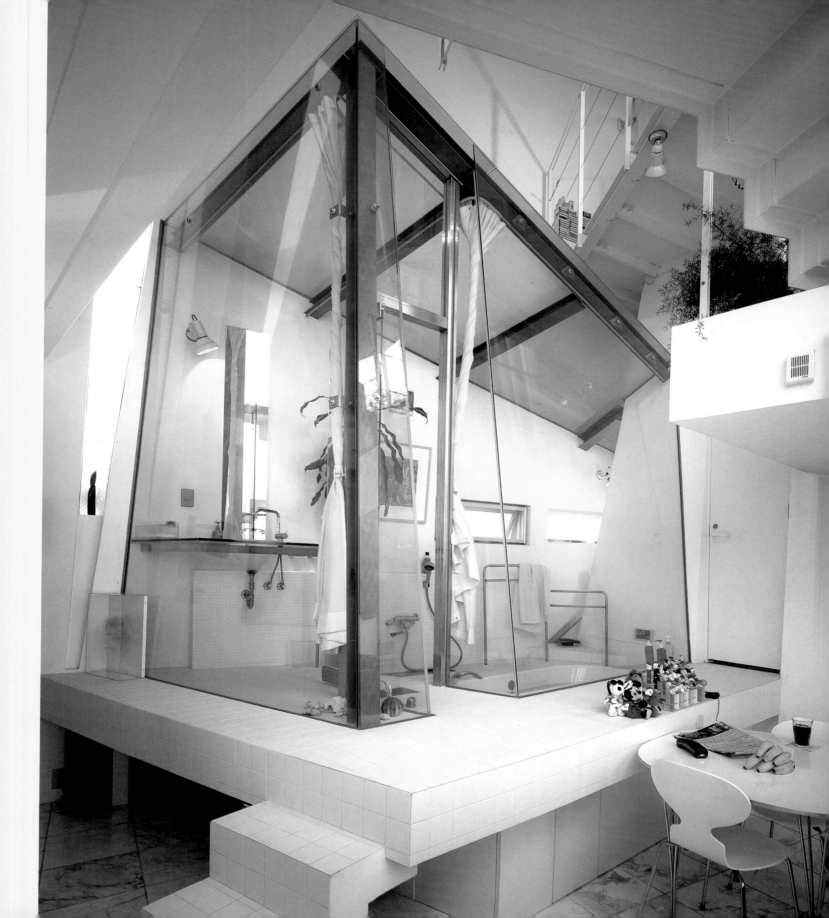

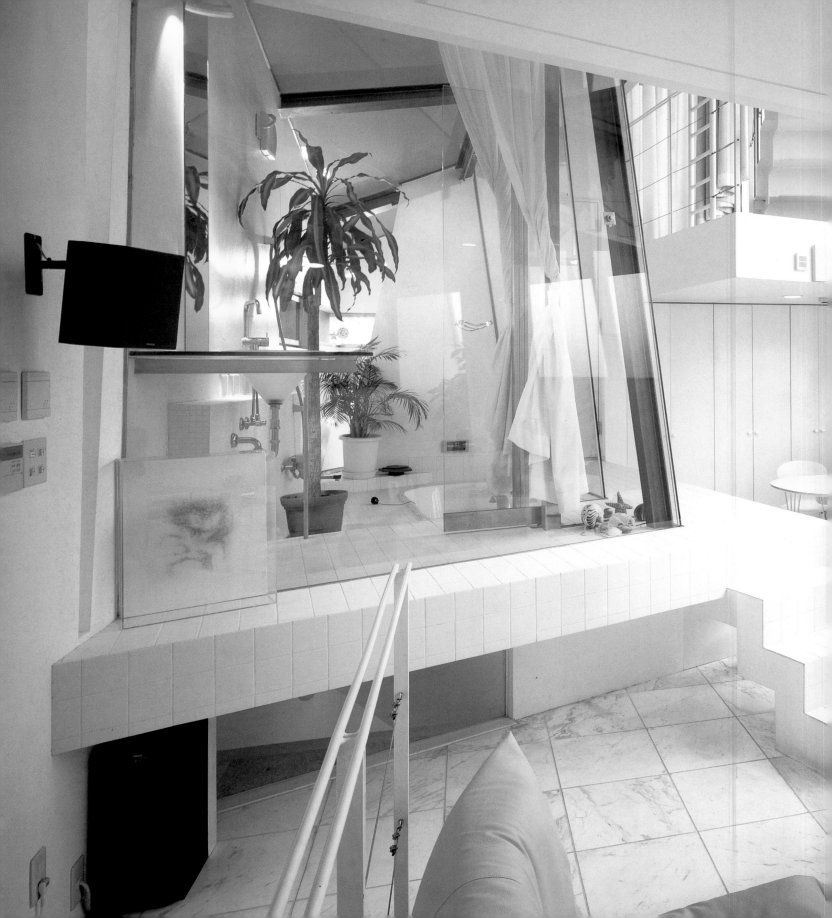

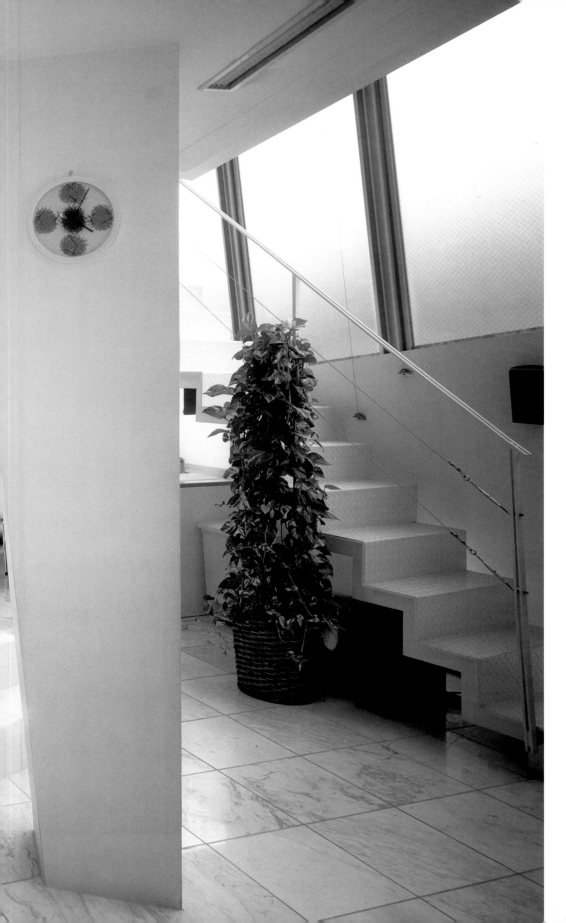

The view from the sitting area, underneath the suspended bedroom, towards the bathroom, kitchen and dining area, and the metal staircase leading up to the catwalk. With few exceptions, such as the step risers, the interior space has no right angles.

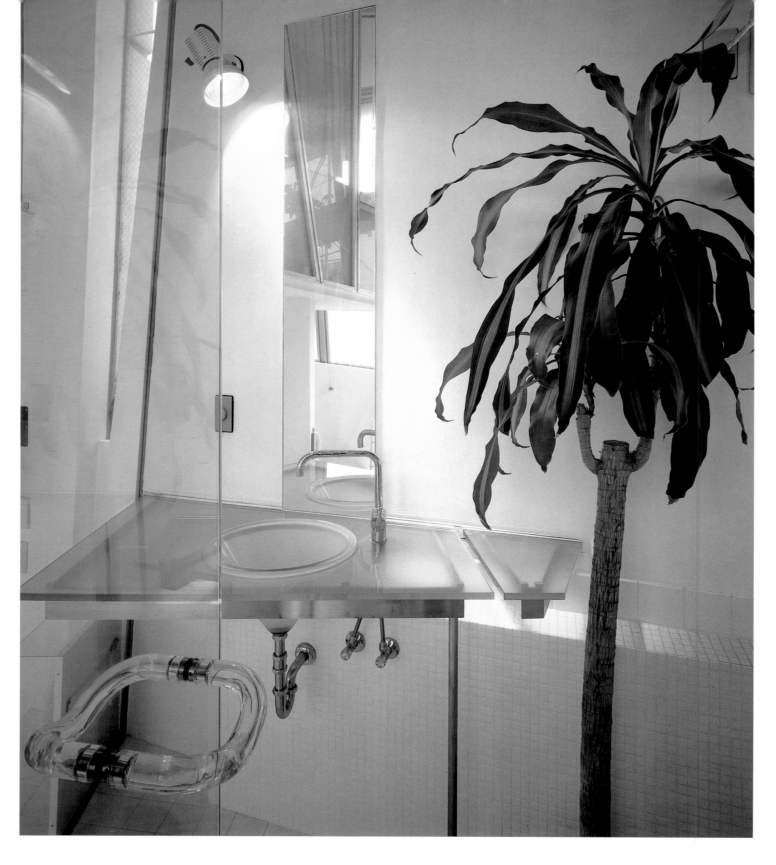

Left: The angular geometry of the house is carried through to the bathroom details, with its corner washbasin and long vertical mirror.

Right: Looking down from the catwalk above where it crosses over the bathroom. Full-length plastic curtains offer privacy when needed.

Below: A high metal catwalk crosses the living area, giving access to the daughter's bedroom, itself suspended in one upper corner, and also to a hanging platform hideaway.

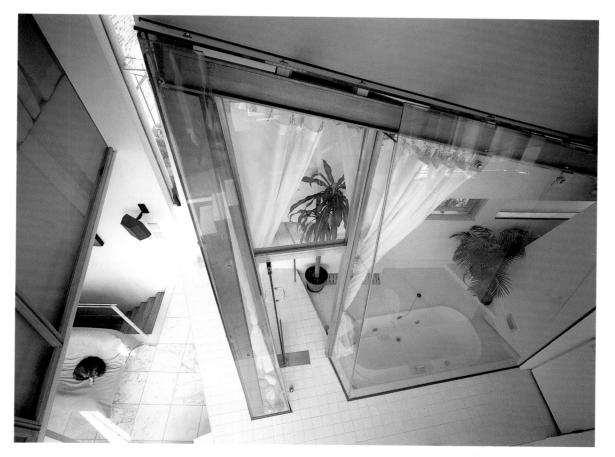

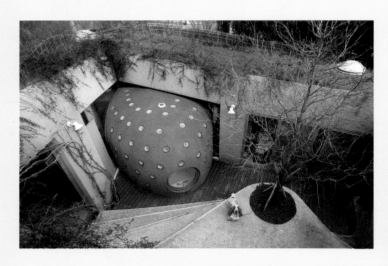

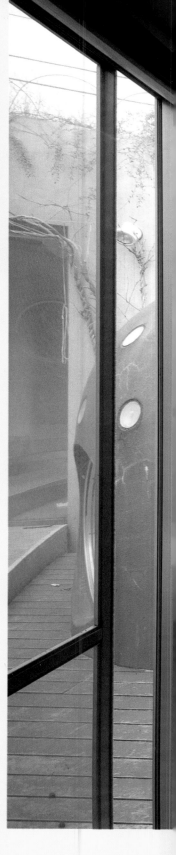

Soft and Hairy House
A radical Dali-esque vision of the future

Above: The view from the garden roof. The bathroom emerges into the courtyard like an egg pushing its way out of the house.

Right: Seen from the main bedroom, the self-contained blue bathroom squats partly in the living area and partly in the courtyard, and acts as the bedroom's principal partition. The walls of the house carry shelved storage space, all concealed by swathes of canvas. Flexible ducts direct air conditioning.

The architectural partnership of Eisaku Ushida and Kathryn Findlay has created some of the most ground-breaking designs in Japan. One of the most striking is the Soft and Hairy House, built for a young couple working in the relatively new Tsukuba Science City. One of Ushida Findlay's trademarks has been the use of a truss wall system that allows fluid structural shapes. Familiar with this from the partnership's earlier Truss Wall House, the clients asked for a radical solution that captures a sense of the surreal, quoting a statement attributed to Salvador Dali that the architecture of the future would be "soft and hairy".

As Findlay noted, factory-assembled houses were already being erected here "changing the landscape into yet another dreary exurb of Tokyo", but the clients strongly rejected this. The architects worked closely with the couple to make a home that would evoke a kind of primitive contact with the earth. The softness of its form, achieved by pouring concrete into pre-formed steel frames covered with wire mesh, evokes something of the rammed-earth adobe buildings of New Mexico, while the roof carries a casual, overflowing garden.

The basic shape is a continuous 'tube' around a small courtyard; the strangest feature of all is the bathroom, a blue egg with port-holes, tucked into one corner. In fact, the building itself symbolizes the family: the two wings represent the couple facing each other, and the bathroom — their first baby — nestles between them.

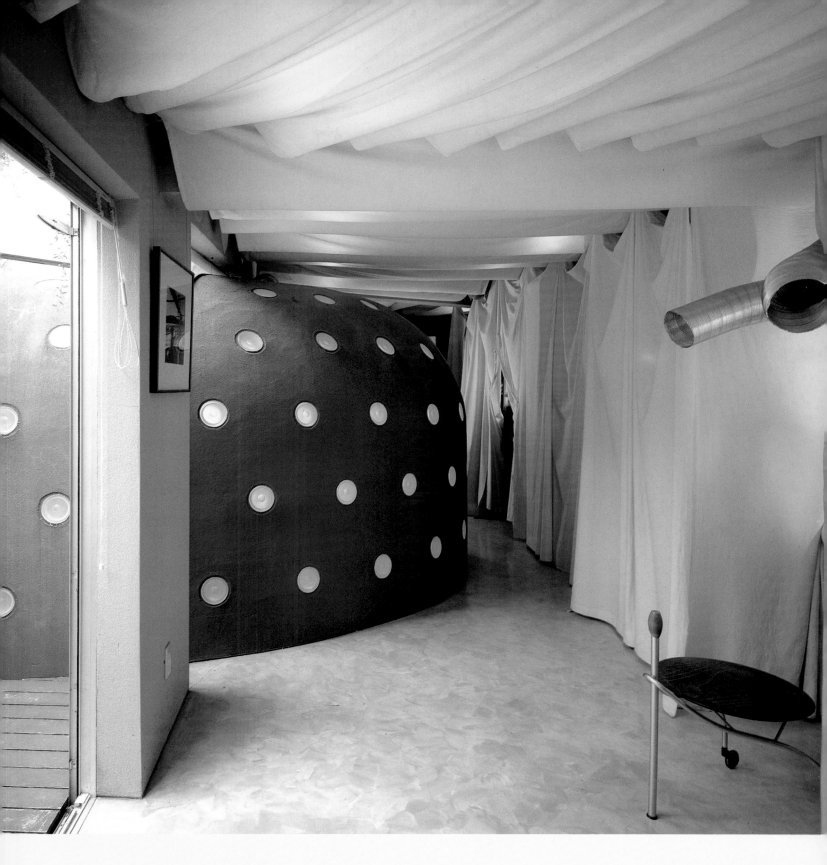

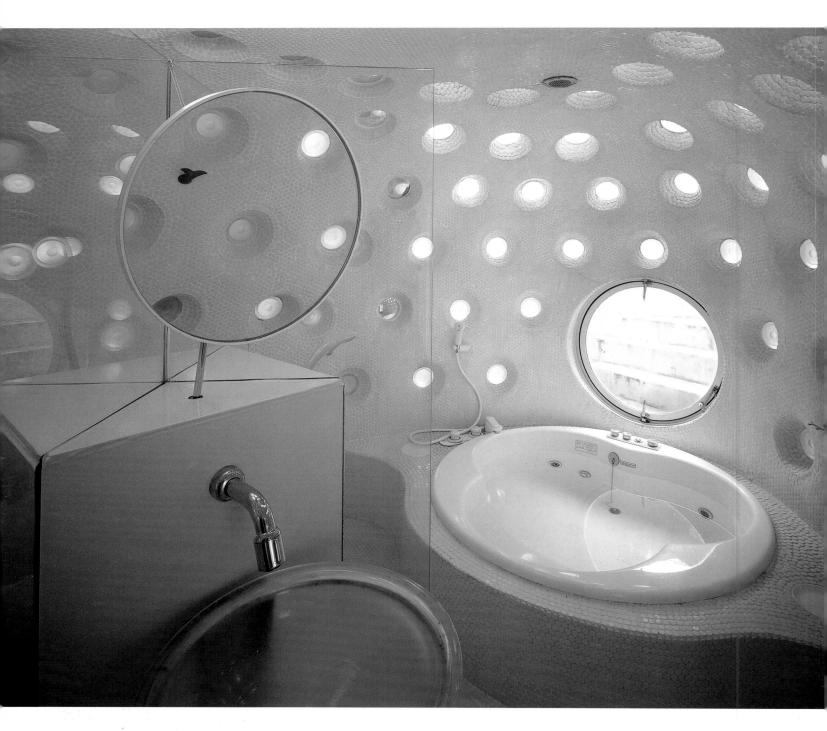

Above: The interior wall of the bathroom is lined with small circular rubberized tiles, and indented with glass portholes for daylight illumination.

Right: The sitting area occupies one of the bends in the house and faces through floor-to-ceiling windows onto the small courtyard. Bunched drapes of canvas form a dramatic shade for the ceiling light above the fitted semi-circular seating — the central sections roll out as stools and foot-rests.

Below left: A specially designed free-standing unit carries all the bathroom's utilities, including wash-basin, Japanese-style taps and shower, toilet, and (on the opposite side) a urinal.

Below right: The dining table, shaped like an over-sized ironing board on steel tripod legs, was also designed by the architects. A massive stainless steel cylinder houses the extractor and serves as a hanging rack for cooking utensils.

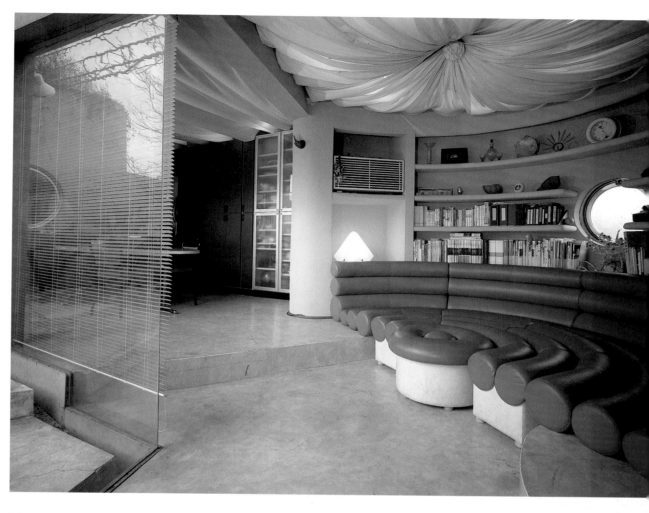

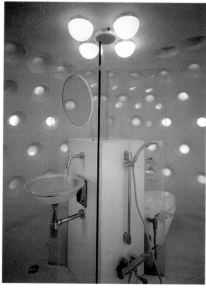

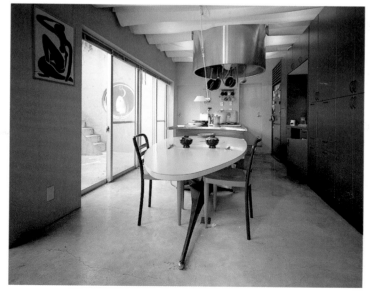

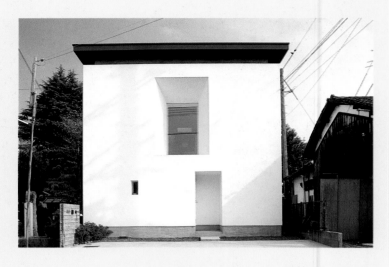

Curtains for Walls
Gentle partitions inside the Samurai Skirt House

Built for a couple in their thirties with two young children, this spare white structure employs an unusual, soft solution to the problem of dividing a small space. One of the requirements for the house was that from the outside it should have a simplicity in keeping with its location — at the entrance to a 16th-century Shinto shrine, where the owner's father is priest. The architect, Jun Tamaki, conceived the house as a monolithic cube enclosing a simple but flexible space for a family that lives closely together.

The core living area rises the full height (5 metres) of the house, with a mezzanine at the rear, and is partitioned from the peripheral rooms by a series of white polyester curtains that hang gently in vertical folds. When they are drawn, they form a floor-to-ceiling wrapping that covers everything except the windows, and the interior becomes one single mass. The Japanese name of the house — Hakama, the ankle-length 'skirt' worn by *samurai* — alludes to this.

The advantages are several: the cloth is an efficient, yet thin, divider and it creates a soft, light, airy impression. As Tamaki notes: "The internal surfaces may be opened and closed like a curtain. This curtain is blown by the wind. People lift it. The sun shines through it." Different sections may be drawn back to reveal different rooms and storage spaces, but the visual and tactile sensation is such that the interior seems at its most spacious and open when the curtains are fully closed. There is an economic advantage, too: no costly interior plastering and an inexpensive wood veneer is used for the walls.

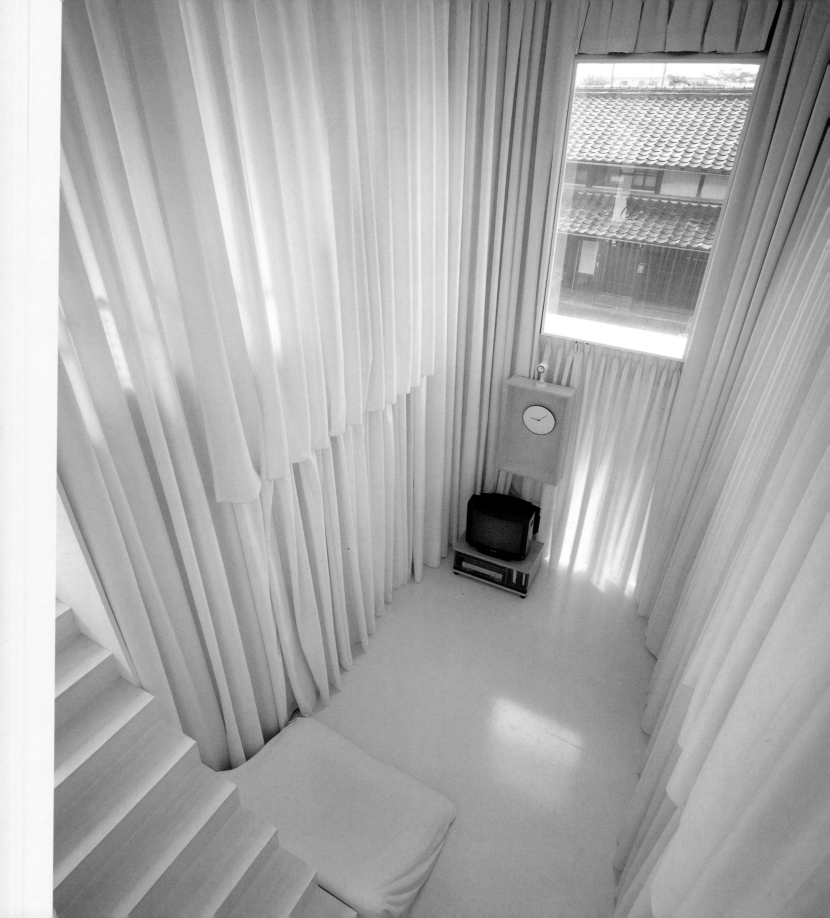

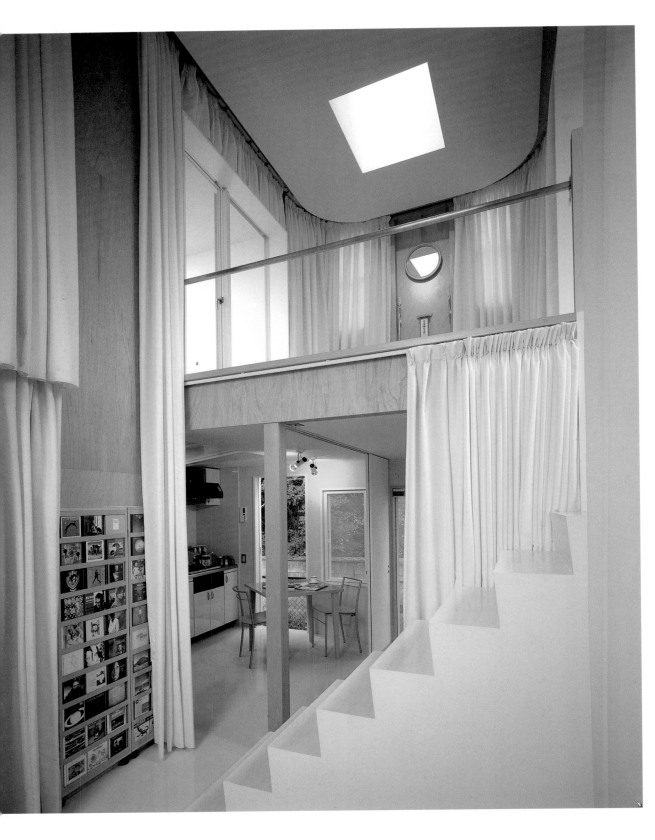

Below: Remarkably for such a compact building, there is space for a sound-proofed recording room, complete with drum kit and electric guitars. The square window at left looks out onto the centre of the house when the curtains are drawn back.

Bottom: The shrine on the rear wall of the second floor balcony.

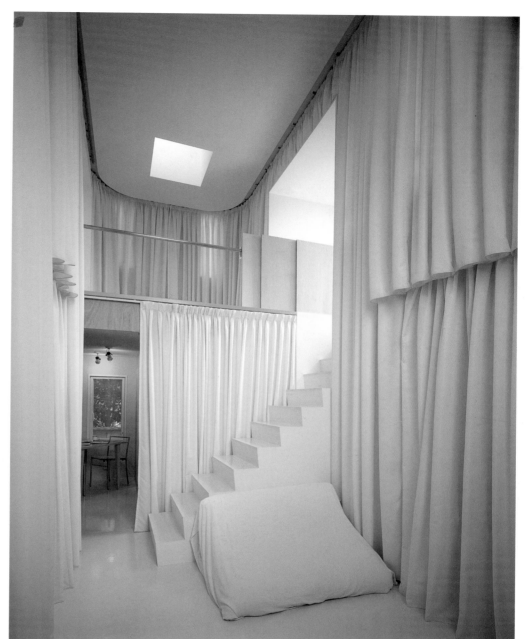

Above: To preserve the simplicity of the interior, access to the second floor is by white-painted box steps without a balustrade, recalling the traditional Japanese *kaidan-dansu*.

Levels in White
Bringing commercial design sense into the home

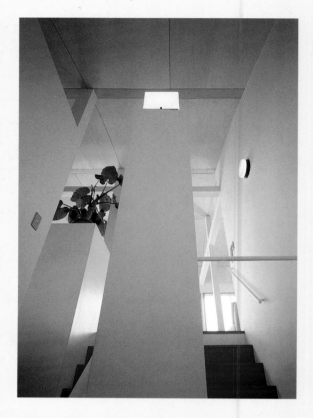

Above: **Approaching the living area from the ground floor, the return on the stair-case gives a first indication of the interplay between the various white surfaces and the lime-wood ceiling.**

Right: **With its combination of flat and curved planes, the deep bedroom, a short flight of steps down from the living room, is one of the most elegant spaces in the house. The dormer window at right adds a second, overlapping curved surface.**

When a well-known graphic designer moved to the fashionable Yoyogi district of central Tokyo with her husband and set about planning a new house in 1997, she turned to interior designer Yasuo Kondo. The two had previously collaborated on a commercial project for a boutique, and she was impressed with the designer's sense of scale and space. "His designs are usually radical and have a strong impact," she said, "but at the same time he managed to make the showroom feel comfortable. It's difficult to explain, but that was my feeling."

Kondo, who also designed two of the other homes in this book (pages 78 and 154), worked to a brief in which most of the ground floor would be given over to the client's design studio, and which included her strong preference for white. He devised a plan in which the rooms would all be at different levels, partitioned rather than completely closed off, and all united under the curve of a barrel-vaulted ceiling. His basic concept, he explains, was to enlarge the apparent space by having rooms of different heights, with the curve of the ceiling making them visually wider. The play of light across the white wall surfaces was also carefully orchestrated, using the pale lime-wood panels that cover the ceiling to distribute a warm glow from the windows, and in the evening from lamps concealed in a trough where the ceiling meets the wall.

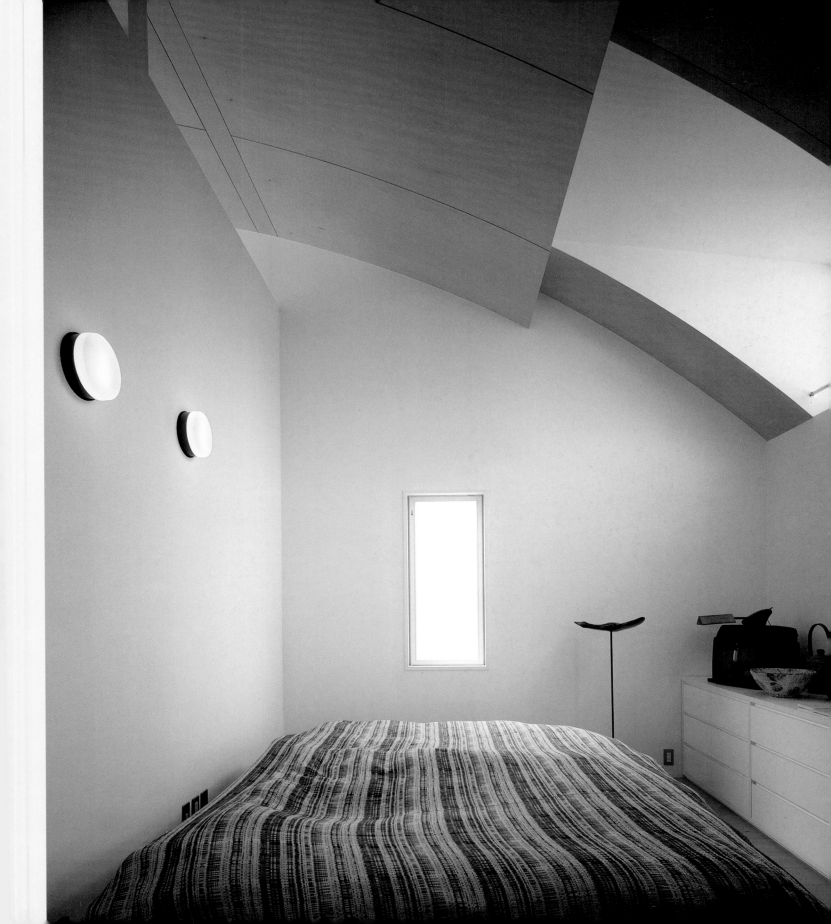

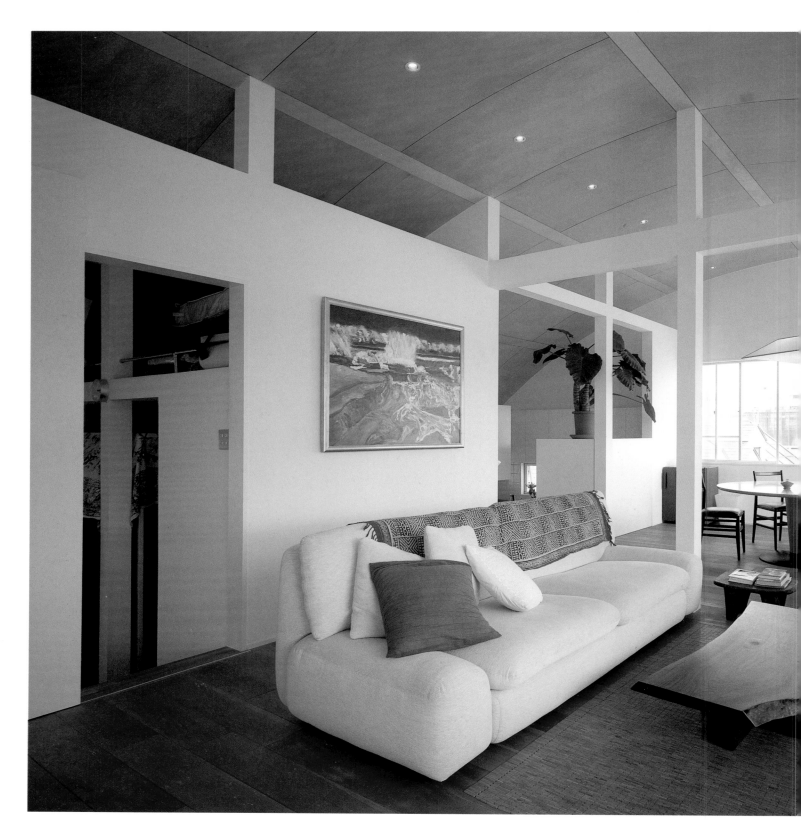

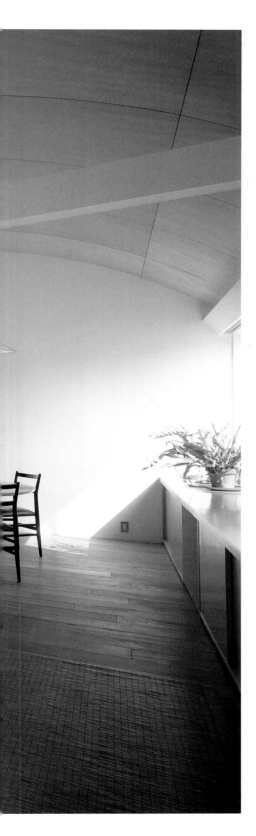

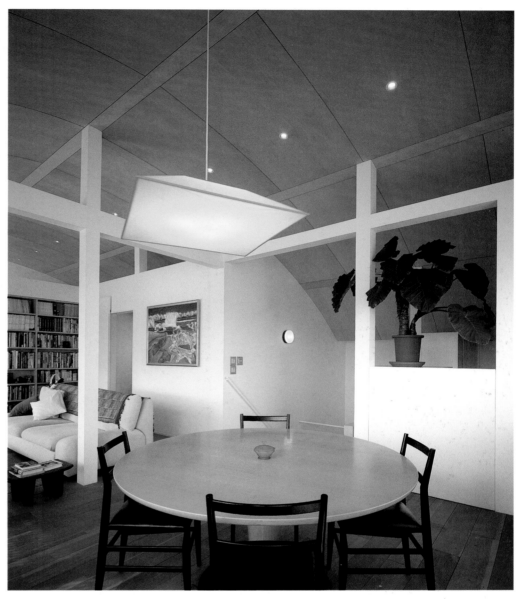

Left: The open-plan living and dining room occupies most of the length of the upper floor. Gaps in the partitioning wall at left allow almost the full span of the ceiling to be seen. Access to the lower-level bedroom is via the doorway at left and down a flight of steps.

Above: The dining end of the upper floor, adjacent to the kitchen (concealed behind and below the white partition at right). The trapezoidal light, christened the 'tofu lamp', was designed by the owner.

Right: On the ground floor is a traditional *washitsu* or Japanese-style tatami room, here updated by Kondo with frosted glass sliding doors and a single window placed high in one corner.

Below: The ground-floor entrance, located next to the *washitsu*, achieves a clean but warm simplicity with its box steps and floor in natural wood.

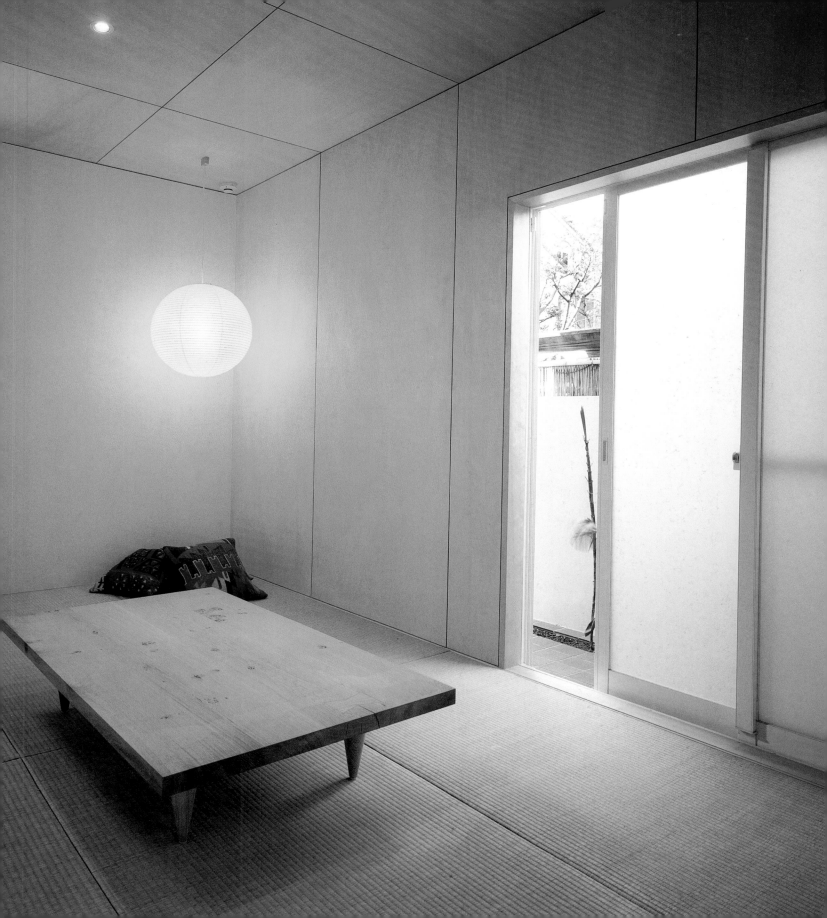

Glossary/Acknowledgements

Note: the prefix o- is an honorific term signifying respect. Also, the first consonant of certain words changes when they are used in combination; thus a chest is *tansu*, but a stairway-chest is *kaidan-dansu*.

Ainu the aboriginal people of Japan with their own culture

bunko library storehouse

chashitsu tea-ceremony room

chigai-dana staggered display shelf

chigiri wooden joint shaped like a traditional Japanese spool, taken from a word with the original meaning of spool or reel

daikoku-bashira main structural pillar of a house

doma flooring made of concrete or the floor at the entrance of the house, taken from the original term for "earthen floor"

o-do dome-like roof of a Buddhist temple

Edo both a period of Japanese history (from 1600 when Tokugawa Leyasu took control until the emperor regained power in 1868), and the capital at that time until it was renamed Tokyo

fukuro-shoji a treatment of *shoji* screens q.v. in which the paper seals both sides of the wooden frame — *fukuro* means 'bag'

o-furo traditional Japanese bath, for soaking and relaxing (washing is performed before entering the bath)

fusuma opaque sliding door, more substantial than a *shoji* screen q.v. ; made of wood faced with paper or cloth

futon mattress and bedding

gaku decorative tablet similar to a lintel placed in the *ranma* q.v.

go Japanese board game of strategy

hakama ankle-length 'skirt' worn by *samurai*

hanami cherry-blossom viewing

hina-ningyo porcelain dolls placed on display in the *tokonoma* q.v. for the March girls' festival

irori traditional sunken hearth set in the floor, over which is suspended a kettle and cooking vessels

kanji Chinese ideograms, one of three sets of characters used in written Japanese; the other two, *hiragana* and *katakana*, are scripts based on syllables

katsura-dana display shelving that originated with the *samurai* class, traditionally in a prominent position, carrying writing materials among others

keyaki Japanese elm, popular in parks, gardens and shirines

kido-mon typical wooden house gate

kotatsu traditional foot warmer, consisting of a low table covered with cloth reaching the floor concealing a charcoal fire beneath

minka traditional Japanese folk house, using massive, open post-and-beam construction

mizuya area adjacent to a tea-ceremony room for washing and preparing utensils

natto fermented soybeans wrapped in straw

nihon-ga Japanese painting

nijiri-guchi 'wriggling-in' entrance to a *chashitsu* q.v. The dimensions are 67 cm high and 64 cm wide, small and low so that guests at a tea ceremony must crawl into the room

ranma the space between the top of an interior partition and the ceiling, used for decoration

sado tea ceremony (literally 'the way of tea'), conducted in a special room, the *chashitsu* q.v.

sakura cherry tree

samurai Japanese warrior

sanmata tripod

seikatsu-shu 'lived-in atmosphere' of a house

shibamune thatched roofs with plants growing on them — an old country style

shoji lightweight and light-transmitting sliding screen, made of paper stretched over a wooden frame

sukiya style of architecture and design characterized by restraint, simplicity, understatement and subtlety

tamaryu perennial, evergreen plant in the family of the lily grass

tampopo dandelion

tansu chest, with several varieties; a space-saving *kaidan* ('step') *dansu* doubles as access to an upper floor, and a *kuruma-dansu* has wheels

tatami mat used for traditional flooring, made of straw and rush over a wooden frame, edged with cloth strips; the standard dimensions are 1757 mm by 879 mm, although there are regional variations

tofu bean-curd

tokonoma alcove for displaying treasured objects such as a scroll painting; a focal point for contemplation

tsuitate free-standing screen

tukeshoin shelf desk used for writing and display

wabisuke variety of *tsubaki* (camelia)

ware-garasu type of glass with cracks inside, named by the designer, Shiro Kuramata

washi hand-made paper

washitsu traditional Japanese room, floored with tatami q.v.

yojo-han room with four and a half tatami mats

yokogi cross-piece for raising and lowering the potboiler over a traditional hearth (*irori*)

yoshizu reed screen, with various uses, including a temporary shade for sunlight, and fencing

The author would like to thank the following for all their help during the process of researching and writing this book:

Ken Frankel
Hiromi Egoshi
Hikaru Soga
Ikuko Kaitani
Tomomichi Natsume
Ikizaka Architects
Masahiro Kamijo
Taz Yamasawa
Hiroshi Yamashita
Seiji Asari
Takashi Tachibana
Akito Hirotsuji
Nobumichi Ohshima
Jun Yamaguchi
Yoshikazu Yokoyama
Kiyoko Tosaki
Kazuko Ninomiya

Index